Two Worlds of Andrew Wyeth
A Conversation with Andrew Wyeth

By Thomas Hoving

Illustrated

HOUGHTON MIFFLIN COMPANY BOSTON

Library of Congress Cataloging in Publication Data

Wyeth, Andrew, date
 Two worlds of Andrew Wyeth.

 Originally published as the catalog of an exhibition
held at the Metropolitan Museum of Art, New York.
 1. Wyeth, Andrew, date —Exhibitions. I. Hoving,
Thomas Pearsall Field, 1931- II. New York (City).
Metropolitan Museum of Art. III. Title.
ND237.W93A4 1978 759.13 78-16545
ISBN 0-395-27089-8
ISBN 0-395-27080-4 pbk.

Printed in the United States of America
H 10 9 8 7 6 5 4 3 2

We are especially grateful to Betsy James Wyeth, H. Donald Widdoes, and the Brandywine River Museum for providing many of the photographs used in this publication. Other photographs were supplied by: Harry N. Abrams, Inc.; Amherst College; The Art Institute of Chicago; Art Reference Bureau; Donald Brennwasser; Coe Kerr Gallery Inc.; Edward Cornachio; Alexander McD. Davis; M. H. De Young Memorial Museum; The William A. Farnsworth Library and Art Museum; Frank Fowler; Peter Juley; M. Knoedler & Co.; Gerald Kraus; Paulus Leeser; The Metropolitan Museum of Art Photograph Studio; Vincent Miraglia; Museum of Fine Arts, Boston; The Museum of Fine Arts, Houston; The Museum of Modern Art, New York; Charles Patteson; Triton Press; Malcolm Varon; Herbert P. Vose; Richard D. Warner; Wildenstein & Co.; and Alfred J. Wyatt.

Editors: Katharine Stoddert Gilbert and Joan K. Holt
Design: Barnett/Goslin/Barnett

Two Worlds of Andrew Wyeth

"Maine to me is almost like going to the surface of the moon. I feel things are just hanging on the surface and that it's all going to blow away. In Maine, everything seems to be dwindling with terrific speed. In Pennsylvania, there's a substantial foundation underneath, of depths of dirt and earth. Up in Maine I feel it's all dry bones and dessicated sinews. That's actually the difference between the two places to me."

Andrew Wyeth

Introduction

Andrew Wyeth the man and his creations have had a compelling fascination for me throughout the two decades I have been an art historian. When I was just starting, in the early 1950s, I had become captured by the spiritual realism of *Christina's World*. I would make frequent pilgrimages to the Museum of Modern Art to look at *it,* only it. Subsequently, in graduate school, where I was being fully trained in art history, I gained sophistication and rejected Wyeth. At that time I embraced the more fashionable painters of Abstract Expressionism. Yet, despite my intellectual blinders, I could never entirely dismiss Wyeth's penetrating, sometimes annoying images from my mind. Was he *valid*? Could he be more than a mere illustrator? In time, I began to realize that for years I had stopped looking at his works of art themselves and was just reading the labels others had affixed to Andrew Wyeth.

Few contemporary painters have been more neatly packaged than Wyeth. In one camp he is an "anachronistic nineteenth-century realist"; in another, a "humble painter revealing the true American bucolic scene"; in another, "an avant-garde abstract-realist"; in yet another, "anti-academic." The very name Andrew Wyeth conjures up wildly varying responses and spirited controversy. There are those who describe his works as honest bulwarks of clarity defending us against degenerate abstraction, and others who look upon his paintings as sickeningly popular, deliberately reactionary, and coldly trite. Both swings of the pendulum are fanciful, amusing.

When in 1975 I learned that the Metropolitan Museum would be able to mount a major exhibition of Andrew Wyeth, through the generosity and interest of Joseph E. Levine, a passionate collector of his works, I was delighted. Now, I thought, would be the opportunity to examine the artist penetratingly, without preconceived labels: to observe him, to reveal, perhaps to complicate rather than to simplify him. It was time to remove the wrappings.

But what would the artist himself think? I had met him once, offhand, in 1967 at the time of his major exhibition at the Whitney Museum. He had greeted me testily with the words, "Well, why are you against my work?" What sort of a mind reader was this man, I had thought? I had launched a flurry of fatuous disclaimers and red-faced excuses, which had been received with skepticism. So with anxiety, I made the trip to Chadds Ford in Pennsylvania to discuss with him the possibility of an exhibition.

Andrew Wyeth was forthright, mischievous, charming. "You must *promise* to go after me like a surgeon," he demanded. "And don't be afraid of a helluva controversy either." Instantly I knew that it was going to turn out just fine.

To structure a major exhibition of a living artist is a delicate piece of work. The idea—the theme—of how to present the works rarely emerges at the beginning. Wyeth and I both recognized we did *not* want a standard retrospective. Both of us yearned to focus on, to probe, to make manifest Wyeth's creative process. During a visit to Maine, some months after we had started planning, Andrew, his wife, Betsy, and I all at once, together, got the idea. The exhibition would deal with two subjects alone, the two fundamentally important environments of his life—Kuerners Farm at Chadds Ford and Olsons Farm in Cushing, Maine. It would show for the first time a large body of preparatory material.

Then the exciting work began. I was taken to dozens of locked drawers in his studios and to the Farnsworth Museum in Cushing to examine studies and pre-studies of every tempera, dry-brush painting, and watercolor Wyeth had made of Kuerners and Olsons farms. No one but him and his family had ever seen most of them

Pencil study for The Prowler, 1975

before. There were more than fifteen hundred studies. Every time another hidden work was revealed, my admiration for the artist increased. It was like being present at the construction of a magical edifice.

I had decided not to publish the normal catalogue for the show. I was determined to do more than a series of descriptive entries containing sizes, materials, dates. But how to do it? And who would write it?

Andrew Wyeth is acutely sensitive, virtually superstitious about the fact that his ideas for paintings come to him "by chance," or "through the back door." He relishes the flashing concept of the split-second, the unexposed revelation that will, over weeks, develop into a tempera, a dry-brush, a watercolor. And oddly enough, the book for the exhibition came into being in the same way. The curator at the Metropolitan who had requested the job suddenly withdrew. The task abruptly fell upon my shoulders. I knew at once what I wanted to do—engage Wyeth in conversations. He agreed.

I decided to approach Andrew Wyeth from the point of view of an art historian, not a social commentator. I hoped to reveal the depth of the artist; I desired to get into his eyes, his mind, even his fingers, to unravel his creative process. Deliberately, I avoided reading anything about him. Freshness counted. But I immersed myself in all the Kuerners and Olsons material. Saturation with the works of art would be vital. I selected the paint-

ings I would ask him about and memorized them in random order—a Kuerners, two Olsons, two Kuerners—so that the artist would not respond to them as pieces of a chronology but as individual entities.

I drafted a list of questions about Wyeth's beginnings, his concepts of realism, his influences, his *media,* his two environments and memorized them in the precise order I believed would translate, eventually, into a good visual layout of the overall book. Memorization was crucial, for it would have been ruinous to have interrupted the artist to glance at a clipboard of notes.

Reticent at first, faintly embarrassed that he might seem garrulous, Wyeth warmed up to the conversations. They took place over five consecutive days in the fall of 1975 at Chadds Ford—in his studio, in an eighteenth-century grain mill that he has restored to working capacity, in his kitchen before a fire—six to eight hours each day. I knew I had one chance; my portrait of Andrew Wyeth had to be sketched out in one series of sittings. Neither of us ever felt tired throughout the hours of taping. On the contrary, for as Wyeth remarked, "You never get tired when you're *burning up the track.*"

At the end of each day, I would spot-check the tapes; they appeared to be perfect. Wyeth had revealed himself as never before. Yet, weeks later when I eagerly began to read the typed transcript, I was horrified. The first page was gibberish; throughout the manuscript numerous gaps appeared, some up to five minutes. Dozens of words had been labeled "incomprehensible" or "inaudible" by the transcriber. I was crushed. For the first time in my professional life I simply quit, went home and lay down, almost physically ill. How could this disaster have occurred? Profoundly depressed, I inserted the first cassette to try to reconstruct the reasons for the calamity. But I heard Wyeth's voice very clearly. I picked over the transcript as I listened. Suddenly I realized that there was nothing wrong at all. Wyeth's distinctive high-pitched inflections had thrown the transcriber for a loop. It was all still there. And so with the greatest elation, I began the process of listening and stopping, writing it all down, losing nothing throughout, beginning with Wyeth's confident, excited answer to the first question.

Thomas Hoving
Former Director
The Metropolitan Museum of Art

Beginnings

1, 2. Pencil and watercolor drawings by Andrew Wyeth at the age of eight
3. An oil painting by N. C. Wyeth, Andrew Wyeth's father, illustrating "The Black Arrow" by Robert Louis Stevenson (Scribner's Illustrated Classics, 1916)

''How did it all start? How did you become a painter? What are your earliest recollections?''

"Well, I sort of backed into art, and I learned backwards, too. Most people tend to begin tight, frugal, in an academic manner, almost fearful or at least overly respectful of getting it right. I started off just the opposite – wild, free, and even explosive."

''But art was in the air at Chadds Ford, wasn't it? Your father was a highly successful artist, a famous illustrator who produced a considerable number of dramatic, sometimes romantic illustrations for books such as *Treasure Island, Robin Hood, The Last of the Mohicans.* This must have had a profound effect upon you.''

"Art was in the air, as you say, but not so much for me, curiously enough. I was the youngest of the five children and was frail, unhealthy. I never went to formal school but was tutored, and consequently felt on the outskirts of the family. My sisters, Henriette and Carolyn, who showed early talent for painting, were brought very quickly into the studio by my father. I was almost forgotten. So I played alone, and wandered a great deal over the hills, painting watercolors that literally exploded, slapdash over my pages, and drew in pencil or pen and ink in a wild and undisciplined manner. My earliest things were landscapes, hills near our house, romantic images of medieval castles, knights in armor, a lot of drawings of doughboys, soldiers of the First World War, because I was just fascinated by a collection of lead soldiers I had of that period. My father did see the work, but casually. I wasn't exactly ignored, it was just that I wasn't focused in upon like the rest of the family. Then, one evening, when I was about fifteen, I showed my father a miniature theater I had made out of cardboard, with painted scenery and the like, and told him about a playlet I had written – at that time I was much influenced by Shakespeare, as I am to this day – and he looked at it, rather casually I thought at the time. But, offhand, he said, 'Andy, next week I want you to come up to the studio, draw from casts, and get started in academic training.' "

1

2

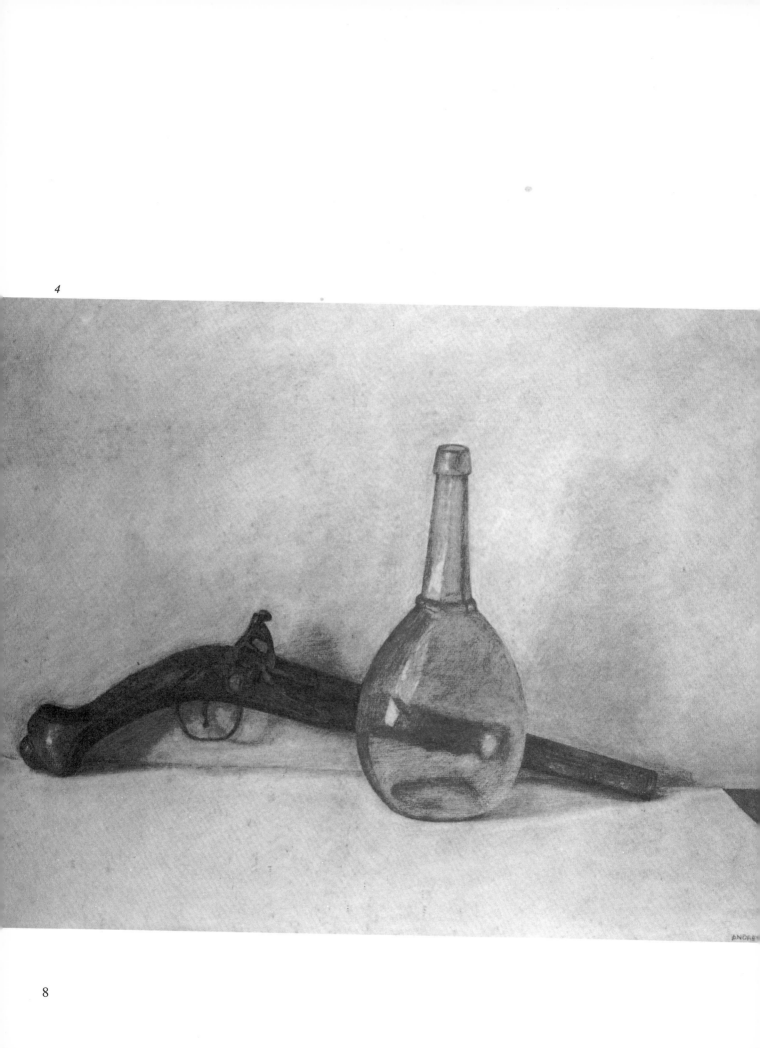

5

"I wonder whether your father was really ignoring you, but, rather, was considerably impressed with your naturally skilled work and was waiting for just the right moment. A glance at some of the very early things, those pen and ink scenes of castles and medieval soldiers [5], shows a talent bordering on that of a child prodigy. They are facile and sure, yet rather strong despite their inherent freedom. Perhaps your father recognized that the worst thing he could do would be to start you on formal training too early, because that might blunt the emotional freedom and what I would call the 'fortunate' wildness of those youthful skills."

"That's quite possible. He was deft, gentle about it and in retrospect I have to admire his almost sleight-of-hand quality in bringing me along. Well, at first, I resented what I suppose you might call this intrusion. Wanting recognition of a sort, I suppose I resented it when it came. I did hate the regimen at first. But I remember the first thing my father put up in the studio for me was something purely to gain my interest. So I guess you have a point. Usually he would set up for a beginner a wooden sphere and a cube, painted flat white, and arrange them together on a neutral background. You were expected to draw these objects very carefully in charcoal, getting the proportions and perspective, and strange shadows and reflected lights perfectly accurately. With me, he did something that he never did with the rest of the kids – a very interesting thing. With me, he took a marvelous flintlock pistol, a pirate pistol, that he had around as a prop, and leaned it against the flat white paper background [4]. Suddenly I was excited and no longer resented the discipline of the task. Of course, deftly, he was trying to bring me slowly into the direct observation of an object and of reality without too abrupt a change from my young, romantic feelings. I remember that very clearly. For about five months of that – these things last a long time – I drew this assembly from all sides and angles very accurately with no color at all, just in charcoal on white paper, black and white with gradations of tone. Then after this long period in which I actually got more and more interested rather than bored, he removed the pistol and I did drawings of the cube and sphere alone.

"Then he set up a still life with apples against a drapery and I did that in oil. For a long time I experimented in still life in this manner and, as a nudge, from time to time there were changes. For instance, I remember working on a copy of Beethoven's death mask. It was fascinating to observe the subtle planes of the face and to link them to the great man! Then back to more still life. I remember vividly a great cutlass against some drapery, with its long, sharp, bold form and its massive handguard.

"My father certainly came down upon me, firmly pressing me on, but at the same time he left me really very free. He made me get down and approach the object, and work from it rather than the images from my mind. Slowly, he gave me the taste of really wanting to get closer to the image in front of me. And so, after a while, with all the freedom I had, I began to realize that there was something else there, too. I didn't get to the object, I didn't proceed to the realism that comes from the intent examination of the object because he told me to do it. I did it, finally, because I really wanted to. This moment of discovery of the object was quite literally an impulsive act, something sharp, like darting after a thing. It was like someone who thinks about a certain type of food, then tries it, likes it, and goes after it voraciously. It is something that came through the back door and then I seized upon it."

"Having a father who did not exert pressure upon you at an early stage, or rigorously demand that you had to show you had what it takes in academic work, might have been one of the single greatest blessings that happened in your formative years, because it preserved the natural duality of freedom and discipline within you."

"There's simply no doubt about it. You see, my father got me to the point in realism, in observation, where I would say to myself what I had just painted or drawn isn't *really* like the object. It doesn't have the texture of it. It looks like a *painting* of the object rather than the object itself. I was seeking the realness, the real feeling of the subject, all the texture around it, everything involved with it, even the atmosphere of the very day in which the object happened to exist. All of this just naturally came about, with, of course, the right push from my father who recognized that excitement I had within me.

"In time, a rather extraordinary thing would happen. When I was drawing a tree, let's say, I would walk right up and count the branches, every one of them, right down to the finest tendrils, the buds, the tiny irregularities on the bark, to be sure that I got everything in. I got as intoxicated doing that as I had been in throwing paint and ink around exuberantly in my earliest work. I suddenly realized that I wasn't after an image of something or an illusion of something. I quite literally wanted to have – in my own vision of it, of course – the real object itself, or at least primarily the real object and only a little illusion. It was, in a sense, an almost *primitive* point of view, somewhat similar to the works of the Italian primitives of the thirteenth and fourteenth centuries."

"You mean primitive in the sense that although the style of their pictures seems unrealistic, the paintings are super-real in that they are living dogma."

"Absolutely!"

"It might amuse you to know that there are legends, particularly in the Middle Ages, about certain cult images – a Madonna and Child, let us say – that appear to our eyes to be abstract, hieratic in style, primitive. The legends relate how these carvings were seen actually getting up off the altar and moving around, so real were they in all respects, artistically and thus spiritually. One tale has it that during a small fire, one Madonna and Child walked out of the choir, out of the nave, climbed into a protective tree, and had to be coaxed down by the priest."

"Marvelous. Well, in a way, that type of power of realism was what I was after. I don't think I ever achieved it – never will – but, anyway, that was the search. My father seemed pleased with what I did, although he didn't say too much. He would come into the studio and correct a few things, but not meddle.

Good-Looking **Glass**

See the remodeled Delaware Art Museum in a new light.

TWENTY-FIVE dazzling colored-glass sculptures suspend from the second-story archway of the newly renovated Delaware Art Museum. Textured and vibrant, their blown-glass shapes appear like frozen liquid, refracting a rainbowed palette onto the floor. If these "Persians," created by Dale Chihuly, the world's premier glass artist, hint at the rest of the museum's new look, its reopening will amaze.

The same soaring two-story East Court houses outsized modern artworks such as Alexander Calder's 75-foot-long painted-aluminum hanging sculpture "Black Crescent" and the colorful geometric shapes of Al Held's giant acrylic "Rome II."

"In its previous incarnation, the museum was limited in size and number of pieces we could display," says the museum's Lora Englehart. "Now we have more wall space." Not only that, the entire wall on the northeast side of the East Court raises at the loading dock, so oversized pieces, including traveling exhibits, may be brought in and installed.

The museum's grand reopening in late June marked the end of a three-year $31-million construction project that increased the facility's size by nearly 70 percent, from 60,000 to 100,000 square feet. The expansion allows the museum to exhibit significantly more of the 11,000 works in its permanent collection, which focuses on American art of the 19th and 20th centuries. Even Chihuly's glass art has expanded. Whereas previously the museum housed only 18 of his "Persians," they've now added seven more.

The museum's exquisite collection of pre-Raphaelite art, the largest outside the United Kingdom, is currently on tour.

From the East Court, you'll find galleries radiating out in every direction. A light installation by American artist James Turrell illuminates the museum's upper-level windows inside and out, making the building itself into a work of contemporary art. Turrell used LCD technology for the piece, which changes color gradually based on a celestial calendar.

The outdoor space, too, has had an infusion of art with the creation of a nine-acre sculpture garden set amid winding, tree-lined pathways. The sculpture garden is just one of the kid-friendly additions. The new Kids' Corner Gallery features a storytelling corner, an orientation of the museum's collections, and hands-on activities that allow children to explore color and texture.

Even at night, Englehart reflects, interior lights shine through Chihuly's "Persians," creating a myriad of glowing colors seen from the Kentmere Parkway.

— *Theresa Gawlas Medoff*

*The Delaware Art Museum (**delart.org**, 302/351-8500) is in a grand, old residential section of Wilmington at 2301 Kentmere Parkway. Hours: 10 a.m.–4 p.m. (Tuesday, Thursday, Friday, Saturday), 10 a.m.–8 p.m. (Wednesday), noon–4 p.m. (Sunday). Admission: $10 for adults, $5 for students. Free on Sundays.*

Extreme Makeover:
Water Park Edition

Six Flags America offers a new look to match its new rides this summer.

SUPERSTAR CARPENTER Ty Pennington and the cast of *Extreme Makeover: Home Edition* might not be involved, but Six Flags America's water park in Largo, Maryland, has quietly undergone a renovation of its own, just in time for the summer season.

"It's the ultimate makeover," says Lahne Mattas-Curry, the park's public relations manager. Besides changing its name, the newly dubbed Six Flags Hurricane Harbor boasts the addition of two new award-winning thrill rides (Tornado and Bahama Blast) and the cre-

ation of a new children's area called Buccaneer Beach.

The park also offers private cabanas for rent, providing visitors a place for privacy and pampering. There's no shortage of

uses for the cabana; families can take advantage of their own enclosed space as a meeting place, a place to stash their gear or just somewhere to get out of the sun for a while.

The rest of the park has also taken on a Caribbean theme, with bright new colors (think teal and pink) re-energizing the park. New restaurants and retail offerings complete the park's first major upgrade in over a decade, while keeping many of the attractions longtime visitors have come to know and love.

Named the "Best Place to Get Thoroughly Soaked" by *The Washington Post* in 2001, Six Flags Hurricane Harbor is open daily from late May to early September. For more information, including video of the new rides and online ticket sales, visit **sixflags.com/parks/america**.

7. *Maine watercolor, 1937*
8. *Music and Good Luck, 1888, by William Harnett. Oil on canvas,*
40 x 30 in. Metropolitan Museum, Catharine Lorillard Wolfe
Fund, 63.85

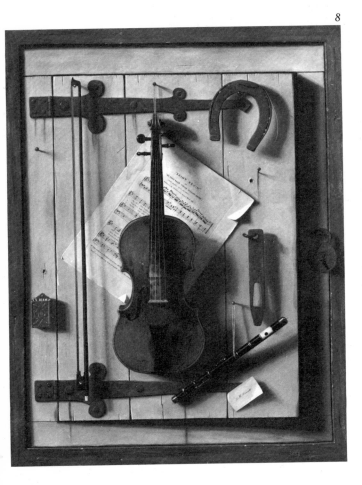

"When I was eighteen or nineteen, he showed some of my watercolors, primarily of Maine, to William Macbeth who had the only gallery in New York that exclusively handled American paintings. And Macbeth put on an exhibition and the show was a big success. Sold out. That was unusual, for it was at the end of the Depression and not too many artists were that fortunate. I achieved a sort of renown for watercolor, gained considerable confidence, and even made a little money – cleared about five hundred dollars after the freight bills. Funny thing, the late Coe Kerr, who handled my work for years, bought a watercolor at that show.

"So I returned to Chadds Ford pleased but then in a while a bit disturbed, because I felt that the work was still too free, too deft, too popular, perhaps still too undisciplined. My anxieties led me to get more into the thing, into realism, into the human figure, which I had done but not too well. So I started on anatomy. My father helped me greatly in this, giving me books to look at and read and putting a skeleton to draw in the studio. And that was a marvelous revelation. I drew it hundreds of times from every conceivable angle. This went on for months. Then one day, my father said to me, 'Fine, now you've done those things. Now we'll take the skeleton away and I'd like you to do it from memory to see what you've gained from it.' That was sort of a blow. I had to do it, in a sense, intuitively, looking from all angles, looking down, up, under. My father was a hell of a teacher. He wanted me to see the third dimension of something, not simply a frozen image in front of me, not the way the nineteenth-century American *trompe-l'oeil* painter William Harnett would have done it. He wanted me to come alive with the object."

"Once again, I have the feeling that your father was watching your work and your progress very carefully and again was sensitive enough to know that you were entering into another phase of creative endeavor, even perhaps before you knew it yourself. And I think it is this stage that buttressed and confirmed that strong existence of what I might call 'aroundness' in your work – the fullness, the feeling that there is always the other side of the hill, the sense that everything, whether it's a house or a figure or the branch of a tree, has been

9. *Jimmy. Oil painting by Wyeth at the age of nineteen*
10. *The Gulf Stream, 1889, by Winslow Homer. Watercolor,
11⅜ x 20 in. The Art Institute of Chicago, Mr. and Mrs. Martin A.
Ryerson Collection*

10

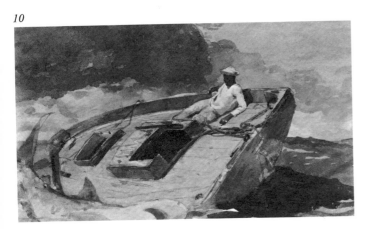

observed from all sides many times and locked in your memory.''

"Perhaps you are right. And, indeed, I do consciously and deliberately try to impart to my work that sense of completeness of all sides, shapes, subtleties, and flavors. Again, it doesn't work all the time, but that's what I try to do.

"After getting going on anatomy, I hired some models from the neighborhood, old men, a couple of old women, and started painting from life in my father's studio. From that moment on, I carried on my training by myself. But it was no longer training, it was more like balancing, refining what I had already done. The local people would come for maybe three, four hours a day and would pose in a position I would fix them in, and I'd work in oil or perhaps charcoal. And then one day, and this is something I've never told anybody before, when I'd tell them to have a rest for fifteen minutes or so, I'd really begin to work. That's when they would sit or stand or relax in odd, truly human positions. *That* was really the human figure. That taught me action, taught me to capture them in movement, made me engrave upon my mind several natural positions they'd go through so I could draw them later from memory. I was getting something absolutely real, akin to human nature, fluid. Finally, even if the subject was not before me, I would have a subject so deeply within my memory – whether it was still or moving rather rapidly – so that when I started to paint it, it was there in my mind more vividly perhaps than if it were physically present."

''We've spoken about your early training and about the point at which you began to refine your work by yourself. What influences outside of your father helped shape your style?''

"I soaked up an almost bewildering number of flashing impressions of a wide variety of works by a large number of artists. But these influences did not come from any particular study. They, too, came in the 'back door,' kinetically, swiftly, naturally, almost the way a dry sponge soaks up the smallest drop of moisture. I loved the works of Winslow Homer, his watercolors,

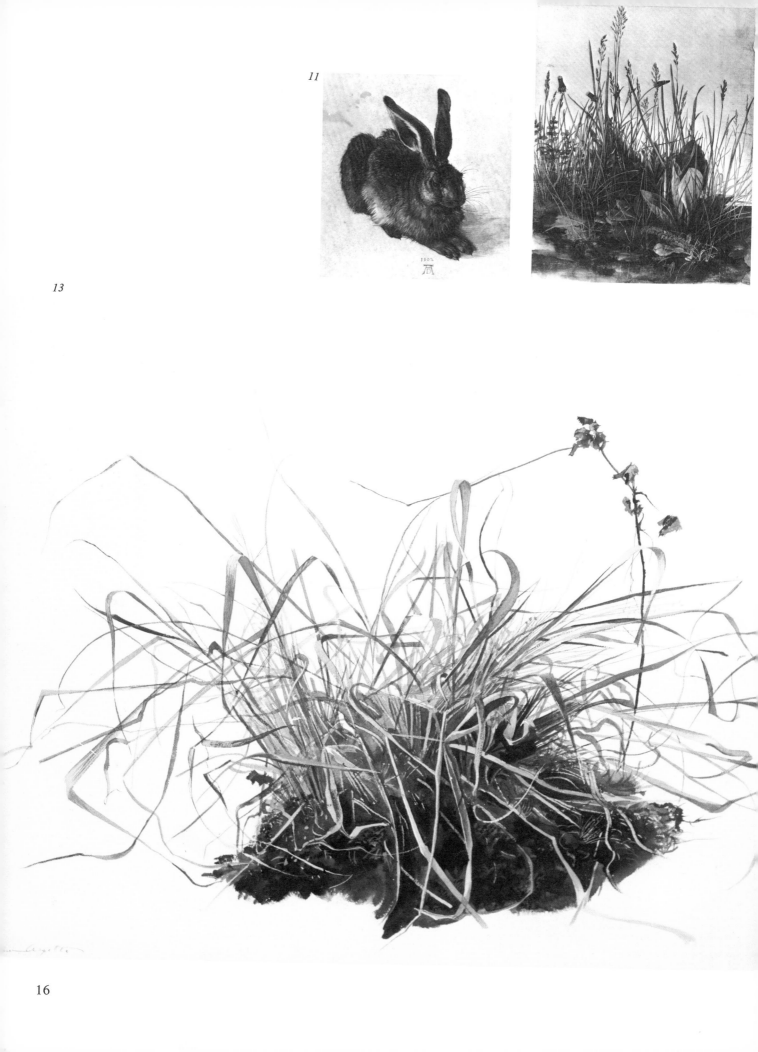

11

13

16

11. *A Young Hare, 1502, by Albrecht Dürer. Albertina Collection, Vienna*
12. *The Large Piece of Turf, 1503, by Dürer. Albertina Collection, Vienna*
13. *Grasses, 1941, by Andrew Wyeth. Drybrush drawing, 17 x 21½ in. Private Collection*
14. *Oil painting by Howard Pyle for "The Sea Robbers of New York" by Thomas A. Janvier (Harper's New Monthly Magazine, 1894)*

which I studied intently so I could assimilate his various watercolor techniques. I was so much taken by the lucid blues, silvery grays, and subtle yet crackling black and brownish black reflections in the water in reproductions of the works of the Renaissance master Piero della Francesca. But above all, I admired the graphic work of the northern Renaissance genius Albrecht Dürer. When I was thirteen my father gave me a splendid facsimile publication of certain of Dürer's watercolors, drybrush paintings, and prints, reproduced by the Viennese printing house of Anton Schroll in such a manner that the work still stands today as matchless. I lived with that marvelous book all my life. See, the thing is practically worn out on the edges, I've turned these leaves so often and seen so many things with fresh surprise! My father gave it to me because he saw me poring over it. I was much more interested in it than he was, and he loved Dürer very much, but he realized my intensity.

"I have said to myself many, many times that I think Dürer must have been the originator of the drybrush method of watercolor. People have thought that perhaps I was, but I certainly am not. I think his technique in the *Hare* [11] is unbelievable in the way he did the texture of the pelt, in such a way that each hair seems to be a different hair of the brush. Oh, how I can feel his wonderful fingers wringing out the moisture of that brush, drying it out, wringing it out to get that half-dry, half-lingering dampness to build up, to weave the surface of that little creature's coat. In fact, one of the Electors of Nuremberg was so interested in how it was done, it is said that he came to watch how Dürer did it. He was certainly the greatest master of that. To me, it is his greatest work next to *The Large Piece of Turf* [12]. Of course his woodcuts are terrific, but I think some of his watercolors are fabulous. Some of his watercolors, particularly the views of town, or the interior of a courtyard at Nuremberg have this remarkable, almost primitive effect. Not primitive, perhaps that is the wrong word – perhaps frank is the right word. He was discovering the truth, and wanted to put it down just as it was. That's why it has this marvelously *awkward* quality. He was searching. I think that one of the most important watercolors is the policeman on the horse that stood outside of his house in Nuremberg, which he

romanticized and later made into the *Knight, Death, and the Devil.* The mundane, observed, became the romantic. It is definitely the same horseman. He has made it a little more fanciful, you know, the armor is much more intricate, but it is the same horseman. He just let his imagination go. That is exactly what he wanted.

"I was also influenced to some extent by Howard Pyle [14], my father's teacher. Some art historians have said that they see a significant impact in my work of the art of Thomas Eakins. I appreciate Eakins, but he wasn't an influence. Eakins is, in a real sense, more European than American and was less interesting for some reason to me. Eakins trained in the studio of the French academic painter Gérôme, and is more Spanish, roundabout Venetian, more Velázquez and Mazo than American.

"You never know how influences come in. If they come with me, they come in casually. I'm certainly never conscious of them, if I am truly interested in what I am doing. Knowledge of the works of certain others is, of course, important. But that doesn't mean that you should think about it. These things should go into your bloodstream and disappear."

"Your art has this duality: part great freedom and part held back in a thoughtful control. And I don't mean tightness, I am referring to what comes from discipline. As a person, you strike me as also having a duality that explains your art. You are gregarious, but gregarious within a special group. You are definitely not in the party circuit or a "hail fellow well met" in the political sense – pasted smile, big hello. But within your own environment, you are extroverted, very free within self-imposed restraints. Your art could not have come out of a formula-ridden academic training where one learns by rules about spheres and cones, or where one builds the human figure by intersecting diagonal and horizontal and perpendicular lines."

"My training *was* academic, you see, but it wasn't a frozen type of academic thing. It was fluid. I allowed myself to break free from it and my father encouraged me to do that. Something was there in the beginning, I suppose, that had a good deal to do with inner excitement, the joy of celebration. I might shoot off in one

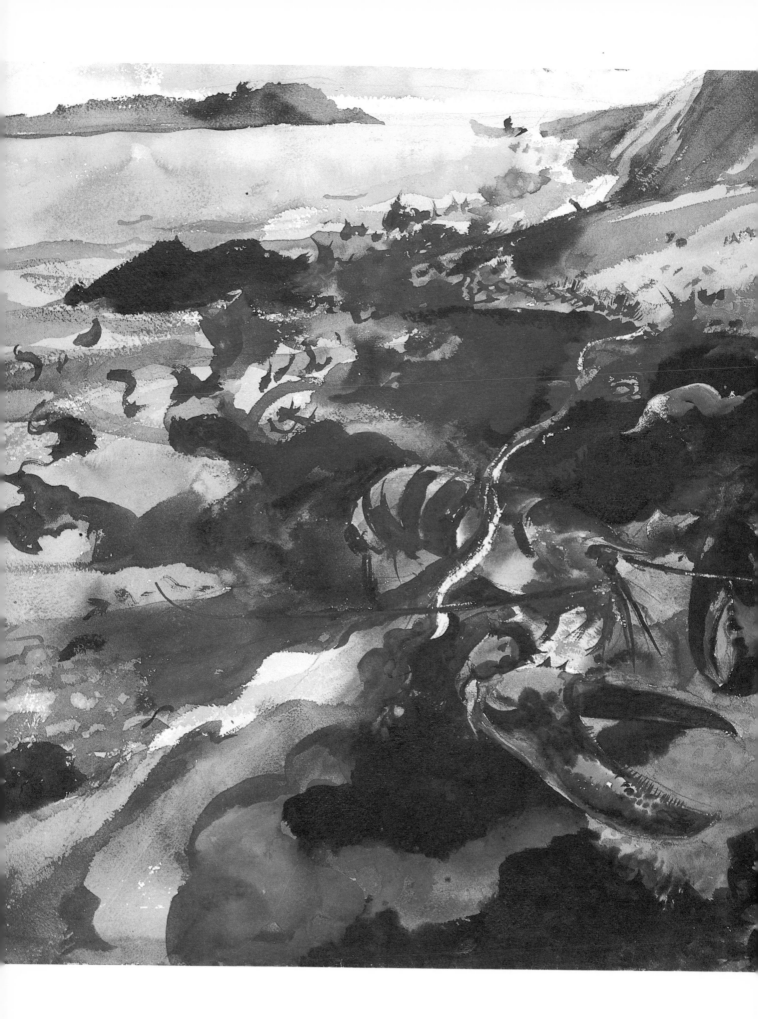

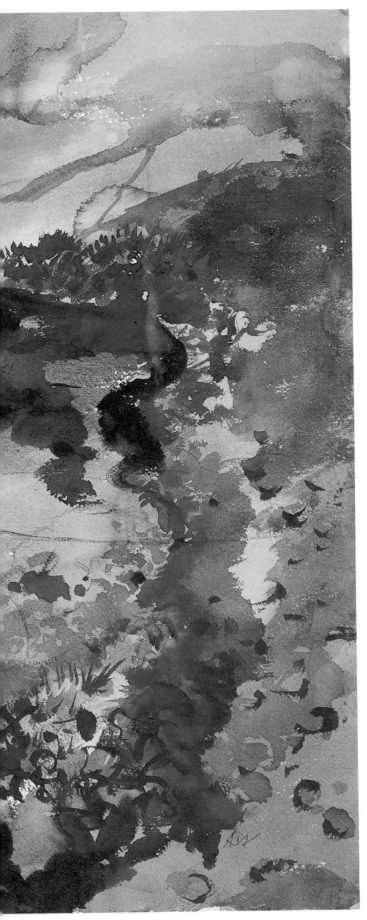

direction and then pull back. My father used to have some people ask him, 'Well, aren't you scared that all this academic, stiff training that you're putting your son through is going to kill this marvelous freedom?' He would say 'If it kills it, it ought to be killed.' I think that's a very good statement. If it isn't strong enough to take the gaff of real training, then it's not worth very much. I think that's true."

"But even in the watercolors done very early, some just before your first show, some just after, one can observe the growing desire for discipline within a sense of freedom, and also a desire to experiment, to test and observe a subject. There's one series of watercolors, for example, in which you have captured a lobster just five or six inches below the surface of the water amongst some rocks [15-17]. There must be twenty-five to thirty-five of these, each one totally different – in some the lobster is light green, or bluish, in others black-green, then even a sort of reddish green."

"That's what I mean about not being frozen. Why shouldn't one make dozens and dozens of pictures of the same subject? There are so many ways to skin a cat."

"As you know, with some young artists today – and some not so young – there is a renewed interest in realism. Do you think these people are interested in getting academic training of the sort you had?"

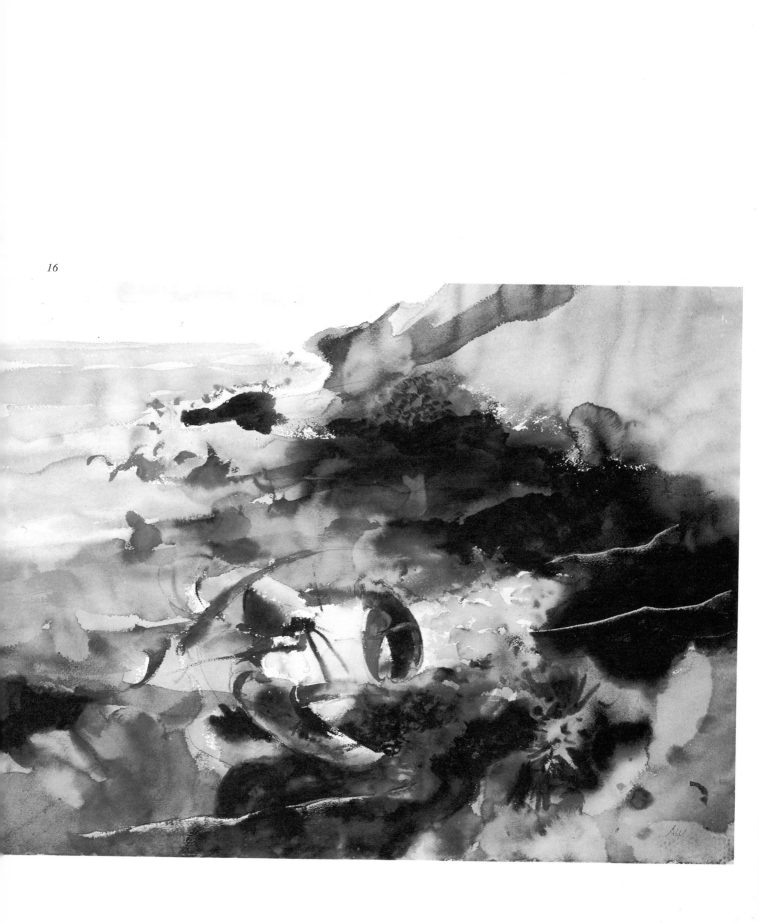

16, 17. Watercolors of a lobster, 1942

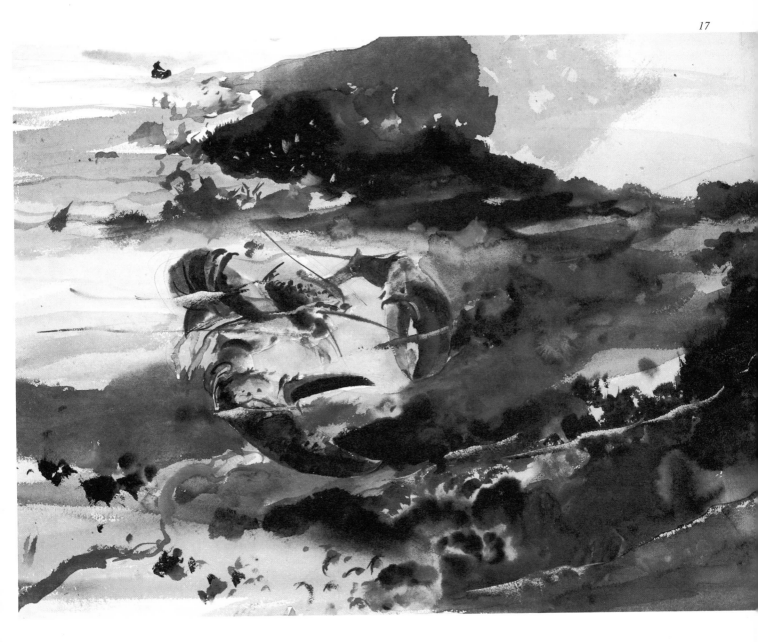

18. *Fence Line, 1967. Watercolor, 12 x 29½ in. Mr. and Mrs. Joseph E. Levine*
19. *Snow Flurries (see No. 89)*

18

"Of course, it depends on the individual. The young seem to have the freedom. They seem to want it, although it can be deceptive. But I'm not too certain whether they can get that appetite for academic training or knowledge along with their freedom. Maybe they are so intoxicated by the freedom that it will take a while, perhaps a generation, to get to want the training. It's got to come naturally."

"A number of people have observed that for several generations, broadly speaking, there has been not only a kind of worship and expectancy for freedom, but a search and worship for the new. And it seems – again generally speaking – that since the monumental and history-changing experiments of Picasso and Braque in breaking from earlier restrictions of visual reality in the first decades of this century, the academic has become the search itself, the yearning itself for the new, the changing. It's been observed frequently that the pendulum may have swung too far to novelty and freedom for its own sake. And the problem is, of course, that after a while the new image, pressed too far, simply becomes another form of the petrified."

"Why not have both? Why not have abstraction and the real, too? Combine the two, bring in the new with the traditional and you can't beat it. I believe, however, that I don't want to let the one take over the other. I try for an equal balance. If somehow I can, before I leave this earth, combine my absolutely mad freedom and excitement with truth, then I will have done something. I don't know if I can do it, probably never will, but it's certainly a marvelous challenge to me. And yet pull it back at the last moment to make it readable – and tangible. I want the object to be there in my paintings, perhaps in all of its smallest detail, not as a *tour de force*, but naturally, in such a way that I have backed into it."

"You probably know the classic story about realism told by the Roman historian Pliny, about the contest between the painters Zeuxis and Parasios to see who could paint most naturalistically. Zeuxis painted some grapes so stunningly real that birds flew down to try to eat them. Turning toward his rival's work, Zeuxis said, 'Well, now, take the drapery off your picture so the judge can see the work underneath.' But it turned out that the drapery itself was Parasios' painting, and Zeuxis ceded the prize, saying, 'I fooled the birds, but you fooled a painter's eye.' But this kind of thing isn't what you have in mind, is it?"

"No, not at all. Because that is the pure illusion. It is tricky, marvelous, magical, *and* near-charlatanic, if you can say that. That's a type of realer than real that I do not seek. That's the type of thing that has the blare of trumpets, the curtain parting, and there, *there* it is! That's what William Harnett and his follower John F. Peto were after. They were playing to the audience with their works. It got to be a trick, I'm afraid. But true reality goes beyond not only reality itself, but tricks and illusion as well. You see, I don't think reality comes out of a camera. That's only an image. Reality is more than that to me. That's why I have never felt any competition between the camera and the reality I'm striving for. I've had young artists say, 'Of course, Mr. Wyeth, I can go out and take a photograph in a blizzard of that tree with the snow hitting it; and I don't know why you waste months making dozens of drawings, because I can take you back in a couple of seconds with this splendid photograph that I can work from in the studio.' I said, 'You're forgetting one thing, you know, and that's the spirit of the object, which, if you sit long enough, will finally creep in through the back door and grab you. With a photograph you will lose all that.' I don't think anyone can deny it."

"Of course, it depends largely upon how you view photography philosophically. The Impressionists really emerged in part from photography. They were fascinated by it, but didn't try to copy it. They emulated it. Their work was not a reaction against early photography; nor did they ever feel threatened by, say, the daguerreotype. They thought the print showed accurately and scientifically what the human retina was truly reflecting. Photographs from the early camera showed people slightly fuzzy because there wasn't sufficient shutter speed for total stop-action. They had legs in motion, a tree in the wind – all slightly blurred – and the Impressionists were thrilled by this. But this is different from the realists of today who use photos. The curious thing is that your work is so *alien* to the photograph, because photography, after all, is a process that tends to immobilize images, although there are techniques that suggest

movement but primarily through speed. Your work, at least to me, is definitely not immobile. Your works are hardly ever at rest. They are in movement, for some strange reason. Very rarely are they frozen."

"You bring this to my mind very clearly. People say to me, 'How can you stay in one place and paint again and again?' Well, the point is, if I were interested as a camera would be, I would want to record new objects, new images onto the film, wouldn't I? In painting the whole process is different. You can look at the same object in all times of day or in your imagination with the myriad shifts of tones. It's like Rembrandt painting his own face as many times as he did. A change of subject is really very unimportant to me, because there are always new revelations coming out of that one subject. I spent almost a year on the tempera *Snow Flurries* [19, 89], because I was fascinated by the motion of those cloud shadows on that hill near Kuerners farm and by what that hill meant to me. I've walked that hill a hundred times, a thousand times, ever since I was a small child, so it was deathless as far as I was concerned. I could probably just paint a hill for the rest of my life, actually.

"Some other people say, 'Well, he uses too much subject matter.' But actually the subject becomes unimportant to me. I finally get beyond it; for it means many more things to me than just one object. Sometimes, when I do a painting with people in it, I have ultimately eliminated them, much to the horror of those who pose for me, because I find really that it's unimportant that they're there. If I can get beyond the subject to the object, then it has a deeper meaning. That's why I said I can limit the subject without much trouble or else suppress it to the point where it's really not terribly important. And yet I think that at the same time I have to watch out that I don't nullify the very thing. Margaret Handy, who owns *Snow Flurries,* says that the one thing that bothers her about the painting is the presence of the fence posts. But by taking out the fence posts I think I would have gone too far. I think you can overdo it in simplification. You can be too Homeric, too life-eternal. I don't like that either. It's a very fine boundary."

"You don't like a forced universality. Do you feel you've done a universal thing? Do you ever think about it?"

"I think it would be very dangerous. I don't like to think about it that way. People say sometimes, 'Will your temperas last?' I tell them I don't give a damn. I'm painting for myself. If my paintings are worth anything – if they have quality – that quality will find a way to preserve itself. I paint for myself within the tenets of my own upbringing and my standards.

"There's a quote from *Hamlet* that is my guide. It comes when Hamlet is instructing the players just before they act out the death of his father before his uncle. He tells the players not to exaggerate but to hold a mirror up to nature. Don't overdo it, don't underdo it. Do it just on the line."

"Even in the current swing back to realism by the young, even the 'avant-garde,' there seems to be a mirror all right, but it's one of detachment, distance, even coldness. You don't want detachment, do you?"

"No, I don't. They do. To me, they're somewhat cut and dried. They are, as a matter of fact, in this sense, curiously more abstract, more purely cerebral than even the most abstract painters who produce and produced very sensitive decorations of deep inner excitement. I find some of the new realists are even more decorative, cold, and flat."

"You seek involvement. Do you want romance?"

"No. Let it come in a very subtle way. If it's in there, fine, but watch out! Well, don't even watch out, I don't think it even matters. Romance can come in many forms. It's inside, it's part of evolution. You must be part of a thing: I can never get close enough to an object, or inside of it enough."

"When you do something, how do you know you have been close enough?"

"You know only in your bones, I suppose. I'm kind of like my friend the photographer Cartier-Bresson – he takes literally hundreds of photographs to get a good one. He has told me that he doesn't think about it and that, afterward, he chooses one or two that really hit. I am the same. That's why I make a point of never

showing pictures I'm working on to anybody because if
a person likes it too much, I'm disturbed and if a
person doesn't like it, I am also disturbed, because
somehow that will freeze it and I wouldn't dare go on
with it. Either I want to destroy it or else I think it's
so good that I don't want to touch it. And that's the
beginning of the end. That's why I keep my paintings
locked up. I have pictures all over this countryside
in places I call studios, which are not, because they are
private homes, barns, and the like. I don't know
whether or not they will work out or how they will
end up. But I can't show them to anybody for fear that
the act of painting might not be a natural and organic
process toward their completion. Not only an artist
can freeze something, but, curiously enough, outsiders
can too."

"Maybe you're like another photographer, Alfred
Stieglitz, because it was said about him that he could
take photographs no farther than a hundred yards from
his house and have his entire career. Like him, you have
deep roots and can express worlds in a fairly restricted
environment. That is one reason why we picked the two
environments, Kuerners and Olsons, for this exhibition.''

"I feel limited if I travel. I feel freer in surroundings
that I don't have to be conscious of. I'll say that I love
the object, or I love the hill. But that hill sets me free.
I could wander over countless hills. But this one hill
becomes thousands of hills to me. In finding this one
object, I find a world. I think a great painting is a
painting that funnels itself in and then funnels out,
spreads out. I enter in a very focused way and then I go
through it and way beyond it. A painting has to come
naturally, freely, organically in a sense, through the
back door. And one has to be careful of getting too
wrapped up in the meticulousness of the technique,
or of getting frozen or constipated.

"For instance, let me tell you about the struggles
I go through in making a tempera. I may get an idea,
or emotion, of what I want. I may be walking from
the bathroom down to the kitchen. Or I may be walking
over the hill. I may be driving the car too fast. And
I'll get this idea, this emotion that I've been thinking
about for a long time, perhaps something has sparked
it off, it's a feeling that I've always felt about something,
and I'll say, 'Jesus, this is terrific.' And I may hold
it back, purposefully, for a while, before I even put it
on a piece of paper or on a panel. I think timing is very
important in this thing. I may rush into my studio
and, on a piece of paper or maybe on a panel sitting

21. *A hill at Kuerners with drifting snow, 1956. Watercolor,*
14 x 21¾ in. Private Collection
22, 23. *The first drawing for Christina's World and the finished*
painting (see No. 122)

21

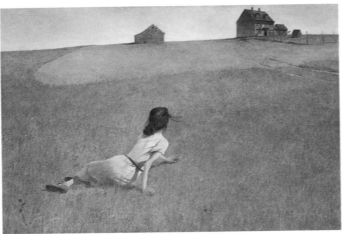

on my easel, draw one line, sweep it up and down, rush out. I don't even look at what I've done. And then, the next morning, when I'm fresh, I'll run into my studio or wherever I did it, and look at it. Either it will excite me or it will not. Then, if it excites me, I'm in a nervous state. It really drives me bats. Then I start to form my mind. I may go back and make drawings, leaving that one line. Then I go through a stage of slight boredom, doubts. And I'll go back and look at that line. That line is marvelous. Then I maybe make more drawings. I may even start on a picture. And that's the time when I can usually tell whether this is an enduring thing. Is it worth developing, or is it just a flash in the pan? Perhaps it isn't worth pushing into anything more than that one line. That's the thing in its most pure and emotionally simple form.

"I have a good friend, Rudolf Serkin, the pianist, a very sensitive man. I was talking to him one day backstage after a concert and I told him that I thought he had played particularly sensitively that day. I said, 'You know, many pianists are brilliant, they strike the keys so well, but somehow you are different.' 'Ah,' he said, 'I don't think you should ever strike a key, you should pull the keys with your fingers.' And I think this is expressive of what I try to do in my work. I try to pull a mood from a painting rather than trying to strike or force something into it.

"There's something else that I feel is important about a painting other than excitement and drawing the mood out of it, and that is I feel that a picture must be abstractly exciting before you get into the image. That sounds awfully far-fetched. But that's exactly what I feel. I don't like to think that such and such is going to be a good painting because it looks just like Karl Kuerner, for example. I want to see if it's good even without a likeness of him.

"I am continuously seeking, trying out new ways. It utterly absorbs me. I am continually producing drawings, although most of them don't ever develop into anything because I get another idea of something that is better than that initial, sharp, idea. And sometimes I deliberately take something, even if I don't particularly

like it, and go on. I suppose I've got a New England conscience; for every now and then I have to take something and push it just as hard as I possibly can."

"It obviously doesn't bother you that from the very quick line, that immediate stroke, throughout the long process toward the finished product, significant changes are made."

"I expect that, and I obtain great excitement in the changes. Because with them, the painting begins to discover itself. It begins to roll. It's like a snowball rolling down the hill. The process of change is extremely important to me. That's what I love about tempera. You can build over it, you can leave something out."

"I've been told that between layers of your temperas there are often quite different things. And if one could delicately, microscopically, shave those layers away you would have *many* pictures, some rather different than what you started."

"Absolutely. One case is a very early picture of mine, a portrait of Nicholas sitting in profile [24]. I had been working for months on a winter landscape here in this corner of the studio and I loved the color of the thing – but it wasn't really expressing the way I felt. I wanted something closer to me. Nicholas came in from school and sat down in the corner and began to dream about airplanes. And he looked – my God. And I said, 'Nicholas, stay where you are.' And I hauled the easel over in the corner and I painted Nick in right over the landscape very slowly and gently. He seemed to express more about the hill itself than the landscape. He was in this coat with fur on the collar and with this fey face that he had, he seemed to express the winter landscape mood to me very powerfully."

"At the point where you do reach exhaustion in a painting, what do you do then? Do you drop it, or do you do many things at a time?"

"Well, I carry it as far as I can and then I'll say, I'm done, I can't do anymore. Sometimes I get back to it and take another look after weeks of working. When I've done anything, I sometimes go back, and maybe

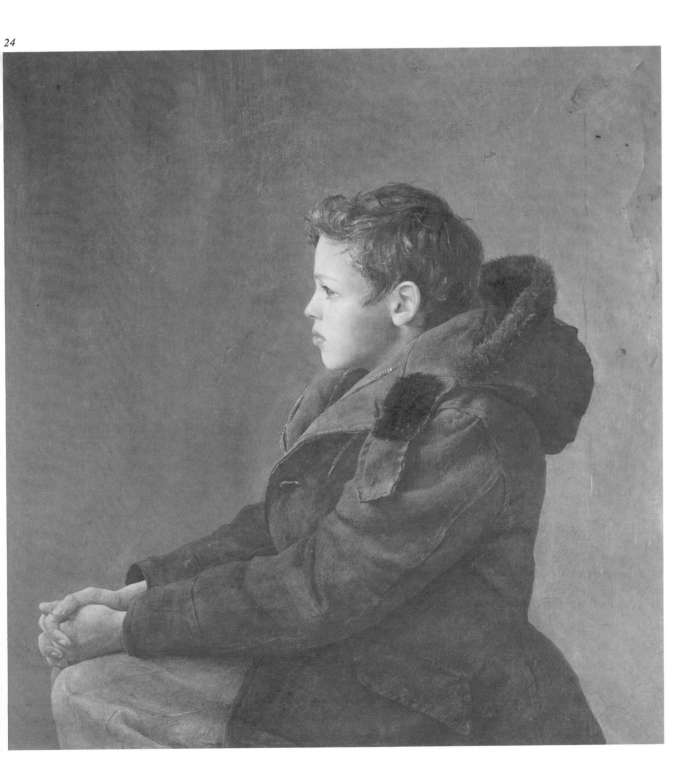

work on parts of it. But rarely. I go as far as I feel right and then drop it. I'm washed up. I drain myself of every ounce of what I feel about the thing and that's that.

"There's a very interesting thing which has happened to me a number of times. I may do a painting or a very complicated drawing (maybe it will take me months to do it), and I finish it and I will feel exhausted. And then the very next day I will get an idea or a notion about wanting to do something, and it is almost the aftereffect of the intensity that will make me do this next thing spontaneously, and I hit it right on the nose. I think the reason for that is almost the residue, the cream of the nervousness and intensity that finally comes to the surface with a flash. Once I was talking to Robert Frost about a poem of his that is so beautifully written, it is considered by some to be actually perfect. It is called 'Stopping by Woods on a Snowy Evening.' And I asked him, 'You must have worked a long time on that. It must have been done in the middle of winter. What was your experience?' He said, 'Andy, I'll tell you about that. I'd been writing a very complicated, long-drawn-out poem, almost a story type of poem entitled 'The Death of the Hired Man.' I had finished at two o'clock in the morning. It was a hot August night, and I was exhausted. I walked out on the porch of my house and looked at this mountain range. It came to me in a flash! I wrote it on an envelope I had in my pocket, and I only changed one word. It came out just like that.' "

"What about failures within a successful picture? Do you ever find that?"

"Oh, yes. I will simply repaint it. In tempera, of course, you can repaint. However, in a drybrush and a watercolor, sometimes a passage that looks like a mistake can be the precise making of a picture, because it will bring out maybe the transparency of a pure blue or gold, near the mussiness that may be around it. In this case you have to build up the so-called mistake and isolate it like a liquid eye in a landscape or in a pool of water. So, curiously, sometimes the more you achieve an opaque heaviness in a medium, the more it might bring out the flashing quality. I think Rembrandt is a very good case in point, for he brought out jewelry by making the rest rather heavy and solid, soggy almost. So a terrible mistake technically can sometimes bring forth a depth that's unexpected. It's a very fine line. You certainly do not want to make any picture a perfection of technical quality so that's all you see when you look at the thing. There are a great many pianists today that technically are perfect in their playing, but I think they are a bloody bore."

"About how long does it take you to do a tempera?"

"Well, it depends a little on how big it is, but even the size doesn't really matter. It takes sometimes four to six months or longer. Sometimes I don't do any temperas in a given year, sometimes I've done as many as three. Early on, I would do as many as five.

"But there are no rules in my thinking about painting. That's why I hate to teach because my theory is to have no theories at all. I don't think you should tie yourself up. I don't think you can be fenced in. I don't particularly like teaching because I have to go through things I have already done. To be a good teacher you have to stick to fundamentals. I've had a good many fundamentals in my life, but I want to go beyond and be experimental and be always eager to look around the next corner. I feel there is such a wide opportunity in what I'm after that it's more a matter of boiling something down to the thing that is closest to me in my heart. And I am not talking about technique, which rather bores me. Technique will take care of itself. I've read reviews that say that Wyeth has reached an excellence of technical quality, and for that reason he's just standing still. They're not looking at my work in the right light. Because technique is not what interests me. To me, it is simply the question of whether or not I can find the thing that expresses the way I feel at a particular time about my own life and my own emotions. The only thing that I want to search for is the growth and depth of my emotion toward a given object. In that way I free myself from the bonds of routine technical quality. I don't think one can develop technically in new ways unless one's emotions dictate it. To be interested solely in technique would be a very

25

superficial thing to me. If I have an emotion, before I
die, that's deeper than any emotion that I've ever had,
then I will paint a more powerful picture that will have
nothing to do with just technique, but will go beyond it."

"The particular medium you use seems to be extremely
important in expressing the various sides of your per-
sonality and subtle aspects of your subject matter. Tell
me about your tools, these media, and your feelings
about them."

"To me, pencil drawing is a very emotional, very quick,
very abrupt medium. I will work on a tone of a hill
and then perhaps I will come to a branch or leaf or
whatever and then all of a sudden I'm drawn into the
thing penetratingly. I will perhaps put in a terrific black
and press down on the pencil so strongly that perhaps
the lead will break, in order to emphasize my emotional
impact with the object. And to me, that's what a pencil
or a pen will do. Any medium is an abstract medium,
I suppose, but to me pencil is more abstract because
it is an outline. I may go into tones at times but to me it
is a very precise and a very vibrating medium.
 "You must not be afraid of it, though. Pencil is sort
of like fencing or shooting. You make a thrust at your
opponent yet you must be ready to recover into the
on-guard position, and when you thrust you must not
think that you will miss the mark. Your opponent may
parry, so when you thrust you've got to put your
heart and soul into it and then, in a split second,
withdraw. This is very much to me like pencil drawing.
You've got to dart with a sharp point and hit it. Either
you hit it or miss it, but you must have no hesitation.
Pencil drawing to me can be likened to having a blade
go in and out quickly. When I'm out walking, searching,
observing, I am almost like a sharpshooter when I see
something, I put my sights on an object and pull the
trigger, so to speak, with my drawing. Sometimes my
hand, almost my fingertips begin to shiver and this
affects the quality of the lead pencil on the paper. It
becomes dark and light, dark and light. The thing
begins to move. The drawing begins to pull itself out of
the blank piece of paper. You can't concoct that.

26

27

32

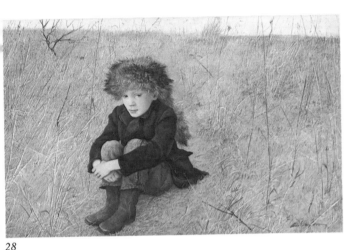

28

"Now about watercolor. The only virtue to a watercolor is to put down an idea very quickly without too much thought about what you feel at the moment. In some senses it is similar to drawing but drawing in all aspects of color. With watercolor, you can pick up the atmosphere, the temperature, the sound of snow sifting through the trees or over the ice of a small pond, or against a windowpane. Watercolor perfectly expresses the free side of my nature. You know, it's funny, some years ago I remember seeing a book entitled *Making Watercolor Behave.* That's such a ridiculous mistake. Watercolor shouldn't behave, it simply shouldn't.

"I work in drybrush when my emotion gets deep enough into a subject. So I paint with a smaller brush, dip it into color, splay out the brush and bristles, squeeze out a good deal of the moisture and color with my fingers so that there is only a very small amount of paint left. Then when I stroke the paper with the dried brush, it will make various distinct strokes at once, and I start to develop the forms of whatever object it is until they start to have real body. But, if you want to have it come to life underneath, you must have an exciting undertone of wash. Otherwise, if you just work drybrush over a white surface, it will look too much like drybrush. A good drybrush to me is done over a very wet technique of washes. One of the very first drybrush pictures I ever did was entitled *Faraway* [28], which is the one of Jamie, my son, as a small boy. That started out as a straight watercolor but then I got interested in the texture of a coon hat he was wearing and I kept working and working, shaping and molding, if you will, with that dried-out brush and drying paint. I've done others after that, and they were an even drier technique. But what I am after is a mixture of straight watercolor with drybrush. I consider one of my most successful ones to be *Young Bull* [26] – underneath that built-up dry paint is a luxurious wash and that's why it works, at least for me. Drybrush is layer upon layer. It is what I would call a definite weaving process. You weave the layers of drybrush over and within the broad washes of watercolor.

"Now tempera. I was introduced to the technique of tempera by Peter Hurd. He had read up a good deal about it and in a sense he was responsible for bringing the technique back into use in this country. He gave me a terrific grounding in the medium. He simplified it down to the egg emulsion and didn't use oil emulsion at all. You see, there are a lot of mixtures with beeswax and materials like that, which are not technically sound or artistically satisfying.

"Technically speaking, tempera is just a dry pigment mixed with distilled water and yoke of egg. You mix half pigment and half egg. You use your own judgment. You can tell by putting it on the palette: if it skims off as a skin, you know that you've emulsified it right, but if it patters off, you know that you haven't got the right mixture. I think the real reason tempera fascinated me was that I loved the quality of the colors: the earth colors, the terra verde, the ochers, the reds, the Indian reds, and the blue-reds are superb. I get colors from all over the country, even the world. They aren't filled with dyes. There's nothing artificial. I really only like things that are natural. I love the quality and the feel of it. It's just fabulous. I like to pick it up and hold it in my fingers. To me, it's like the dry mud of the Brandywine Valley in certain times of the year or like these tawny fields that one can see outside my windows. I've been blamed, from time to time, for the fact that my pictures are colorless, but the color I use is so much like the country I live in. Winter is that color here. If I see a bluebird or something spontaneous with a brilliant flash of color, I love it, but the natural colors are the best. I suppose, when you get down to it, I really like tempera because it has a cocoon-like feeling of dry lostness – almost a lonely feeling.

"There's something incredibly lasting about the material, like an Egyptian mummy, a marvelous beehive or hornet's nest. The medium itself is a very lasting one, too, because the pure method of the dry pigment and egg yolk is terrifically sticky. Try to rub egg off a plate when it's dry. It's tough. It takes tempera about six months or more to dry and then you can actually take a scrubbing brush to it and you won't be able to rub off that final hardness.

"I tried many methods in the beginning. I even tried applying it with a palette knife. I tried painting it as I did my watercolors, freely. I tried many things until I found out what the quality of that medium really meant to me. Watercolor, as I have said, gives me something free. Pencil has that other quality of freedom because you're able to dart in and hit the precise small thing that you want. Drybrush has another quality – it's an intermediate state. But tempera is something that I can truly build. My temperas are very broadly painted in the very beginning. Then I tighten down on them. If you get the design and the shape of the thing you want to paint, you can go on and on and on. There's no limitation. The only limitation is yourself. Tempera is, in a sense, like building, really building in great layers the way the earth itself was built. It all depends on what you have in the depth of your being. If it's shadowed, you are likely as not somehow to be in shadow. I've always argued that this is true in any medium. I've had people say to me, 'Why do you waste your time with watercolor, it's such a light medium, a fragile medium. It lacks depth.' Well, it isn't the medium that lacks depth, it's the artist. You can never blame the medium.

"You will notice that in my temperas I am not trying to gain motion by freedom of execution. It's all in how you arrange the thing – the careful balance of the design *is* the motion. It's a moment that I'm after, a fleeting moment but not a frozen moment. Tempera is not a medium for swiftness; it's marvelous, but it's not for the quick effect. As I said, there are other media that do quick things better, oil or watercolor. Why go

29

to all the trouble of mixing egg tempera, emulsifying, and getting it right when you can do it with another medium? I see no point in that.

"You learn it slowly. It's trial and error. It's experience. It's almost fatal to work in impasto unless you build it up very slowly. To take a heavy palette knife with a mixture of egg tempera and put it on in gobs is disastrous. It will simply drop off in time. You've got to weave it, as if you were weaving a rug or tapestry, slowly building it up. The dark's the most difficult part because you can cover very quickly with a brush in dark. With white it's a slower process, so the dark passages are technically the dangerous passages. When you study the early men, like Botticelli's *The Birth of Venus,* you will note that although it is done on canvas, it is very beautifully woven together. I've tried painting tempera on canvas, but I didn't like it. I had it primed with a pure gesso but it didn't work. I didn't like the give of the canvas. It bothered me. Somehow that indicated to me that the give was for the quick effect, and I don't use tempera for that.

"But you have to watch yourself so very carefully in tempera. It is a dangerous medium, because you can get to be a master technician with almost any subject in tempera and that's when you have to really watch out. It's a medium that can lead toward cold technical quality, so I think you have to fight this, and I find fighting it a very good thing. If I just stayed in my studio and meticulously worked panel after panel, it would become a bloody bore. In my technique I constantly fight the perfection that I believe I've obtained. I try to do things deliberately sloppily at times. I know I'm known for putting every blade of grass in a picture and for being almost microscopic, but as a matter of fact I think, technically, I'm sloppy. I have done pictures that to me looked like technical perfection in tempera, but after a while I don't like them. I see the danger in them.

"Some people say a drawing or a watercolor is the most sensitive medium. I think any medium is sensitive if you know how to handle it right. Tempera is on a very fine line of balance. If you don't hit it right, because it is such a strong medium, it shows its weakness quicker than almost any other. You can't fudge it. It does not cover up for you. It is not forgiving. Now drybrush comes to me through the fact that after I finish a tempera I may feel exhausted. I may have worked four or five or six months on it and I'm desperately tired. But then I may see something that interests me and watercolor doesn't have the strength somehow. I start with a watercolor sometimes and realize, damn it all, I feel stronger than that. I want to go into it with a little more detail so I start working in drybrush. I start building it up, working over the watercolor, getting more crosshatching into it, getting more texture, weaving it. I do this on a piece of paper, perhaps Bristol board or maybe on a thin piece of scrap board, and all of a sudden it becomes a drybrush. The one, *Garret Room* [30], with the Negro stretched out in bed, is a very good example. I started that as a free watercolor with broad washes done very quickly and then became fascinated by the pillow that his head was resting on, actually a sugar bag made into a pillow, and damned if I was going to go home (after all, here he was sleeping) and grab my tempera box and start working on it. So it turned into a drybrush. Now there are some professional drybrush painters today, but I don't think very much of that. A drybrush happens. It isn't something you plan to do any more than I can say I'm going to make a fine drawing this afternoon. It may turn out to be a good drawing, more likely it'll turn out to be a terrible thing."

"It's important, I think, to realize that you use each medium to express exactly how you feel at the moment, something that people have misunderstood about you. But I suppose they really don't know materials, since it is really only a musician who can tell you why at one point the violin is very necessary, and then at another time the viola.

"Of the various categories of subject matter – landscape, still life, portraiture – is there one that you particularly favor or dislike?"

*30. Garret Room, 1962. Drybrush, 17⅞ x 22¾ in. Private
Collection*

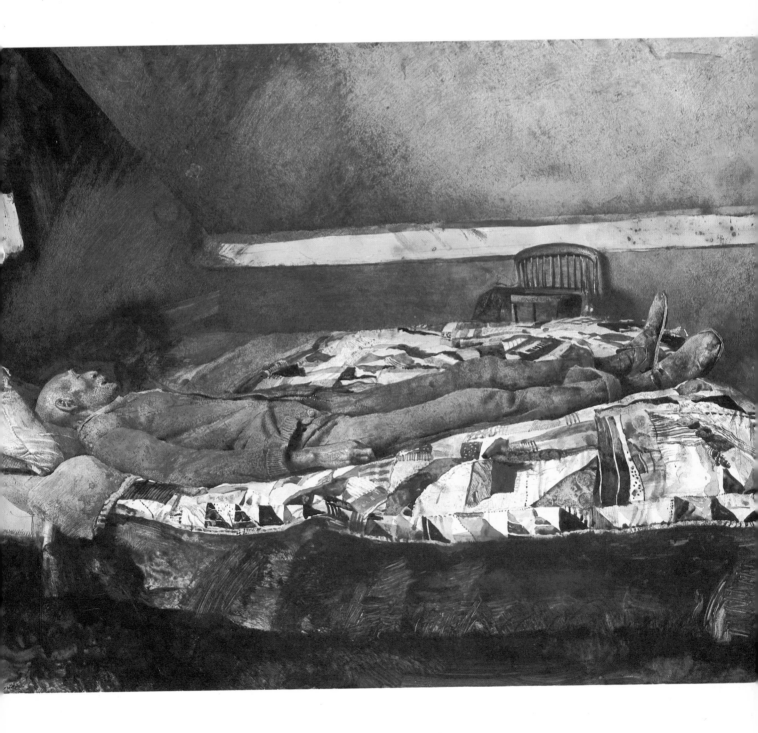

"No, not actually. However, I don't think I'm really a portrait painter, because I only use a head to express something more. And, if a painting stays just a head, I'm not satisfied with it. If it's an outdoor person, I feel that his countenance reflects the skies he walks under: the clouds have reflected on his face for his whole life and I try to get that quality into the portrait. So it's more than a portrait to me. People have even asked me what color I mix when I paint a portrait. 'Do you mix a neutral skin tone?' they ask. Well, that is utterly foreign to the way I work. It's like painting a landscape and then painting the sky. To me, a sky and a landscape are together. One reflects the other. They both merge."

"You have intense loyalties to specific places and environments, don't you?"

"Yes, and it is the total environment. A human being within an environment is a reflection of all of the aspects of that environment. Some other painters are maybe still-life painters or landscape painters or seascape painters or portrait painters, but to be categorized would be intolerable or impossible for me. I couldn't just say, 'Now I'm going to be a portrait painter.' It couldn't work. Once in a while I'll see something alien in a landscape, maybe it's a new shingle roof or asbestos roof or tin roof that's just been put on a building. The shocking quality of that newness is fascinating to me, simply as a shocking form. But it doesn't take long for nature to take over. Take a winter of skies or a year of skies and that roof contains all these skies within it. A child, a newborn child, is alien for a while, but finally the environment it lives in changes it, doesn't it? In a sense these things are bathed by the light of not just an hour or a day, but countless hours and hundreds of days. My light is not linked to a specific time. Unlike Claude Monet, or some of the other Impressionists, I don't paint a picture with the light of eleven o'clock and then twelve o'clock and then three o'clock. I think the camera is the master of that. I am fascinated by the changing, changing, changing quality of the sky. I would like to try to paint so nothing is at rest in my work. Nothing is frozen. I would like people to sense even in those paintings with brilliant passages of sunlight, that the sunlight is not really still but that you can really see the passage of the sun.

"I'm not much for the new thing or the new object. I like to go back again and again because I think you can always find new things. There are always new emotions in going back to something that I know very well. I suppose this is very odd, because most people have to find fresh things to paint. I'm actually bored by fresh things to paint. To make an old thing I've seen for years seem fresh is much more exciting to me. Of the essential environments in my life, Kuerners in Pennsylvania and Olsons in Maine are probably the most important. One has the colors of Pennsylvania and the surrounding area, the strength of the land, the enduring quality of it, the solidity of it; the other is spidery, light in color, windy perhaps, sometimes foggy, giving the impression sometimes of crackling skeletons rattling in the attic."

"Tell me about Kuerners farm. When did you first come across it and why do you have this deep fascination with it?"

"You might even say that it has something directly to do with my background. My father was Swiss, French-Swiss, and a certain German element was present in him. That might have been why I was attracted to Karl Kuerner. Kuerners is right over the hill from where I was born. As a small boy, I wandered over there almost every day. I have always been fascinated by soldiers, particularly those of the First World War. I was intrigued by the fact that Karl Kuerner was a soldier who fought in the German army at the Battle of the Marne, was wounded, came to America right after the war, became a hired farmer, and finally owned his farm. He was a machine gunner, and was decorated by the Crown Prince himself. Starting when I was very young, Karl would talk to me about his war experiences, in his broken English. You see, all of that, plus my father telling me about his Swiss background, and my mother discussing her Pennsylvania German forebears, got my imagination going.

"I didn't go to that farm because it was in any way bucolic. Actually I'm not terribly interested in farming. The abstract, almost military quality of that farm originally appealed to me and still does. Everything is utilized. If they kill a groundhog, he's cut up and his innards are made into sausages. The farm is very utilitarian in its quality. To enter that house with those heavy thick walls and have beer on draft or hard cider was an exciting thing. To see the hills capped with snow in the wintertime or to look at the tawniness of the fields in the fall all made me want to paint it. But here again, I backed into it. I didn't think it was a picturesque place. It just excited me, purely abstractly and purely emotionally.

"Some of my earliest watercolors were done there. When I was about ten years old, I had an urge to paint it, curiously enough; it never became a conscious effort or something about which I said to myself, 'I must continue this work.' I've gone on for years and not painted there. Then, all of a sudden, I'll have a strong compulsion to go back. Someone asked me a few weeks ago, 'Doesn't the fact that the Metropolitan Museum is having a show partly about Kuerners cut you off from the farm?' But it doesn't at all, because what I'm doing now is so personal to me, it has nothing to do even with Kuerners as a specific place any more. My work around it has gone beyond that point. If my work changes it isn't because I'm going to stress any particular part of it or because I'm going to change my technique, it's the motivation of something I've found and that has moved me that is going to carry me on. I never look back. I'm always ten jumps ahead of what other people are thinking about what I'm doing. I have other thoughts in my mind. So I really feel, as I am talking to you here about Kuerners, as if I am talking about someone who has already left this world."

"What is Kuerners farm as a physical entity?"

"It must be a hundred and fifty or two hundred acres. It is quite a big farm for this locale, anyway, and it has many facets to it. There's the house with its multiple sections, the woodshed, the pond, the entrance drive, the pines, the porch, the windows. But more important than its individual parts to me is the fact that it's a place that I can walk over, climb over without feeling out of place or observed. Since he is a foreigner, Karl Kuerner seems to have an understanding of the artist that a Pennsylvania Quaker farmer wouldn't have. Karl told me that years ago he had known an old German artist in the town of Münster outside of the Black Forest where he had his flock. This artist came one day and asked Karl to pose and he painted his sheep. From these experiences, I think Karl gained great insight into what an artist was all about. After that he had a certain warmth toward them. So he lets me wander all over that house and paint in any room. I have the key to the house and I come and go as I please. He doesn't think of me as particularly important. I don't think he even thinks of me as being around there half the time. So I don't exist as a person. That's important for my creative process."

"Do you look upon the various rooms in the house of the Kuerners as parts of your studio?"

"No, I don't even think of it as a studio. I think of it as an environment, free, organic, and natural. As a matter of fact, I don't like the idea of having a formal studio. My father always said that living and the painter shouldn't be separated, they should be together. It's like eating and breathing and sleeping. Not something you denote as art and do elsewhere. It should all be together."

"What times of the year are you at Kuerners?"

"I'm there primarily in the late fall, winter, early spring, and from time to time even in the summer, too."

"Tell me about Olsons. Why that fascination?"

"That, too, was deeply imbedded in my childhood. I went to Maine when I was a very young boy with my

33. N. C. Wyeth's studio in a photograph taken in 1945
34. Gull Scarecrow (in the Olsons' blueberry fields), 1954. Water-
color, 27⅞ x 21¾ in. Private Collection

33

34

father and mother. We were in Port Clyde first when
I was about ten years old or younger. Before that,
my family lived in Needham, Massachusetts, where I
spent a lot of my boyhood. And it was in Needham that
I got a feeling for New England and particularly pine
trees, which seem to say New England to me. I used
to play under the pine trees at Needham and remember
them very vividly. As early as ten I began to paint
Maine. I painted around the islands, and did my first
pen drawings, and then I went into watercolor.

"On my twenty-second birthday, I met my wife
Betsy. One day I drove across the river to Cushing,
where I'd never been before. I had heard about a man
by the name of Merle B. James, who had had a friend
who had bought a watercolor of mine. I don't know
exactly why I did it but on my twenty-second birthday
I drove over to meet him. He was away but I met
his daughter Betsy. That very day she told me that she
wanted to show me a marvelous house and she drove me
down to Olsons, and I met Christina for the first time.
She had been a very close friend of Betsy's since she
was a little girl. Betsy really knew her intimately – even
used to comb her hair from time to time.

"Through the Olsons I really began to see New
England as it really was. It is just the opposite to the
Kuerners. Overall, it's dry like bones, the house is like a
tinderbox. Christina was a remarkable woman, as was
her brother Alvaro. And there again, they would let
me wander all over and through the house. Again, I
didn't have or need a formal studio and so I used the up-
stairs rooms of the Olson house as a studio. I'd go
down there by boat early in the morning and stay there
all day long. And that is where I painted the first
Christina [117], *Wind From the Sea* [144], *Seed Corn*
[164], and so on. I stayed right within that environment.
It was everything. The world of New England was in
that house overlooking the mouth of the Georges River.
Its emotional effect was powerful upon me. I remember
flying over the Olson house when I'd leave late in the
fall and soaring over I would think of Christina sitting
in that dry, magical house. She was a cripple, and
wasn't very attractive to look at, but she had a marvel-
ous mind. You know, I wasn't even conscious when
I did *Christina's World* [122] that she was crippled.

Isn't that strange? I just thought this is a simply splendid
person and I never even realized about her crippled
arms when I got her to pose outdoors. I never thought
the picture was the least bit odd until people around
Cushing began to say, 'God, Andy, why are you
painting that old pile of bones?' The picture was posed
in one sense and then in another utterly unposed.
It was spontaneous and it had an organic growth about
it. It wasn't a preconceived idea; it just happened.
Coming in contact with both places, Kuerners and
Olsons, was simply a natural extension of my life.
I didn't plan anything; it just happened."

"I find it extraordinary that you were assimilated into
these two households, worked within them as environ-
ments, and that this never bothered you or them."

"It might have a lot to do with the fact that my father
was a person of the period where the studio was an
all-important thing, like Frederic Remington's studio,
or Sargent's studio, or Hassam's studio, where they had
drapery and formal objects around. My father's studio
was jammed with curious objects from birchbark
canoes to guns and swords. It was marvelous, but I
always felt that I never needed a host of special accou-
terments. I never wanted to add anything to the environ-
ment where I paint. All I need is just the room and
an easel and the environment where I am painting.
I don't like the tradition of the big studio, the mystic
salon that becomes some sort of affected heart of crea-
tivity where you have afternoon teas to show off your
new work that is draped and then dramatically unveiled.
This I abhor. It is wholly antithetical to my feeling
of creativity. I need to be casual, almost sloppy. I need
my drawings just around, strewn around. After the
Olsons died, the people who went down there to clean
out the place found a whole lot of stuff of mine that
I'd forgotten I'd even left there. The drawings were like
old pieces of conversations or thoughts, still hanging
in the air. My studio is where I'm working, wherever I
am. I have drawings, studies, pictures sitting all over the
place. I like loose ends. It's part of my creativity. I don't
think I exist really as a person, particularly. I really
don't, and I'd rather not."

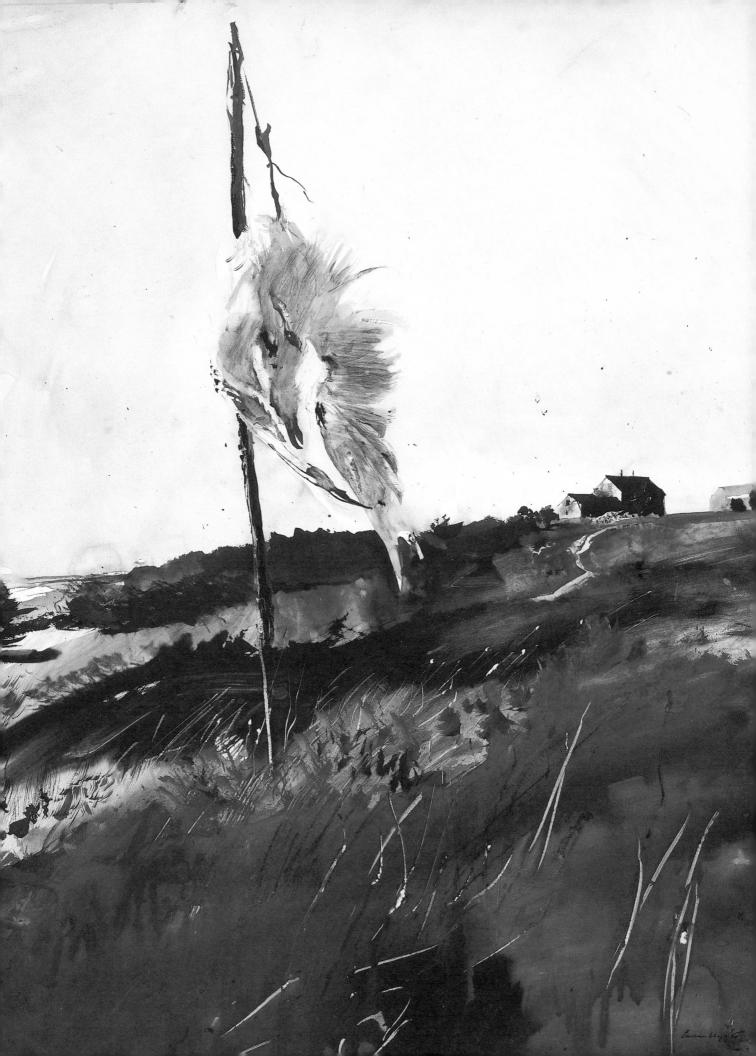

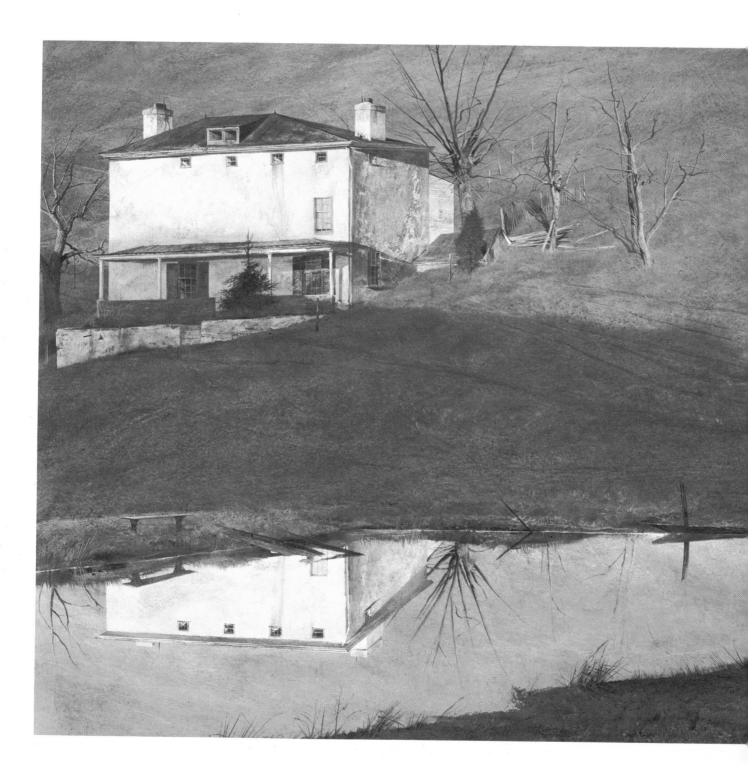

*35. Brown Swiss, 1957. Tempera, 30 x 60 in. Mr.
and Mrs. Alexander M. Laughlin*

"I'd like to discuss a number of specific paintings of the Kuerners' farm that you've done over the years. One that particularly intrigues me is *Brown Swiss* [35], painted in 1957, because in a way it's a portrait – a portrait of the farm, the house, the property, the Kuerners themselves, *you* in a very curious sense, light, sky, the color of a late fall afternoon."

"Ah! *Brown Swiss* is indeed a real portrait to me. It was like doing a person's face – so complex! It was like a double portrait, because of the reflection of the house in the pond. I am looking at it in one way, but then I'm looking at it in another. If you look closely at *Brown Swiss,* you'll see many, many very fine details: for instance, the tin pan sitting there on the porch; and if you look in the top windows you'll see the ceiling of the attic room where there are those strange hooks on which the Kuerners hang slipcovers, sheets, sausages, and onions and these hooks are even reflected in the pond. All these things are closely related to the true sense of portraiture to me."

37. Study of one of the Brown Swiss cattle, 1957. Pencil and watercolor, 8½ x 11 in. Private Collection
38, 39. The first drawings for Brown Swiss (see No. 35)

"I'd like to track through the process by which a picture is formed not only in your mind, but also by the various stages of studies and changes. Why not *Brown Swiss?*"

"Well, the very first thing was a pencil study of one of the Brown Swiss cattle [37] – that's where the painting got its name. But then that was kind of forgotten and the real conception, that quick flash, is a drawing done very free in black Higgins ink [38]. I came in from walking over the hill late in the afternoon one November and something I'd seen out of the very corner of my eye, got me. I suddenly saw the Kuerner house and the hill reflected in the pond at Kuerners, so I went into my studio a couple of hours later. A bottle of Higgins ink was on my desk, I grabbed it, and with a large, number 12 sable brush, quickly did this first deep impression. I wasn't satisfied. I put a mark through it, turned the page over and did this [39], the second one, very quickly – in seconds. And this, I thought, that's interesting. I quickly threw it in my drawing cabinet face up, closed it, and took off. I forgot about it. About three or four days later, I happened to open the drawer just by acci-

dent and this black wash drawing caught my eye. Oh, oh, that's it, I thought. The balance, the flash of that black thing, brought the image of the scene crystal clear to my mind and I recalled the marvelous amber color of the rich landscape and the lucid pond looking almost like the eye of the earth looking up, reflecting everything in creation.

"I put the first impression away and went back to the site itself. But I had the first impression to hold myself to the original idea. You know, it's very easy to deteriorate when you have nature in front of you. You lose the grasp of what you are seeing. You can lose the essence by detailing a lot of extraneous things. At the scene I started to make dozens of drawings: details of the house, the trees, the piles of stone, things on the porch. All of these were absolutely accurate drawings. Most of them are pencil, which is terrific discipline. Because you don't have color, you don't have anything. You're working with basic materials. But again it's interpretive too, which it must be. You have to find a method to capture the quality of an object. And it isn't because you put in every fleck on a pile of stones or every blade of grass on the hill. That doesn't make up a

powerful painting. That's why I feel strongly about a lot of so-called realism that is done today which I think I've had a very bad influence on. *They* think it's the amount of detail, and that really isn't it. Yes, a detail should be there and it should be carried far, but the picture's got to be bigger than that. Otherwise, it doesn't hang together and it doesn't give you the force of the thing. It's got to be abstracted through your vision, your mind. It's a process of going through detail in order eventually to obtain simplification and cutting out. And it's a very fine line because you can't overdo it, you can't cartoon it. It's a subtle quality, very subtle. And with less sometimes to work with, you gain more."

"In the past you haven't really shown many of your studies like those for *Brown Swiss*. Occasionally, but not very often."

"Rarely. I showed the more completed type of drawings, but not the drawings done in white heat and those that get me going emotionally into a picture."

"I am very happy that you feel that it's all right to do this, now."

"Yes, to me these are things that were done in my past and they're alien to me now. It's as if I were dead and someone else had painted them. That's the way I really feel about it. I can be quite dispassionate about them.

"So, in the drawing process for *Brown Swiss*, every once in a while I'd open that drawer and take a quick look at the black thing to keep it in my mind. And after maybe a month, maybe longer, I placed a big tempera panel on my easel, just a blank white panel. I may just look at the panel for days or weeks. That blank white is very exciting to me. And then with *Brown Swiss* one day I came in and put the drawings in the corner and without really referring to them at all, I started to work on the panel with charcoal, very freely, glancing at this first black abstract drawing. But didn't really follow it closely.

"I don't follow anything, finally. I needed it as a check against possible deterioration from my original idea. It's very easy to deteriorate, you know. You may start out with a marvelous idea, and before you know it, you're going down a side road that doesn't lead to anything. The first impression keeps you in line. I wanted *Brown Swiss* to be this double portrait of not only the house, but everything that is going on in that house. I got close to the house in the drawings and then I went inside in order to look outside correctly, then I went back outside again. There's a big pan there that catches the light and minutely has the reflections of the spruce tree in here. One can see the attic windows reflected in the pond. See, you're looking directly into them but at the same time you're looking under too. You're looking up into the ceiling and in the painting you can see details within that room. You can look right up under the eaves.

"I remember one day I was just looking at the whole scene and the house. I was totally lost in it, sitting up on the bank of the hill looking down at the water very carefully. All of a sudden, a head appeared in the water and then a whole figure. It was Karl Kuerner walking in the reflection upside down across this roof and over to the chimney. I noticed he had something in his hand. It turned out to be a big slab of bacon, which he was putting down the chimney to smoke. But in the reflection of the pond, of course, he was upside down, walking alone. It was fantastic.

"One series I like particularly is that of the pond at all times of the year. I was working on this painting. They are purely abstracts of the way the pond looked to me even though it isn't reflecting anything [42-43]. I was interested in being associated with every section of it. And here again, the picture mirrors almost all times of the year. I may have finally made it late afternoon in November, but it could be almost any time of day. I needed that, I felt, for power, strength. The crystal quality of ice that was there from time to time showed up not in the pond but in the dishpan, which is very silvery with a black shadow inside of it. It's almost as if it were a pond with ice in miniature.

46

"The picture developed as I went along. For a while I had trees on the spare expanse on the right side. Then I went back on to a little more literal impression of the trees and the cattle. For a while I decided that I wanted the Brown Swiss animals to be in the painting. They are almost the tawny color of the fields here. And I had them line up here just above the pond. I thought that that was just what I wanted. So I drew dozens of studies of the cattle, because I decided I was going to use them in there, so let's get to really studying these cattle. Then I realized that just the cattle tracks were enough – better – to express their presence. They came out of the picture entirely. That's why I call it *Brown Swiss,* because their tracks expressed the whole thing to me; there are tractor tracks in there, too.

47-49, 51. Pencil studies for Brown Swiss (see No. 35)
50. Hill Pasture, 1957. Watercolor study for Brown Swiss,
13½ x 19½ in. Mr. and Mrs. Paul Bidwell

47

48

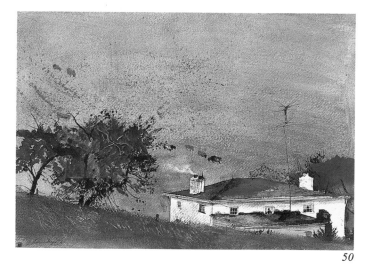

49

50

51

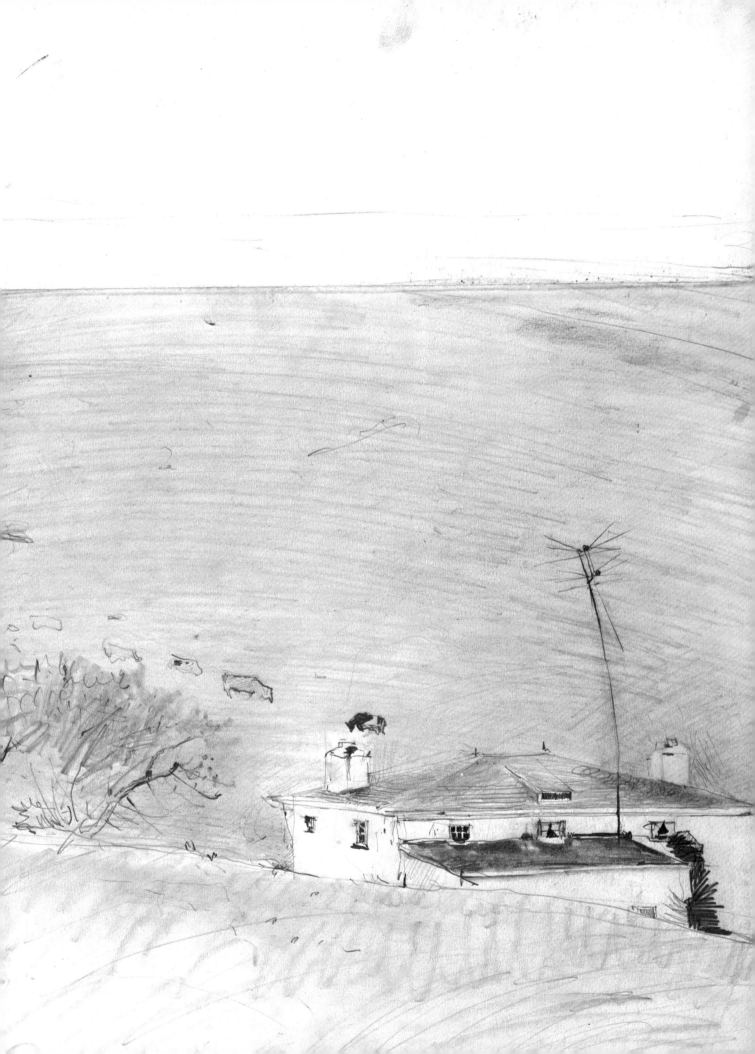

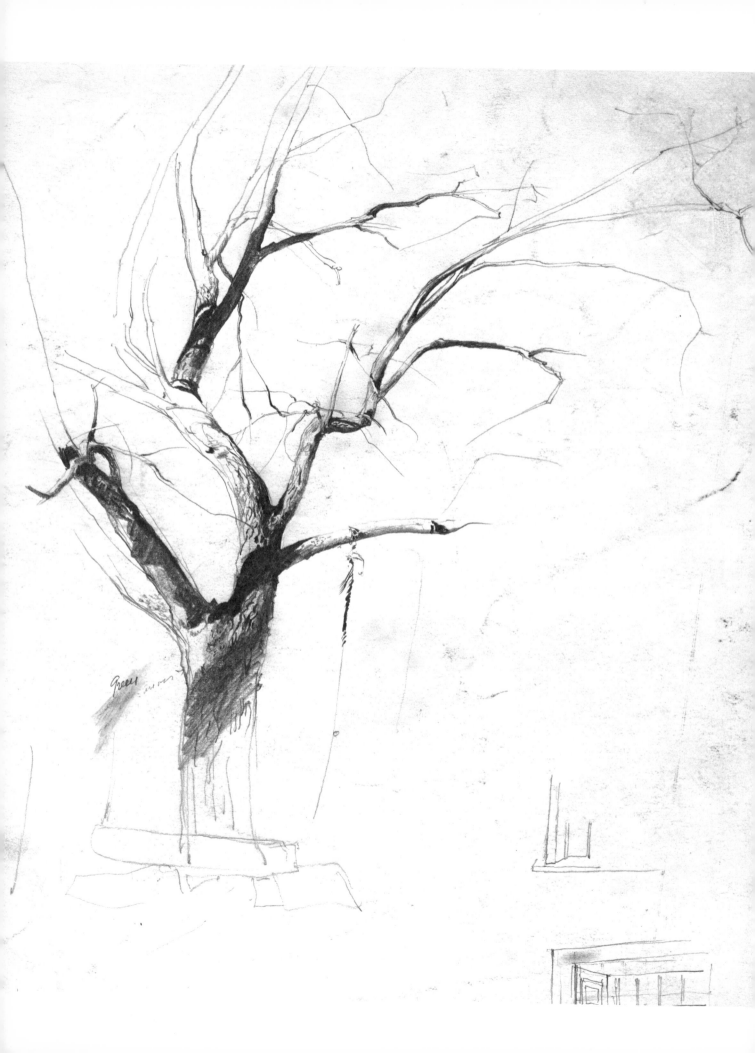

"I did do *Brown Swiss* at a special time of day, because it's late afternoon light. Funny, on the shadow that falls on the hill, you can see this hummock of a shadow across the foreground. That's me sitting up on the hill, casting a shadow right there. As the sun goes down the shadow gradually moves right on up. In the painting, I hope you really get the feel of this shadow creeping as the beginning of night comes down. Also, I totally left out the windows in the house – simplification.

"The green rocks on the bare right side of *Brown Swiss* are strange stuff. It is serpentine stone that came from a building across the way from Kuerners from a house I had known all my life. It burned down in 1912. It was located right across from my father's place, and I used to go up there as a kid and see these ruins that always fascinated me, because here was a bathtub sticking out in the upstairs room; everything had been gutted, but here was this tub hanging on the wall. And that always fascinated me. That house had strange

feelings. Well, it turned out that Karl Kuerner went up there and knocked some of that green serpentine stone down and used it for his porch and also his gateposts. And in the paintings, this is some of the residue. So you see many things were brought into that picture. Many are personal things to me.

"Now some people say, well, this picture is unbalanced. I think it balances because of its very unbalance. To my mind, the vacancy on the right balances the fullness of the left where the house is. The length of the picture is exactly what the first exciting idea was to me. And I tried so very hard not to deteriorate. You can start cluttering something up with a lot of little objects and that kills it. The first early immediate kinetic thought – it really turns out to be what the final thing is. Through many, many changes. The painting *Brown Swiss* is much higher in key than the original thought – not black and white. I didn't want that. I didn't want it to be over-dramatized. I wanted it to be almost like the tawny brown pelt of a Brown Swiss bull."

54. *Detail of Evening at Kuerners (see No. 55)*
55 (overleaf). *Evening at Kuerners, 1970. Drybrush watercolor,
27 x 29 in. Private Collection*

5

''Another portrait of the Kuerner farmhouse, wholly unlike *Brown Swiss* but to me equally intriguing, owing to what I believe is a different sense of poetry, of atmosphere, is the watercolor of 1970 entitled *Evening at Kuerners* [55].''

"Ah, yes. I came down one twilight evening and I was struck by this magical impression of the house sitting there like an enormous salt lick that might be out in the field where Karl's Brown Swiss cattle are grazing. You will notice that on the left side of the house, I simply eliminated several windows, purely unconsciously, in order to strengthen that impression. The house is getting the twilight glow and the moon, just out, is reflected on the side of the building, giving it that phosphorescent glow like a salt lick. It seemed to me to be a most telling atmosphere, in part amplified by the water in the pond, overflowing slightly. It's darkening outside, the moon is just up, the cold light of an electric lamp is illuminating the house from the inside and strangely, the outside, too. It expressed to me the first glimmering hope of spring. The ground is just turning green and there is that messy quality of late winter, early spring, in the ground where the cattle have really messed it up into mud by the brook.

"Technically speaking, this is an interesting picture to me. It's what I would call a drybrush watercolor. I've used the pure rag linen paper for the electric light indoors and in the windows, which adds a glow to the picture. There is only one place in this picture where I used a bit of opaque white and that's for the reflected light under and upon the porch ceiling. I didn't want

any pigment there. I wanted the light there to be like a diamond, crystal clear, no haziness. I wanted it to be a pure piece of glow. But after I tried using just the paper, I knew it wouldn't work, because you see that is reflected light on the under surface of that porch ceiling. So I experimented very carefully with the slightest mixture of white clay mixed with a wash and I think it works, although I am a little doubtful about the opaque white because it might not endure physically.

"It is very important to know that this picture is not describing that time of year when one gets the smell of spring. It is still winter, but a little off balance. If the picture had gone to spring, so to speak, it would in a very real sense have lost its movement. This is ambiguous. This is nature. It's very hard to keep a picture off balance. It's nothing that you preconceive or plan. When you see it, it's a split-second thing.

"There are very few studies for *Evening at Kuerners*, because that year Karl had been very ill and many evenings I saw the light burning there quite late. I had a strange foreboding that this might be the end. That was the real reason for painting this picture. I'd go over there evening after evening. I'd hear that water and I'd see that light up there in the house and I'd lie in bed at night thinking about that strange phenomenon and thinking about that square house sitting in that valley. So it wasn't the fact that I was struck by a beautiful evening, say, in the very early spring with branches against that sky. I tried to get that feeling, but there's something else deeply emotional there. That's what I meant when I say I have to back into something."

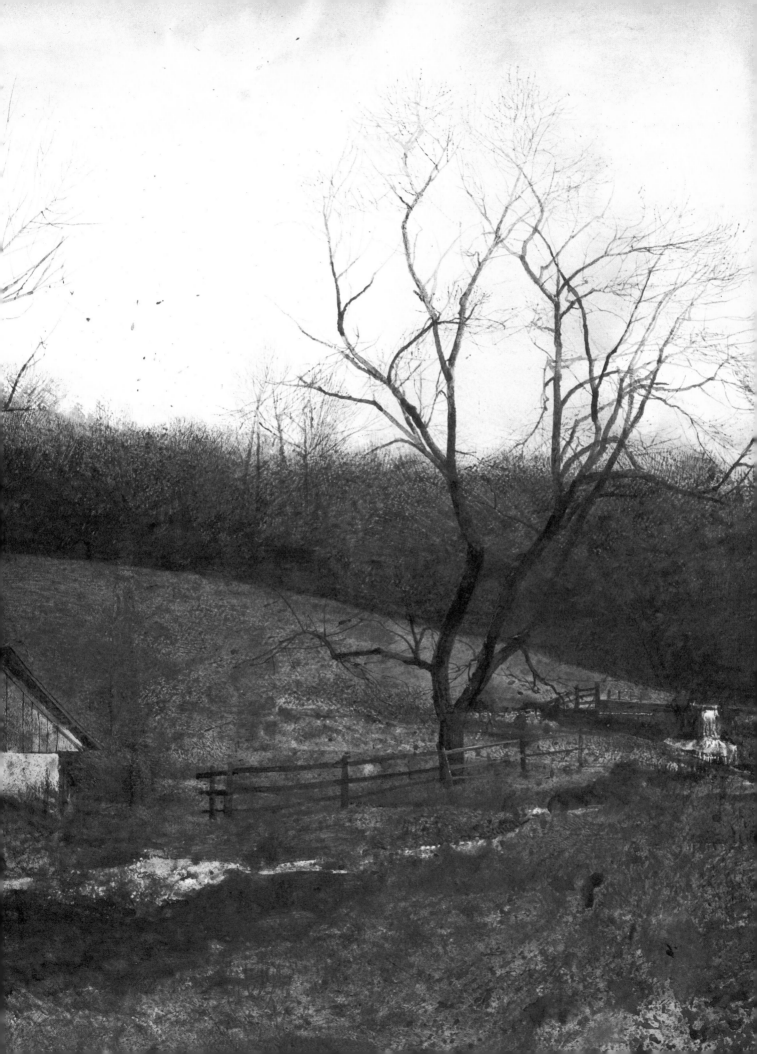

56-58. Pencil studies for Spring Fed (see No. 61)

56

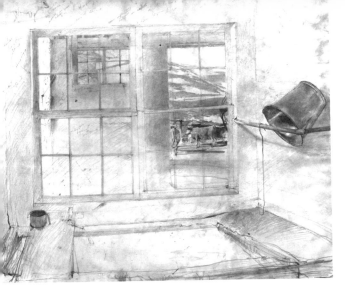

"*Spring Fed* [61], your large tempera of the Kuerners' milk room with the cattle milling around and the hill in the distance and the stolid, everlasting water trough in the foreground is one of the strongest images of the entire Kuerner experience, at least to me. It expresses very powerfully that utilitarian sense of the place and something enduring, something rock hard, but in constant, infinite movement."

"I started *Spring Fed* because I was taken by the remarkable variety of sounds in the Kuerner barn. One day I became conscious of the sound of the running, trickling water all around the place. Suddenly, it dawned upon me one cold winter morning how amazing that sound was and I went into the milk room. The barn was colder than it was outside but I could still hear that water running. I stepped inside the milk room where the Kuerners wash all their things and where they keep the fresh milk cold and here was that continuous water running from the spring which is way up on the Kuerners' hill, trickling way down and in and running out over the side of the cement trough. The whole quality of the distance of the phenomenon and the bucket hanging there like a helm, a knight's helm, fascinated me. I was caught, too, by the clang of buckets, that strange hollow sound of metal.

"For a while, in some studies, I had Mrs. Kuerner in my composition but her presence became unimportant and out she came. More significant was the feeling of winter hills outside and that trickling water, endlessly coming down the hill in ringlets of water. I could hear the water running, nature itself running, running, pouring itself out. I was also excited about the hollow sound of the feet of the cattle on that cement corral and the way the long shadows crept across the area. I think this picture has a lot of sound in it. And, indeed, that was the whole reason for doing it. Everything is sound, the clang of the bucket, the sound of the hoofs, sound of the water. If you've ever been in a milkshed or creamery you always sense that curious echo of things. It's kind of like some sort of Egyptian tomb in Chadds Ford. It's not just a bucolic picture.

"In the tin cup on the left side of the picture [60] there is some of the best tempera painting I've ever done. That cup is almost transparent against the wall, except for the little glint on the lip and on the spigot. The way the bubbles come out from where the water hits, makes constant movement. I've drunk that water many times, it's the most delicious fresh water and it's going right to this day. The way it comes over the ledge of the great trough and runs down the side is amazing. There is a strange transparent quality when it overflows, great cascades or small trickles, all at the same time, some very thin, some not. It's life itself, endlessly moving, making sounds."

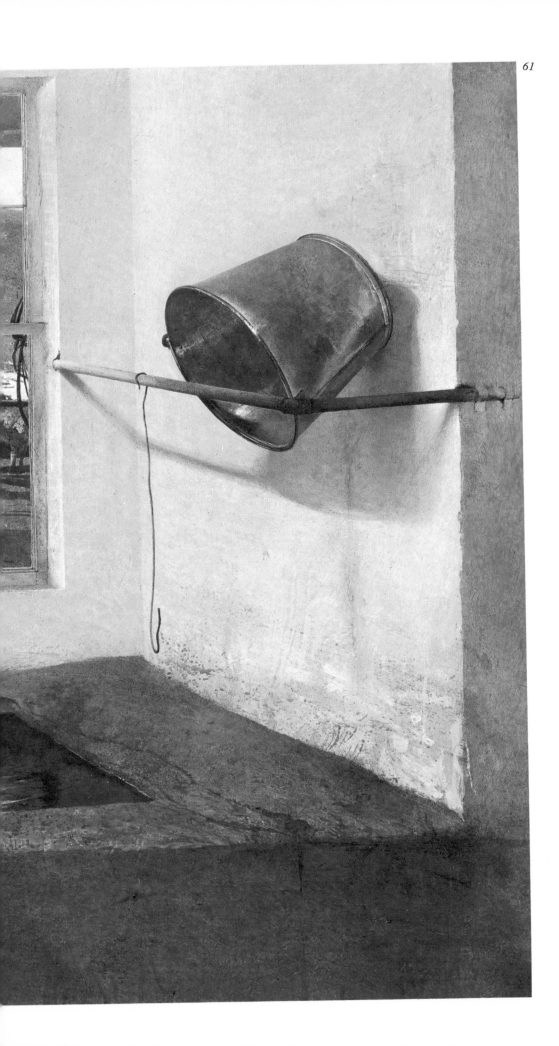

"A particularly successful recent watercolor of
Kuerners farm is the one you call *Wolf Moon* [64]. How
did that come about? It was done in 1975, wasn't it?"

"Yes, it was. I was up there late one night in back of
the Kuerner house, about one o'clock in the morning.
The moon was full and illuminated the melted patches
of snow on the hill in a mysterious way. Suddenly, I
heard a soft, regular sound from the woodshed. It was
Anna Kuerner chopping wood, late at night. There was
only one light on in the whole house and that was at the
woodshed. God, I can still hear this chopping sound,
chopping the kindling, fine, very fine, putting it into a
small basket, to start the early morning breakfast fire. I
stood there in the crisp, chill moonlight, entranced.
Finally she stopped. The light in the woodshed went out
and I saw other lights go on in the different windows as
she went upstairs, turning them on and off on the way
up. And then there was silence and only the moon and
the still house below and the great expanse of the hill
above it with the patches of half-melted snow on the hill.
I made some pencil studies to engrave the idea in my
mind. So back in the studio I sat down and after more
pencil studies I painted *Wolf Moon* in pure watercolor
in one go – in an hour or a half an hour. It was some-
thing I felt about very strongly and I had to get it down
as quickly as I could. I thought that it would either work
or fail utterly. Next day I walked in, examined it, and
never did anything more to it.

"The composition of the first drawing is rather squat.
When I came to the watercolor, I took a rectangular
piece of paper and freely transcribed the preliminary
idea. In the final piece, I literally shot myself higher in
the air so that I was almost taking off over the house.
Then I emphasized the shape of the pond, to pick up an
icy overflow that I had remembered having slipped over
coming back from the place. Actually, a muskrat had
gotten in there and broken the small dam. But all these
changes happened in my brush, as I worked. I felt I had
to let myself go and felt also that I had to record past
memory and the present and perhaps a bit of the future.
I strengthened the TV antenna and eliminated the win-
dows on the left side of the house to emphasize the light
of the moon on the side of the house, and worked on
that golden yellow in the window to record Anna's

62

64. *Wolf Moon, 1975. Watercolor, 40 x 28½ in. Private Collection*

6

strange presence there. And I used a great deal of luxurious black in order to make the thing really shout. In the drawing, the snow on top of the hill is rather simple and muted, but in the watercolor I wanted a clutter of snow patches to emphasize that hill. In *Wolf Moon,* the final watercolor is almost a caricature of the truth, something just this side of bravura.

"What I particularly like about the painting is that you can look at it in every way. It even works as an abstract image when you hold it upside down. It captures, to me anyway, that penetrating quality of the Kuerner house being the hub of the surrounding country. I think it all fits together with the hill interlocking with the building and the sky merging into the hill.

"I worked a great deal on the subtle soft golden-yellow light of the woodshed window, and the gentle reflection of that light on the overflow of the pond where the color suddenly becomes golden. I tried to capture the atmosphere of that late night. This tone of color is what I love the most; to me it represents winter, crystal chill air, the sound of cracking ice on a pond when you skate at night. And the light over those snow patches has a special texture because at that time of night you can't see too well. All the whites in *Wolf Moon* are the pure paper. No opaque color is there at all. There are some strange parts to this picture, too. Those passages on the small shed covered by a corrugated tin roof reminded me of the fangs of the German Shepherd who lives near there. So I deliberately emphasized that effect. And the snow patches had a wild, almost primitive feeling. So I painted them that way. You know, a young girl who comes over to our house from time to time to clean, saw this painting for the first time and said, 'That's Apache country!' It's interesting that she felt that, a strangely abstract thought. The painting *is* like an Indian's painted face, dark and then that glaring white. But *Wolf Moon* is also a portrait of that house, a house full of strange qualities and in a real sense not painted from the outside looking in, but from the inside looking out and in at the same time."

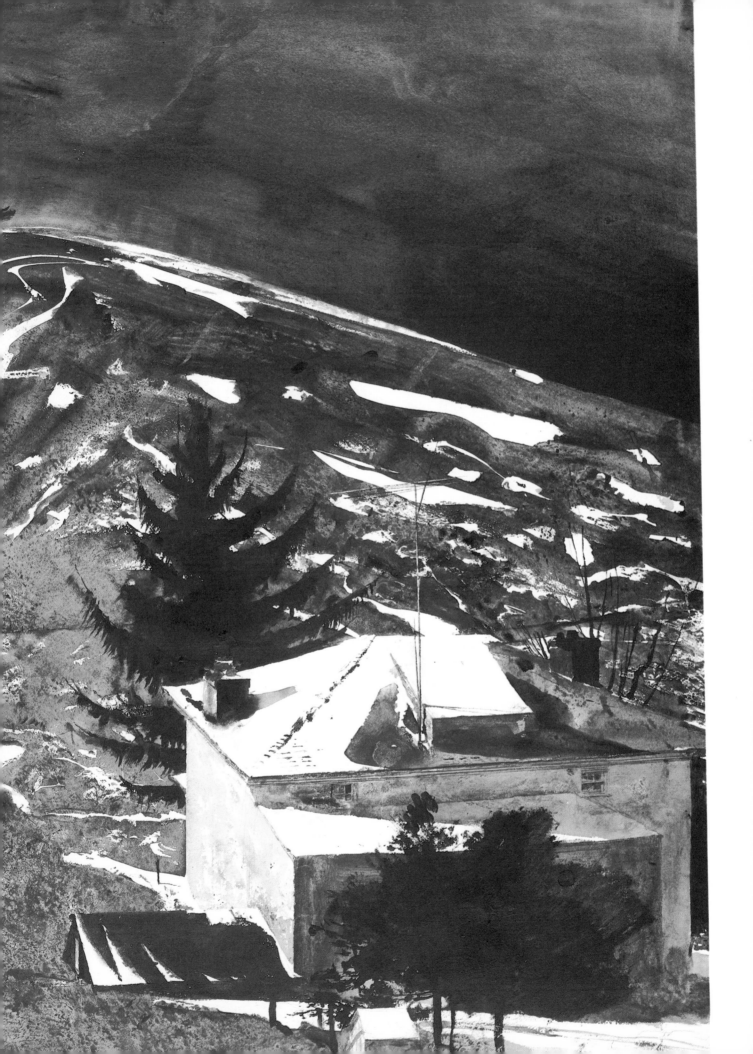

''You told me a little while ago that from time to time your models in portraiture sometimes actually disappear, but that the 'portrait' for that very reason is more powerful to you. Is that the case in the marvelous tempera *Groundhog Day* [74] of 1959?''

"Well, in that all sorts of things disappear or aren't there at all. The dog – the German Shepherd – and Anna were originally in the picture but were taken out, and Karl, who is what the picture is all about, isn't there, which, of course, makes his true presence even more compelling. It happened this way: I had just had lunch one day with the Kuerners (I do that all the time) and I left and wandered around the farm. Then I went up onto the hill where the pines are. I sat for a couple of hours and kept thinking about that kitchen down there with Anna Kuerner in it. And from the hill I saw Karl leaving to go to a farm sale in New Holland. Then, very quickly and penetratingly, because the presence of the kitchen got to me, I started to make some drawing notations from memory showing Anna in the corner with the dog curled up on the cushion next to her. I went back to the house and got Anna to pose, but she didn't pose very well.

"I thought about it, kept thinking about it. The dog got more and more important to me, and I did her in many studies. Karl calls her Nellie, as he calls all his

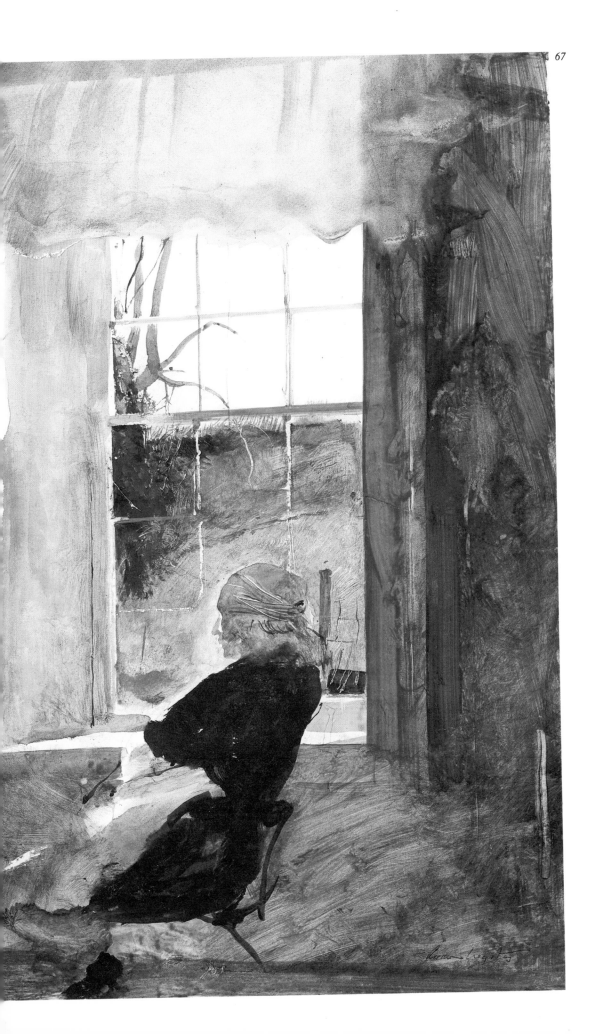

German Shepherds, because a sheepherder always calls his dogs the same name. I kept working on the dog and then I started doing the window. Then the dog disappeared.

"I got interested in the table I saw set there. I kept building on the idea, thinking about it, thinking about it, thinking about it, making dozens of studies of the plate, the cup, and the knife. Then I focused in on the wallpaper and I kept working on the wallpaper.

69

70

72

"Then the dog came back. After that I kept looking at the logs of a gum tree that had recently been cut. As the log was being hauled near the place, the dog went by quickly and I did a watercolor of that strange juxtaposition [73]. I was very restless, perhaps bored, so I wandered all around. And then all of a sudden, the dog disappeared. Again, the ragged, chopped, sharp sliver part of the log became, in another series of drawings, the dog that wasn't there: they became the fangs of the dog. That dog is nasty, you have to watch her. Then the table came back into the picture, but for eating implements, you'll notice only the knife, because I had noticed that Karl eats with a knife most of the time, no fork at all. I wanted to get down to the very essence of the man who wasn't there."

73. *Wild Dog, 1959. Watercolor study for Groundhog Day,*
13½ x 19 in. Mr. and Mrs. James Wyeth
74. *Groundhog Day, 1959. Tempera, 31 x 31 in. Philadelphia*
Museum of Art, Given by Henry F. duPont and Mrs. John
Wintersteen, 59.102.1

''For a portrait of Karl, the one you call *Karl* [78] is exceedingly powerful.''

"I think it's the best portrait I ever did. You'd be surprised at how that picture came about. At first, I got interested in the sausages that hang from those strange hooks in that third-floor room, and I did some series of studies in pencil and watercolor of them. You see, I would never have done Karl's portrait if I hadn't done these. One day, when he was posing for me for early drawings, he reached up suddenly and grabbed one of these salamis that were hanging on a tough-looking hook. They're delicious. I looked up and saw the way he pulled it roughly off the hook. I thought, heh, Christ, *there* it is. I went home and started to think about him with those strange hooks above him. He looked, to my mind, just like a submarine commander with his black turtleneck sweater . . . but those hooks were very important. It's marvelous to go over there during a thunderstorm with lightning and suddenly see the shapes of these damn things illuminated. Talk about abstract power. It's unbelievable. And as the light changes during the day from morning light to afternoon light, the shadows from the hooks change almost as if the ceiling were the Austrian Alps with ski marks in the snow."

''And Anna Kuerner, what about her portrait of 1971 [83]?''

"She's very difficult, you know, but she's very sweet with me, remarkable. Once, when I was over there I grew tired, I went up to one of the bedrooms upstairs

77. *Pencil study for Karl (see No. 78)*
78. *Karl, 1948. Tempera, 30½ x 23½ in. Mr. and Mrs. John D.*
Rockefeller III

78

77

80

and took a nap. I woke up hours later with a blanket carefully placed around me. She's amazing, she'll sew buttons on my clothes – grab the clothes away roughly and bring them back all repaired. She only speaks German, she can't understand very many words of English. For years I've always spoken to her because I liked her very much. I feel her real presence.

"I asked her to pose for me for years with no success. I really wanted to do a penetrating portrait of her and once asked her spontaneously to pose. She nodded, yes, and I almost fainted. Fortunately, I had my equipment there and I grabbed the only panel I had. It was a tiny one. I think it's an interesting picture. It's quite high in color key: indeed it's one of the most colorful things I've ever done. She posed absolutely still for two weeks, and then one day she stared at me in a strange way, abruptly got up and left without a word. I put the finishing touches on the painting working twelve hours a day, from daylight till night. I never thought I'd ever get it. It was marvelous the way she looked at me. I knew it was all over."

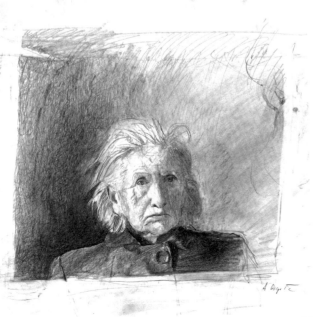

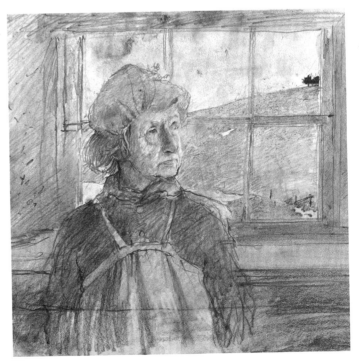

81 82

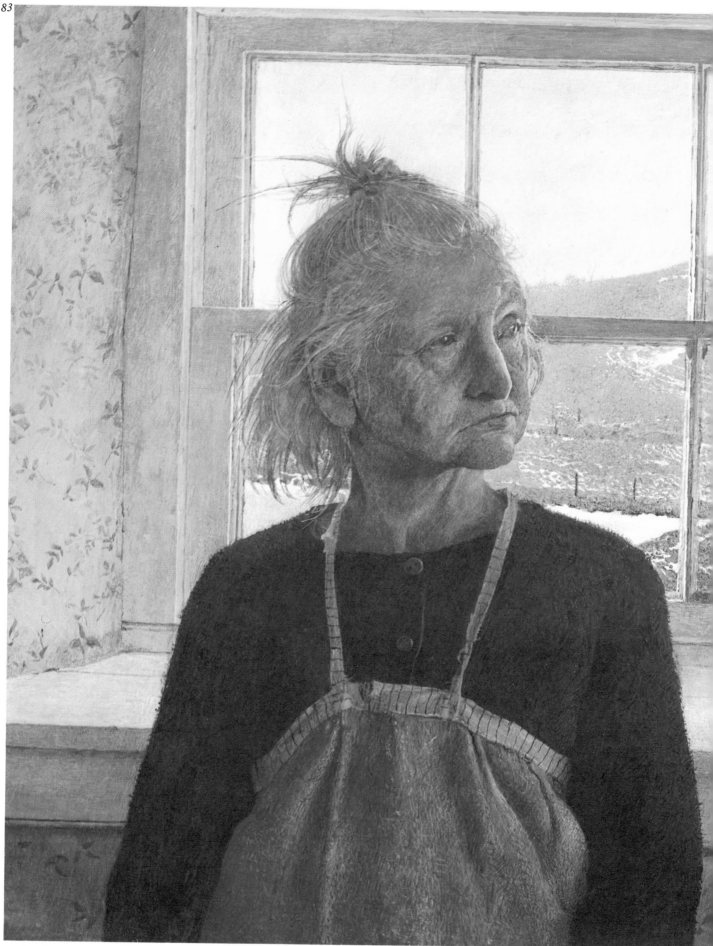

83. *Anna Kuerner, 1971. Tempera, 13½ x 19¼ in. W. S. Farish III*

''But then, you caught both Karl and Anna in one portrait in 1971 [88], didn't you?''

"This is a strange picture, something that actually happened. It was purely an accidental thing that took place over a long period of time. I was very interested in Karl as a subject for portraiture. He's been a crack shot ever since he was trained in the German army. He had just gotten this marvelous rifle with a new scope on it. I got him to pose with it up in the room on the third floor where he keeps his trophies. I wanted him to stand, but found that he got tired, so I had him sit for the head. I worked on the thing for about a year and a half and kept fiddling around with his head and his body placed way off to the left. I didn't know what I was going to do on the right side of the painting. I thought, for a while, I might put one of the moose trophies that hang on that wall. I worked on it for about a year, set it aside, then came back to it a year later. I just let it sit there, incomplete, for two years in his attic room. It was getting toward early spring and I went back to it and painted in a moose's head on the right side. It didn't work. I was dissatisfied with it. Oh, it was effective enough, but somehow it didn't mean anything emotionally to me. I set it aside again. In the meantime, I did the small tempera of Anna Kuerner that I just told you about. Then, again I went back to this picture and I thought, damn it all, I like Karl's quality. I like the way the rifle sticks out.

"And I was working one day with Karl there, specifically on the rifle, particularly the scope and the bolt (which, by the way, is a pure white piece of paper) when around noontime, Anna Kuerner came into the room. She looked at him very quizzically and spoke in German, saying, 'Why didn't you come down for dinner when I called you?' She was quite severe. She had this quizzical look, and I thought – *that's it*. She left. And I thought, I've *got* it. God, her expression when she looked at him with that gun by chance pointed right at her was incredible. Well, I went downstairs later in the afternoon and asked her to pose for me and she said she would. In the meantime, I had gotten some sandpaper and had sanded out the moose trophy I'd painted on the right side of the picture. And that turned out to be marvelous, for it gave it the perfect texture of the real wall. Karl had been a sort of frozen monument there and suddenly she came in. You will notice that she's all in white color, which I believe makes her move more.

"It is a rather abstract picture in a compositional sense, but although I've always felt that abstraction is marvelous, why not have it also mean something to life itself? Truth. Why can't it depict something? But it must also have just as powerful an abstract quality. I don't think you could get a clearer portrait of these two people and what their life has been like. He's been wrapped up in guns ever since he was in the service, he's always going out to hunt. She doesn't think much of it. She's always looking at him skeptically. He's looking away from her. This is not a concocted thing. This is an absolute portrait of those two people in a very abstract way, but that's the way they really are, too. Curiously, I love the feeling of figures just this size. It is as if you could pick them up and take them home and hold them like dolls in your hand.

"To me, one of the most important parts of this picture is Anna's cap. I wanted the white of her cap to come out just so, not too much, so I rubbed my hand over the floor and then kept polishing the paper where the hat was so that it became slightly toned down. I couldn't get the correct quality with a wash so I rubbed it. The ribbon that keeps the cap on her head carries the white down around her chin and reflects her skin tones so that the passage picks up the temperature of the human figure and in a sense itself becomes epidermis. I couldn't show the blue of her eyes so I showed it in her dress. I was also fascinated by the pattern of her dress, which looks almost medieval."

86-87. *Pencil studies for The Kuerners (see No. 88)*
88 *(overleaf). The Kuerners, 1971. Drybrush,*
25 x 39½ in. Private Collection

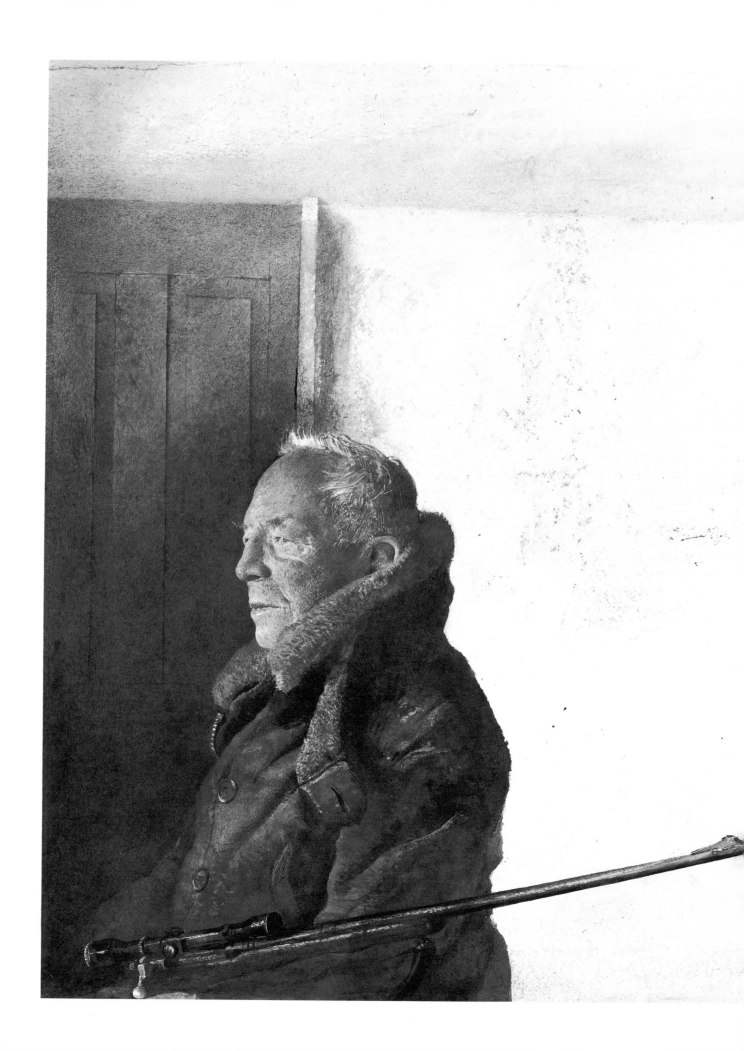

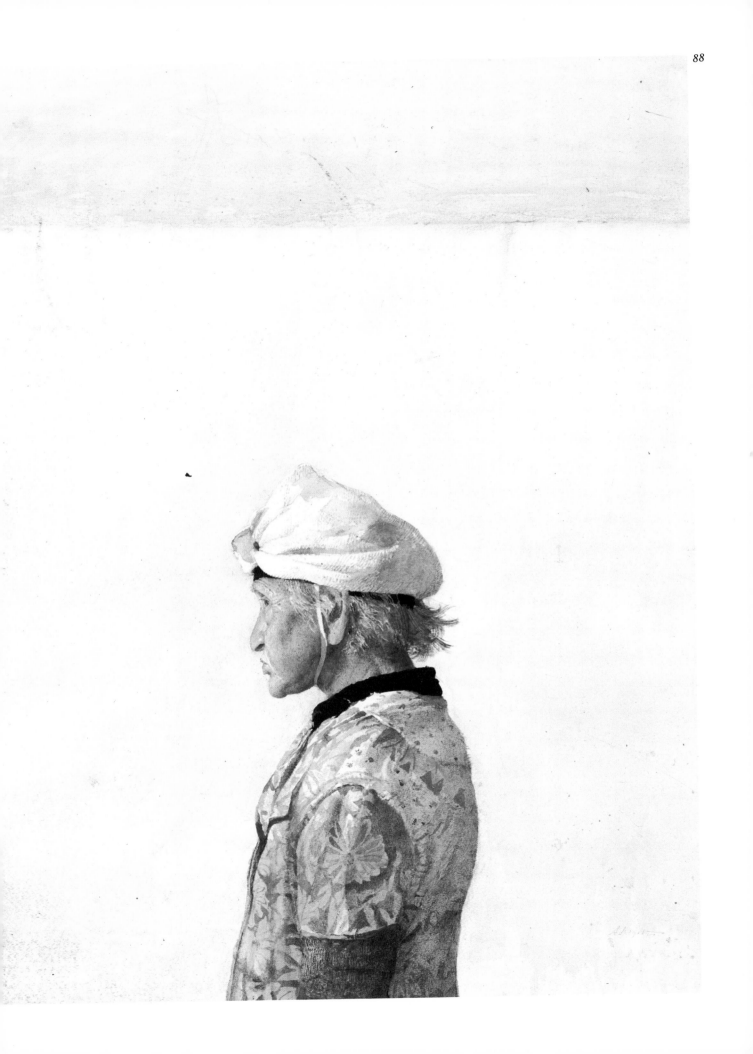

"One of the simplest and yet incredibly complex and universal pictures not only of the entire Kuerners series, but possibly of anything you've ever done, is the tempera *Snow Flurries* [89] of 1953. Tell me about it."

"This was a *very* difficult picture to paint. It really was, because there is not much in it. It's just a hill where I walked a great deal. I used to tell Dr. Margaret Handy that many times, while I was painting this picture, I felt like throwing it through the window. In it, there's very little to grasp and yet everything to grasp actually. Margaret, as I said earlier, has often mentioned that she'd like it better without the fence posts in the foreground, but the fence posts keep it tied down from going too far. They are a thread that holds the painting from going off into the air. I think you see what I mean. *Snow Flurries* is the portrait of a hill where I have walked many years. I think the thing that got me the most about it was the fact that Dr. Handy understood it enough to want the picture. God knows, when I finished it, I just didn't know. There again, as I mentioned to you before, I was greatly taken by the reflection of the clouds that have moved over the hill. Sky and hill are united. I once remember an artist showing me a picture of some hills, but the upper part of the painting where the sky was to be was just blank. I asked him 'What is this? The lower part is all finished, but the upper part, what's that supposed to be?' And he said that he had written on the back of the thing, '*Landscape hunting for a sky.*' I don't think that can happen."

"To me, one of the truly remarkable things about this picture is that after a while one begins to observe more and more the infinite sculptural quality of it. Once you really begin to know its subtlety you can come back with your eyes and visit again and again. These little hillocks are extremely complex. At first the snow flurries tend to make them obscure, as indeed snow flurries do. And then the picture begins to define all these shapes in utter complexity. It is almost as if it were the side of somebody's face."

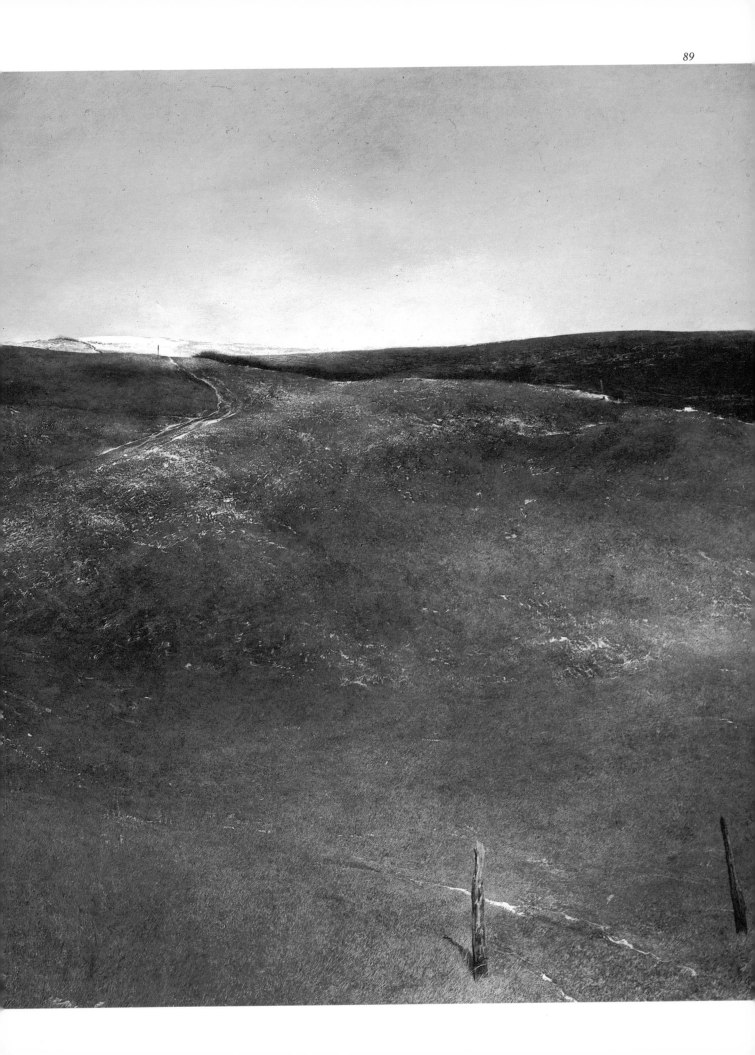

90. Flock of Crows, 1953. Drybrush study for Snow Flurries (see No. 89), 9½ x 19 in. Private Collection

90

"Of course I feel this . . . I have always felt this. I don't agree with the theory that simplicity means lack of complexity. I feel that the simpler the thing, the more complex it is bound to be. I've found that some of the simplest people are very profound and actually very complex. I find a lot of so-called educated, complex people really very simple people. I don't know if many others will agree with that, but this is the way I feel. Just because you have a simple subject of a hill, doesn't mean that it isn't complex as hell. It shouldn't show too much if it is good. It should be all there, but you should cover it up. Don't show every muscle in the body you are painting, emphasize just salient points, just enough. That's where the master comes in, the person who is really good. I have noticed that people who spout great knowledge all the time usually don't have much knowledge. Some simple fishermen I have known will look quizzically at some summer person who considers himself a fabulous sailor and who talks about all sorts of technical matters and yet that fisherman's knowledge of navigation is absolutely impeccable. I have sailed with so-called great experts who aren't so good and with fishermen who are wonderful sailors because they do it with such ease. They make you feel completely at ease.

"Well, actually, this picture is to me a whole lifetime. It summarizes an awful lot. That's really what interests me. What I was after is what you get after sugaring off maple sugar from the maple tree. You keep boiling it down until you have the essence of purity. That is what I was after. I'm not saying it's all that pure or good, but I did want it to be *all* the hills but yet a very definite hill. Funny, I wanted to get rid of it. I thought it would never work. A thing like this works or it doesn't work."

"But the studies worked very well, didn't they?"

"Well, not really. When I did the studies for *Snow Flurries,* they were really only slices of the whole. One showed a tree and an old abandoned house at the bottom foreground of the drawing. And another had some crows in it but I eliminated the crows."

"I don't know if this is a correct way of describing it, but you had the courage to take away the trees that in the early studies formed the virtual center part of the picture. I must say that took guts."

"You would be shocked at the stages *Snow Flurries* went through. There's the jettest black in that picture and the jettest green. Once, that picture was almost literally a black and white; it was once just greens and blacks and extreme whites. At one time it was the kind of picture that *Wolf Moon* is, a sort of abstract caricature of the truth. I kept building over it so that I could get that tilting-in quality of the grass. It is very, very minutely painted, if you look up close. On the upper left side you can see the dark tones coming out. That's jet black in there and the darkest browns and the deepest greens."

"Margaret Handy wants you to explain what all the red is that shows up when the picture is in the sunshine."

"The red is the underpaint up on the right of the field, which was red, red because it was new-plowed earth in January or February. If a farmer has just plowed a field and if it isn't frozen yet, it's very red and it just seeps up the snow when it comes down – sucks it right up. You know, because of all the layers of colors in *Snow Flurries,* this is a very hard picture to reproduce. It's very hard for an engraver to get those shifting tones that are underneath.

"You see, I didn't want to exaggerate the sky. I didn't want to make great big black rolling dramatic clouds, because that wasn't it. There's a fantastic subtlety in a day when you get snow flurries like this – subtlety and great power. That sky was painted from my studio window. There were days when there were lots of snow flurries. If you get up close you will see snow in the sky in parts of it. God, I worked and worked and worked to get it right. I would paint that sky and then I would take a really fine brush and massage it and merge those colors to get it down to that gray which is not an obviously overdramatic gray, but just enough toned down so that a snowflake will count. But I

couldn't exaggerate it because you never get snow in an exaggeratedly dark sky, a black sky. You can put a piece of white paper up against the sky on a day when it's going to snow and you'll find that the piece of white paper almost merges into the sky. I have watched this very closely. It will rain if the sky gets too dark but you won't get snow flurries. That is why the ground plane also has no jet blacks, because I finally realized that the whole picture must express the same temperature. You see this is not an exaggeration of nature. There again we're getting back to Shakespeare and Hamlet telling his players to mirror nature."

"I feel that this is a picture that is really woven. There's a complex webbing, weaving that's an important part of it."

"That is why I do tempera. You are getting to a very fine point and I will now sound very conceited but that is what the medium tries to pull out of me. I can't say I am trying to pull it out of the medium because it's the medium that finally gets it to work. There again, the medium is just a mirror of what I'm trying to say and feel."

"One of the studies has a burst of black pencil off on the left side that just carries back and forth, back and forth [91]. I have seen it several times in your work, but not very often. Does it mean anything special here? Does it signify a point when you are about to move on, or stop?"

"Ah, yes, from that you can see what this picture was to be from the beginning. I wanted that structure to be under it. And if you look at *Snow Flurries* intently, you'll see the right side has a very definite drama to it, *but,* and this is important, I didn't want this picture to be a caricature like *Wolf Moon* into which I wanted literally to drive a high dramatic brown and white quality. That was quite a different thing; that was a moonlight exaggeration. *Snow Flurries* is different. It is daylight – gray, subtle daylight."

"But you started with the idea of this stunning dark and light landscape."

"I find sometimes I may want to *end* up with subtlety, but I have to start out boldly. I think you have got to exaggerate to get it across. Sometimes I have heard Margaret Handy exaggerate to people how ill their child is in order to make them realize how important it is for them to take care of the child. I've got to emphasize it in my mind, otherwise it will all become fuzzy. All I can say is that you have to lean over a little to the left, and overdo it a bit, and then come back into balance, that ever-important balance."

damp wet earth
soaking up the snow in
the
the clouds feet at last flow
waves across it the
off call of crows in his
field & the morning sho
of snow clouds pass.

"You have a special delight in the movement of things and seem to achieve a feeling of unrest in your pictures that is sometimes so subtle that not too many people perceive it. In this search for captive motion, one very recent series depicting Anna Kuerner going up a flight of stairs is especially intriguing [93-96]."

"I noticed her going up this circular staircase on the second floor that goes up to the attic where I painted Karl with the iron hooks, up into that room with the small windows. Over the years, I've been fascinated by things disappearing up that staircase. It seemed to me to say something about the ephemeral nature of life itself. The first sketch of Anna Kuerner darting up the stairs was made from memory. I spent a month and a half just watching her disappear. Every time she'd go up, I'd make a drawing or two. You will notice that she wears different clothes at different times in the drawings and watercolors – or different aprons. You'll notice that in one she has a jacket on and in another she doesn't. I was fascinated by the way she would disappear up those stairs in a way that would suggest strength, vigor, and an indomitability despite her age. I couldn't get her to pose, so I just sat there and waited each time that she'd go up, and I'd try to capture the way she'd open that door – quickly – and dart up the stairs.

"I made many drawings and watercolors thinking about developing a tempera, but somehow it didn't work. I didn't go on with it because after a while, it looked frozen to me. Then I thought for a while that I could perhaps put all of these observations in one picture with different qualities of color to obtain the motion, but that seemed like a tricky way of doing it and I just stopped. Someday it may turn into something. You never know. I might do a staircase disappearing up, without her in it. The sound of her steps implicit in the tonality and the design of the picture may express it better without her actually being there.

"It's very important for me to go through this stage in a picture. It is a sort of structural or abstract attempt at this stage, rather similar to laying out the foundation for a house. The fact that the object may disappear is irrelevant. Often, there's more of the spirit of the object when it doesn't show in the painting. I never consider these studies as drawings. All I'm doing is thinking with my pencil and brush. That's all. Drawings are such a personal thing. A beautiful drawing sort of happens, but if you're a professional draughtsman, I think it gets to be a bloody bore. It is possible that at some point a picture of the door, the stairs, the deep shadow of what is going up those stairs may emerge. And if so, this angular, indomitable figure of Anna Kuerner crunching up those stairs might not even be in the final picture, but those stairs and that door would have had her physical presence. It would be like a mirror, an ancient mirror, with reflections and images still spiritually within it, because I think a person permeates a spot, and that lost presence makes the environment timeless to me. A lost presence keeps an area alive. It pulsates because of that. I never feel that it's a waste of time to make drawings. It is like being in communion with the object, with the place, which soaks up (as a sponge soaks up water) all the life that once existed there."

"In this particular series, you say that you drew Anna going up those stairs from memory. Was there a time in your career when memory wasn't possible, was there a time when you had to have the subject right there?"

"Oh yes. There would have been a time when I would have made hundreds of close, methodical, even oddly dull drawings of an object when I was learning to catch a subject off balance. And slowly, one learns to know anatomy, to know structure, proportion, perspective, when to modify, when not to, when to exaggerate, when to thin down. These are all things that an artist should train himself to do so that at the right moment, the decisive moment, one is there to catch it, whether it's imaginary or graphically right there in front of you. It only becomes good when you no longer think about it. When you've got to think about every motion, you're no damn good. It's somewhat like fencing, as I've said. You get to the point when you almost sense what the other fellow is going to do, whether he's going to lunge, how he's going to parry you, even before it happens – a split-second before. That's when you get

good. In art, you've got to be prepared in every way to catch the thing. That's why I like fencing so much, because to me, it's very much like painting. It's that decisive, sharp, quick stroke that captures the essence of a subject. I am not talking about slick strokes, but incisiveness. My pictures are almost angles of things flashing here and there. That's what excites me, that's why I'll put one stroke on a panel and leave it there to be studied for weeks. That stroke may be off to the right-hand corner or down in the left foreground, but if it's proportioned to the whole size of the panel, I know it's right in my own mind before I even build out the object. Is it in the right spot? I ask myself. It may look like the wrong spot to most people, but to me that's usually the right spot. That's when I know something is going to work and not by the illusion of beautiful drawing. You get down to much more of the abstract essence of what the subject means.

"I enjoyed these drawings of Anna going up the stairs and their abstract elements, but when I started to develop the picture into something more, it seemed to freeze. It got to be academic in the worst sense. When the series of Anna walking didn't work, I still felt that her face had such a haunting quality that I finally got her to pose for me. And then I thought since I'm not going to have her going up the steps, let's have the steps in the background. I made two drawings of her sitting there [97], but then decided that really wasn't what I wanted either. I wanted something even less definite and so I just didn't go on with the thing.

"I went through all these drawings because I was fascinated by the place and all of its associations, the strange, discolored ivory white of the plastered wall and how the steps curve up to the attic, and the cool air that comes out of that door when you open it. Every section of that house is full of strange feelings to me. I often thought I would like to paint the house transparently and look into each room as if it were a series of thin membranes like the insides of a human being. I sometimes reflect on all the different tragedies that have taken place in that house and the raising of a lot of very buxom German Fraus with red cheeks, the haunting quality of Mrs. Kuerner with her mind a little elusive at times, when she mutters at certain times of the month and echoes throughout the house, Karl maybe having pretty strong drinks at times with his German friends, the sound of a rifle crack outside, his cleaning his gun, the smell of cooking food. The house is permeated to me with remarkable qualities, and I'd love to be able to combine it all someday, in something. I've always felt up to now that I've done details of it. In the tempera *Groundhog Day*, I tried to express all the associations of that kitchen. Karl is off at the farm sale. He isn't there, but he is coming into that room with the late afternoon sun pouring through it. All these things are, to me, poignant, powerful feelings of a Pennsylvania German farmhouse with walls two-and-a-half-feet thick. The house is a sort of square iceberg at the foot of those hills. The whole country seems to hang on a pivot on that hub of a building. That's what the Kuerners' farm really means to me."

7. Anna Kuerner by the attic door, 1975. Watercolor, pencil,
nd drybrush, 23⅛ x 23 in. Private Collection

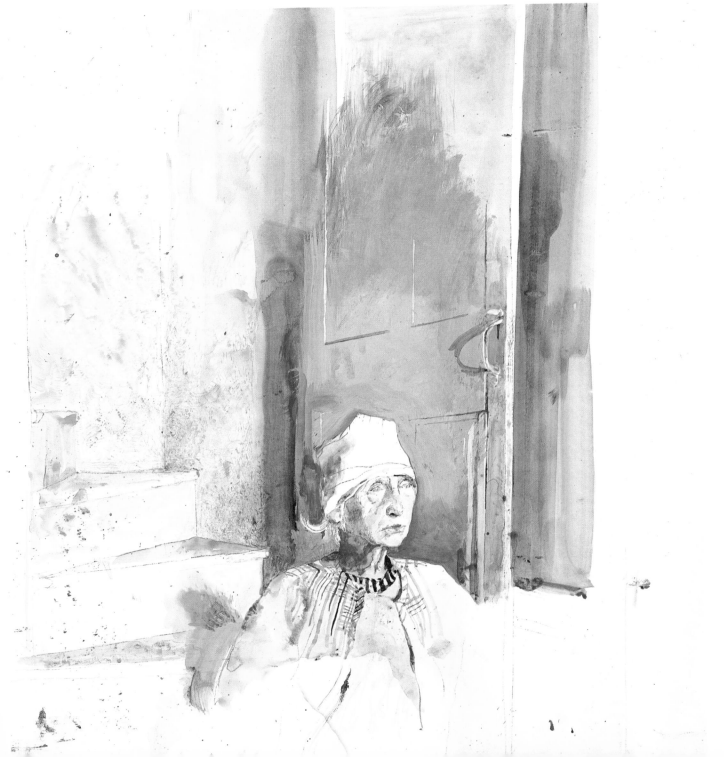

"One of the truly strange images of the Kuerners' farm and Karl, to me, is the watercolor done last year entitled *The German* [99], showing him in a World War I uniform and helmet. What about that?"

"He had his old uniform locked up in the chest upstairs and happened to talk to me about it and said, 'Do you want to see it?' So I had him put it on, and I got him to pose and I completed the whole thing, working very rapidly. It was cold and you can see the eyes are like blue ice. In fact, that is what I thought I'd call the picture for a while, just *Blue Ice*. Because you can see the blue ice back there in the background, and there was an echo in his eyes.

"I brought the watercolor home, hung it in the studio and thought it wasn't right and that I had to do something to unlock the picture. I felt that I had got a good head and body, but knew it wasn't complete. So I picked up a bottle of black ink and simply dumped it right across the top of the picture and lifted it upside down. You can see the drips running on down through the foreground. And those black streaks became the trees. I am telling you that to indicate that you just have to let yourself go. I really wasn't scared whether or not I wrecked the thing even though it meant a lot to me, but my excitement was so strong that I didn't give a damn. It's like skiing down a hill at sixty or seventy miles an hour, you just gotta let yourself go. You can't be precious and think, oh, I spent five hours on that, I'll never get it again."

"It really works."

"Sure, there is a crackle about that black part. There's a little green under here, which I added, but it's mostly just black and because of that it crackles. There is quite a contrast between the ice-blue eyes and the ice in the background. I think when you look at it, you're jolted in many ways."

98. Pencil study for *The German (see No. 99)*
99. *The German,* 1975. Watercolor, 21 x 29 in. Private Collection

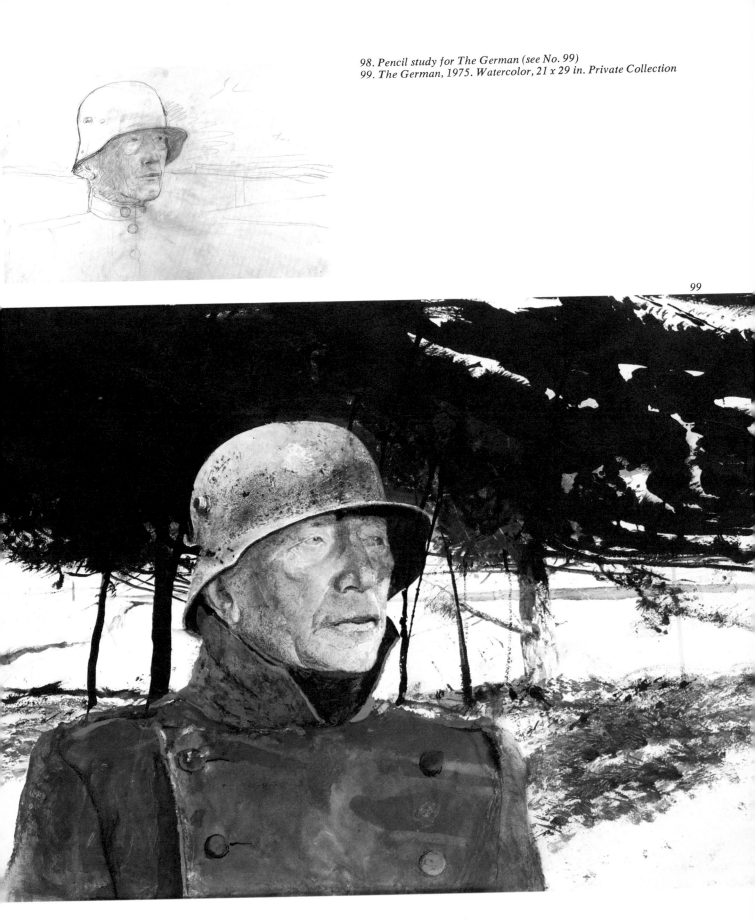

"Speaking of helmets, one of your most recent temperas and a drybrush watercolor and a splendid pencil drawing [100-102] all deal with a German helmet again. How did that happen?"

"I call it the *Pine Baron*. I was driving my Jeep into the Kuerners' entrance one day and suddenly I saw this helmet under the pine trees. I jammed on my brakes. My two dogs, hound and dachshund, in the back of my car landed in the front seat, I put on the brakes so hard. I couldn't believe my eyes. There was a World War I helmet filled with pine cones. It's what Mrs. Kuerner thinks of war and her husband's army experience. And she was using it just to carry the pine cones in to start fires with. Everything is used on that farm, you see – pine cones burn like a dream and have a beautiful smell. And here it was. Right away, I grabbed a piece of paper that I had in the car. I'd used it for something else, and as a matter of fact, there are some drawings underneath it. In the back of my Jeep there's all sorts of pads and paper. I always carry along a watercolor box. And I just did the watercolor, simply put it down.

"There again, I didn't arrange the scene. It just was *there*. I wanted to catch the helmet as it was, not in a way I might place it, but the way she had left it. You can never place a thing the way it's naturally done. To me, it expresses his whole background, his experience in the Black Forest during the War. I was fascinated by that little air vent on the side. In the beginning of the First World War, they had a steel visor that came down over the face. Isn't that strange?"

"That thing is really late medieval, isn't it?"

"Yes, it really is. They threw the visors away because they were in the way, but they still kept the fastenings because they had made so many of them. I just love the helmet's shape. I mean I was struck by the abstract symbolic shape of the thing. That's why I did the tempera square, because to me it expressed the whole shape of the helmet. (I love to call them helms because they go right back to the Middle Ages.) Of course, they cooked their meals in them, they did everything in them. There's an eye that Karl painted in the back of it, beautifully painted, and on the top a horseshoe for luck. I guess it worked, for he got through the war relatively unscathed. He got through the Battle of the Marne all right – he was hit slightly in the arm. It was in the middle of winter and he and his men hadn't covered up the hose that takes the cooling system, and the steam rose up so that the French saw the steam rising and began firing at 'em.

"You know, sometimes I kind of exult in the fact that a page will be partly dirty before I start. I like that because it keeps me somehow flexible. If you have too beautiful a sheet of paper and you preserve that with great care, you dare not paint it that way. You get very picky and finicky and particular. I wasn't thinking of composition when I painted this thing, I was trying to get down the impact that it had on me when I saw it. I wasn't trying to make a nice watercolor. I have seen many, many beautiful color drawings where they fill in the pencil drawing with beautiful color tone. But I do not like to be held in by a line when I am working in watercolor or putting down a color note because that freezes me. I like to be able to enlarge the branch of a tree, or the shape of the curve of a hip or a leg. I can do it freely. It is constipated if I just fill in color."

"You know, it just occurred to me that I have seen very infrequent use of any pencil drawing in your watercolors."

"If I would have taken this drawing of the pines for *Pine Baron* and then had gone over it with watercolor, I would have made a nice picture! But that would not have been it. I wanted to clarify these little ridges in the pine cones."

"You must have to keep in practice all the time – sort of limbered up – so that when that sudden thing happens, you're ready, as in *Pine Baron*."

"You have got to be ready when you get an emotional

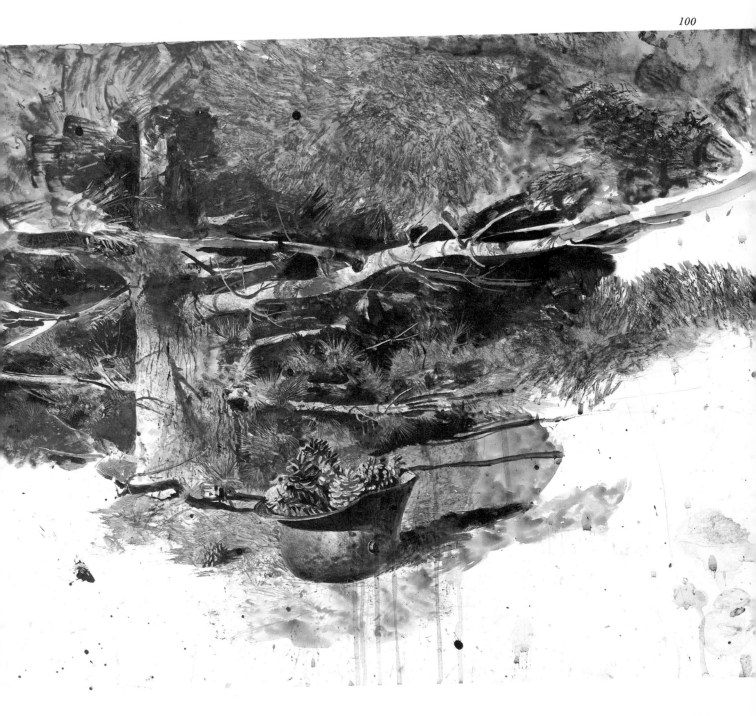

idea of doing something. You do not want to hesitate, you want to be able to hit it right on the nose. People realize that a pianist has to keep his technical quality up, his hands limbered. I think that a painter is very much the same way. I know this idea of being deliberately messy and hesitant is very fashionable, but I do not believe in it. You are going to be messy anyway. Nature is messy. But I like to come in quick and out quick with no hesitation. And I think the more you do a thing, the more you do it subconsciously. If you consciously say, 'Well, I am going to draw well today,' that is terrible.

"At any rate, I had to work fast on the watercolor for *Pine Baron*. All I wanted to do was to get it down before she came back and walked off with it. And, with a little more care, I started the pencil drawing of the helmet itself [101]. I did this because I wanted to make a more careful drawing of the pine cones, you can never get enough. I think these paintings and drawings are symbolic of one of the most important parts of my creative process: that is I really am moved and shocked and delighted all at the same time by something of a powerful yet extraordinarily incongruous nature, then I leap upon it and really attack it in a way. This is the kind of thing that gets me, it's just a helmet sitting there, but to find it there is strange."

"It does have extraordinary impact."

"Well, I'm glad you feel that because it has it for me, anyway. I can only gauge it by what it did to me, and my hair went on end. I mean I turned the corner by those serpentine gateposts, and all of a sudden I saw this gleam of metal, and it just shook me. I was after that terrific feeling of that road going endlessly, upon which something has just whizzed by and disappeared. To me, it represented almost a last road. It could be in the Austrian Alps, or the Black Forest. I tried to get the feeling into the picture of the loden green of the German uniform in the pines themselves.

"The shape of a pine cone is also something unbelievable. Just terrific. I love the dryness of them. You will notice that there's something on the edges of each pine cone that looks like frost, but it's pitch that's dried on it. And, as I said, these pine cones mean a great deal to me. Ever since I was a child in Needham I've loved them. There's something about the wind whistling under cat spruces and pines that is unbelievable. I love the spiky, swift gesture of pines, their sinewy branches that you can't break because they are so tough, resilient, bending, stronger than steel – marvelous! The needle base that you find under a pine tree is soft and velvety and yet rather harsh.

"I also wanted to express that constant movement at Kuerners. You go over to Kuerners after a snow and for a little while it's beautiful. About an hour later their tractors and cattle will have messed it up. I thought as I worked on this that because of the movement, the scene became almost a tank battle that this captain might have been in. I was going to call the picture *The Sniper*, because Karl was a sniper also, but then I thought that would be too obvious and I calmed down.

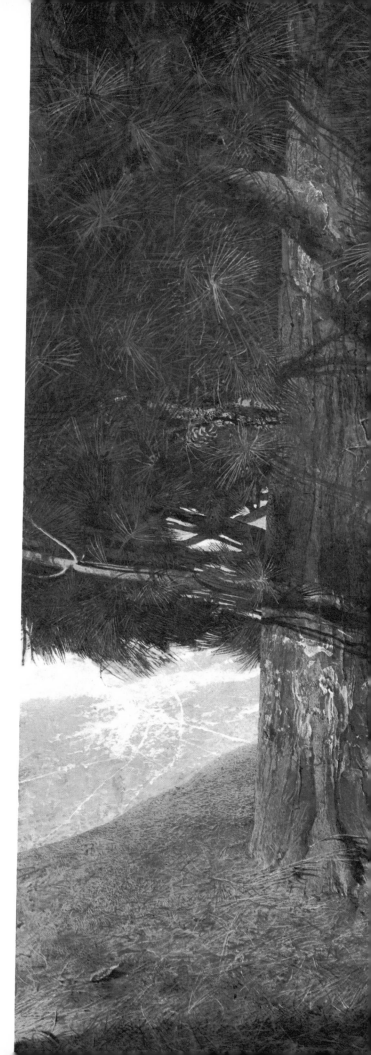

"I just wanted to make it as rich as possible and to suggest what was here inside the pines with all the unseen birds' nests and other things that are so rich in pine trees. I wanted a rectangular feeling with stability and placidity, and then suddenly this horizontal diagonal sweep of branches going out that road, too. I think this is a complex picture, yet it's rather simple. Dr. Handy is nuts about this picture. It's the first picture I've done since *Snow Flurries* that she likes as well. She said she feels the future, the past, and the present in the picture. Isn't that strange? Now I wouldn't think she'd like something with a helmet. I thought that would really throw her off. But she wasn't thrown off.

"I wanted also to capture the strange rusty quality that pine trees have at this time of year, so I coated the whole panel with alizarin crimson, and then painted the green over it. It's the only way I could get that quality of pulsation and vibration. In the background, if you look closely, you will see the place the cattle go up into the field, where there's the post there. You see the cattle marks? I wanted to jam this painting with all the richness that I feel at the Kuerners' farm. This picture is not just a nice grove of pine trees to me."

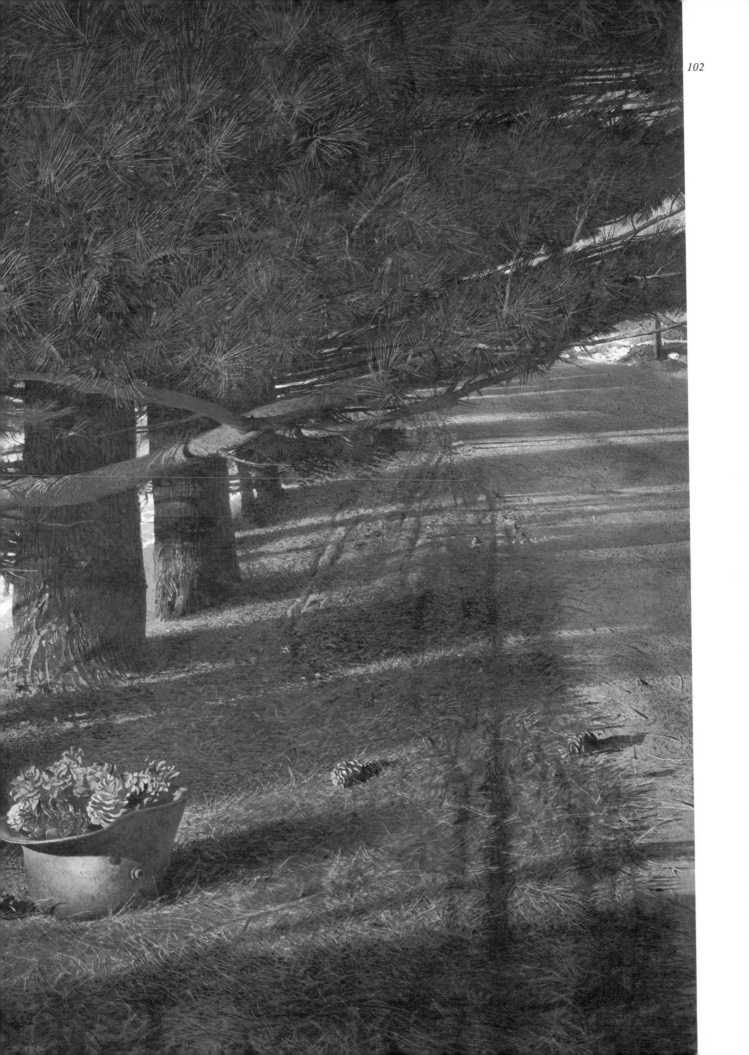

103. Watercolor study for Easter Sunday (see No. 104)
104. Easter Sunday, 1975. Watercolor, 27 x 40 in. Private Collection
105. Trodden Weed, 1951. Tempera, 20 x 18¼ in. Private Collection

"Kuerners has so many parts, the land, the trees, the pines, the entrance, the house itself, the woodshed, the milk room, parts of the house, and its complex interior. I don't suppose you have ever consciously attempted to do it all. I imagine there are plenty of things that you haven't done."

"Oh, of course. Listen, I am constantly shocked by the fact that I have just scraped the surface and haven't even touched the depth of it emotionally. The more you peer within and go deeper, the more you see, the more there is. It's a question of whether or not I'm capable of feeling it or seeing it. And I say feel and see and not just see."

"I detect constant growth in your work at Kuerners. In some of your more recent pictures, of the porch [103-104], I see some of your best things."

"The porch is a part of the house I never really noticed. But, you know, you can be blind to a thing even if you go to it again and again. You still don't see it. I suppose that is why I painted *Trodden Weed* [105]. I had been ill, and one day walking across the field, looking at my feet, watching where I was walking, I became conscious of what we walk on. Sometimes you step on things that are just fantastic. I was then conscious of a few walks I have taken with people, supposedly very sensitive people. You might be walking with them in a spring landscape and they'll say, 'What a sky up there!' and then their great big feet come down and squash some beautiful spring flower or beautiful leaf. You know, you ask yourself, 'Are they really sensitive?' I've often wondered. At times, I don't consider myself sensitive at all, because I miss so much."

105
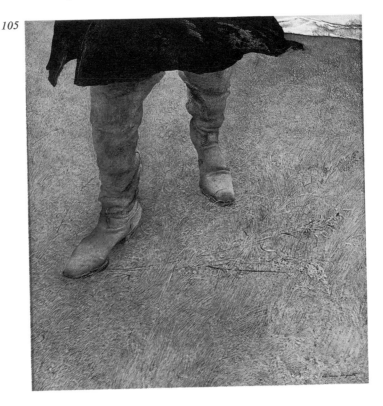

117

Olsons
MAINE

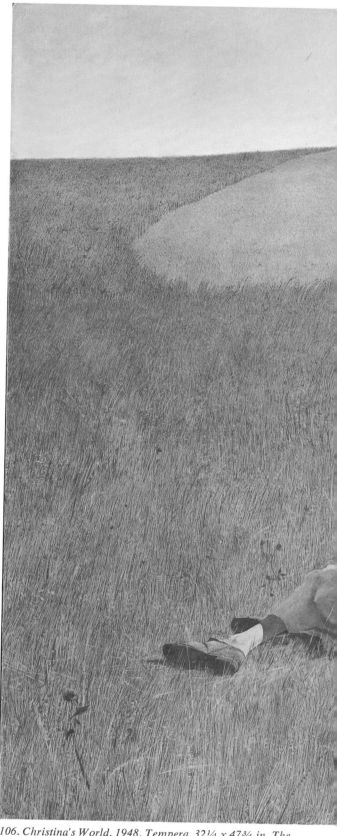

106. Christina's World, 1948. Tempera, 32¼ x 47¾ in. The Museum of Modern Art, New York, Purchase, 1949. Lent for New York City only

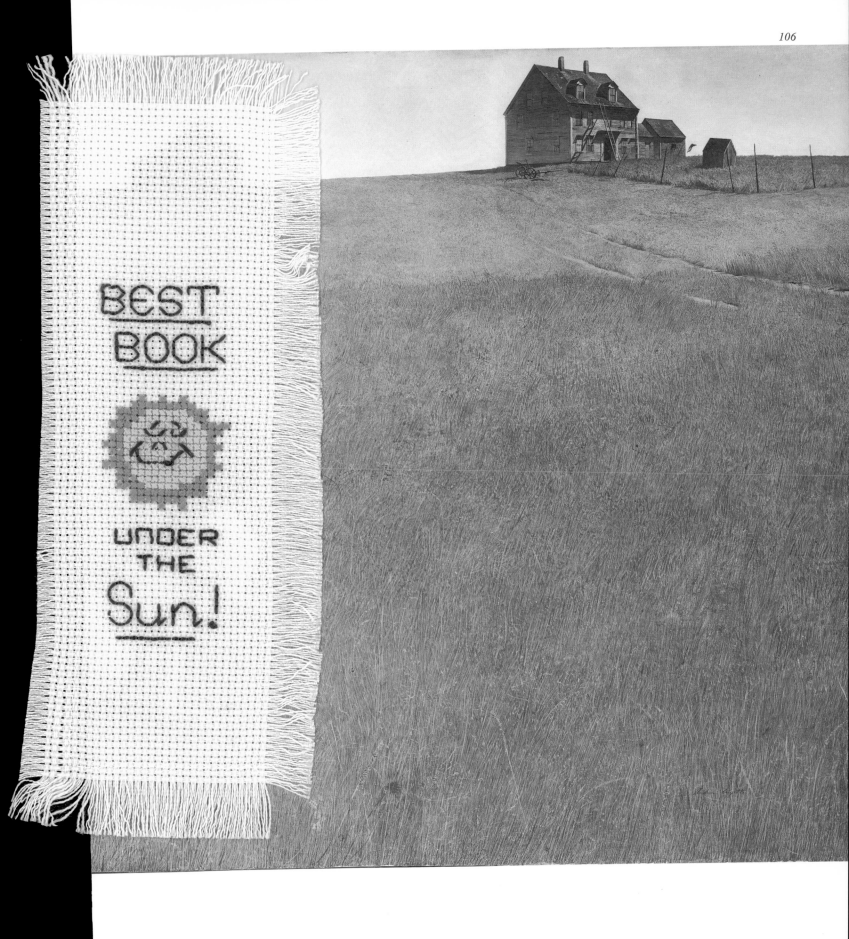

107-109. Pencil studies for Oil Lamp (see No. 110)
110. Oil Lamp, 1945. Tempera, 34 x 42 in. The Museum of Fine Arts, Houston, Gift of Mrs. W. S. Farish

''Let's talk about Olsons. Although in many people's minds, Christina Olson *is* Olsons, you didn't start out with her. Actually, the first tempera you did of Olsons is *Oil Lamp* [110], dating to 1945, depicting Alvaro Olson, Christina's brother. You told me how your wife, Betsy, took you to the Olsons the very day you met and you were considerably impressed with Christina. How come you didn't paint her first? Is there any special significance in that?''

"Not really. I guess I thought I could more readily ask him than Christina, but eventually he turned out to be much more difficult than she was. After *Oil Lamp* he would never pose for me again. Any drawings or watercolors I did of him I had to do on the run, as in the drybrush I call *Egg Scale* [111], which is a study that shows him moving around. He didn't want to pose. But I think there was a certain little New England obstinacy there. The fact that his sister had posed, and the picture got to be well known, made him decide that he was going to do just the opposite. I did *Oil Lamp* in 1945 and made drawings for it at night sitting in the kitchen, talking to him late in the fall. This picture was interrupted. I had almost completed it, but not quite. Then I got word that my father had been killed at Chadds Ford. I had to go back to Pennsylvania. By then, it was October and so I didn't go back to Maine. I had the picture shipped down to Chadds Ford and completed it there, but it was practically finished. The painting has a sort of amber color. It is a very odd picture."

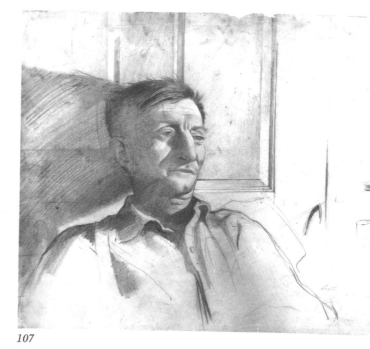

107

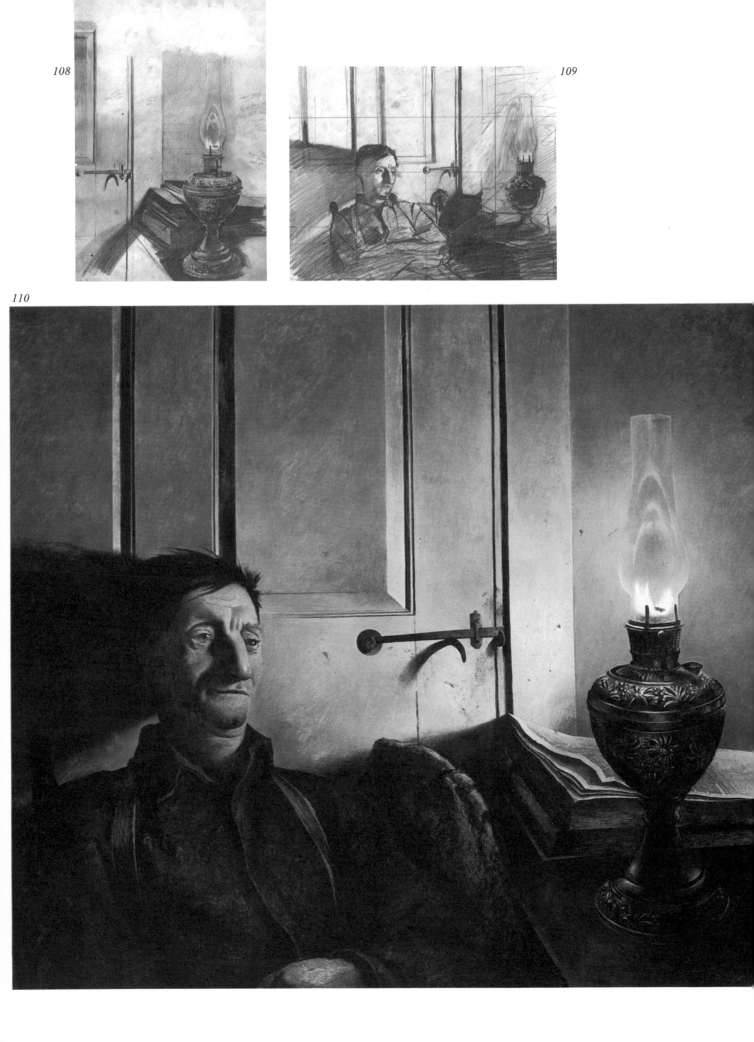

108

109

110

Wyeth

"*Egg Scale* [111] was going to be a painting, and I don't know what happened. It never panned out. But I think it works just as a fragment. I was fascinated by the balance of that scale. I tried to show how delicately he handled an egg on that amazing scale. I wanted to show him with that knife which he carefully used to clean the eggs off. The knife was curved on the blade because he had done it so much. He would scrape them perfectly and put them into the right bin.

"I'd be in there every day for about half an hour for weeks. He said to me later, 'Why didn't you ever go on with that picture?' So he really, in a way, wanted me to do it. In fact, I don't know why I gave up the painting. I think I felt that it was sort of topical, you know? I couldn't lift it out of a genre – weighing the eggs. But I feel that the fragment has the whole story."

112

FOUR PAINTINGS OF CHRISTINA OLSON

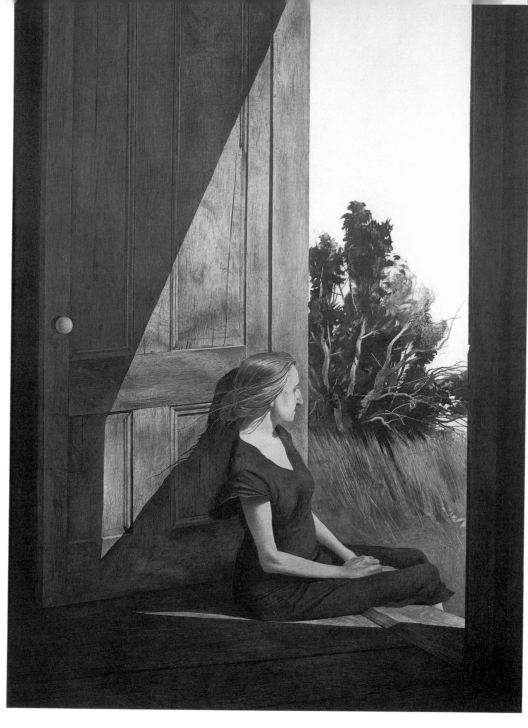

*113. Christina Olson, 1947
(see Nos. 117-119)*

*114. Christina's World, 1948
(see Nos. 106, 120-126)*

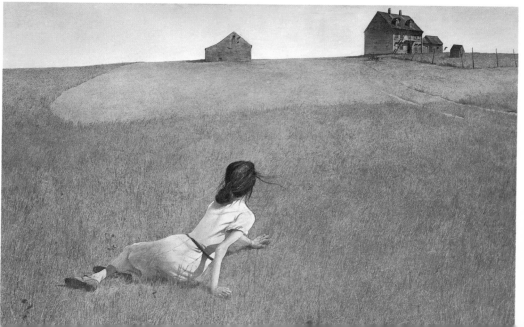

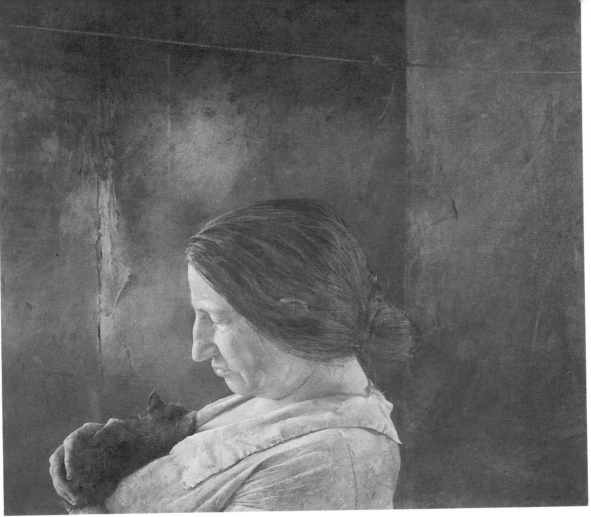

115. Miss Olson, 1952
(see Nos. 127-129)

116. Anna Christina, 1967
(see Nos. 133-138)

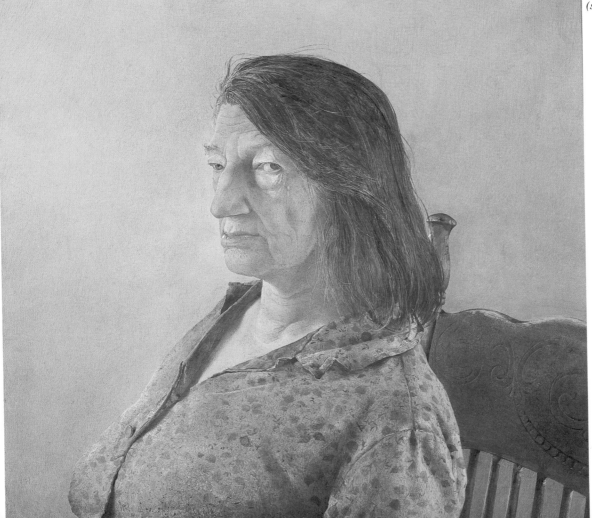

117. *Christina Olson, 1947. Tempera, 33 x 25 in. Private Collection*

117

"The portrait entitled *Christina Olson* [117], done in 1947, is really the first major portrait of the Olsons' environment despite *Oil Lamp.* Tell me, if you will, about the fine portraits of Christina and what she meant to you."

"Christina Olson, to me, is a really haunting picture. As I said, I met Christina through Betsy, who had known her ever since she was a little girl. Owing to Christina's real fondness for Betsy, she accepted me much more readily than I suppose she ordinarily would have. She and Alvaro, too, finally gave me complete liberty to wander over the house as I wanted. I finally used the upstairs room almost as a permanent studio. *Christina Olson* came about like this: one day I came in and saw her on the back door step in the late afternoon. She had finished all her work in the kitchen, and there she was sitting quietly, with a far-off look to the sea. At the time, I thought she looked like a wounded seagull with her bony arms, slightly long hair back over her shoulder, and strange shadows of her cast on the side of the weathered door, which had this white porcelain knob on it. And that was the beginning of the painting. She didn't mind being disturbed at all, actually she enjoyed it.

"We had a great communion. We could go for hours without saying anything; and then sometimes we would do a great deal of talking. That's New England. Sometimes I would even wash her face. She would cook over a wood stove and sometimes she would get dirt all over her face and I'd say I'd better wash your face and she'd say all right. Sometimes I would comb her hair. Touching that head was a terrific experience for me and in a sense, I really was in awe of it. Christina had remarkable eyes, penetrating eyes. I became really fond of her as a friend. She had read a great deal. Her letters to me in the wintertime were fabulous, telling me of moose and foxes that she would see crossing the open fields on moonlight nights. She would write in this strange, ancient, Gothic script, almost a German-like scribble, in a strangely abstract manner across the paper."

"Was the relationship you had with her different than that you had with the Kuerners?"

"Well, of course, everything is different. Every personality, just as every landscape, has its own atmosphere.

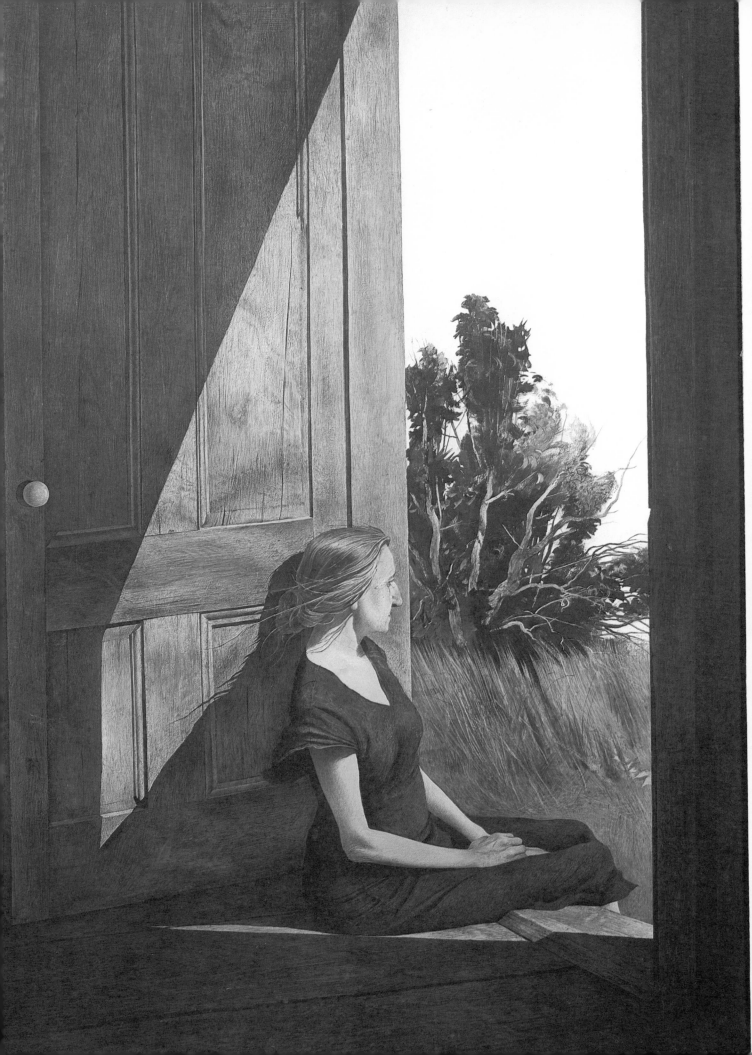

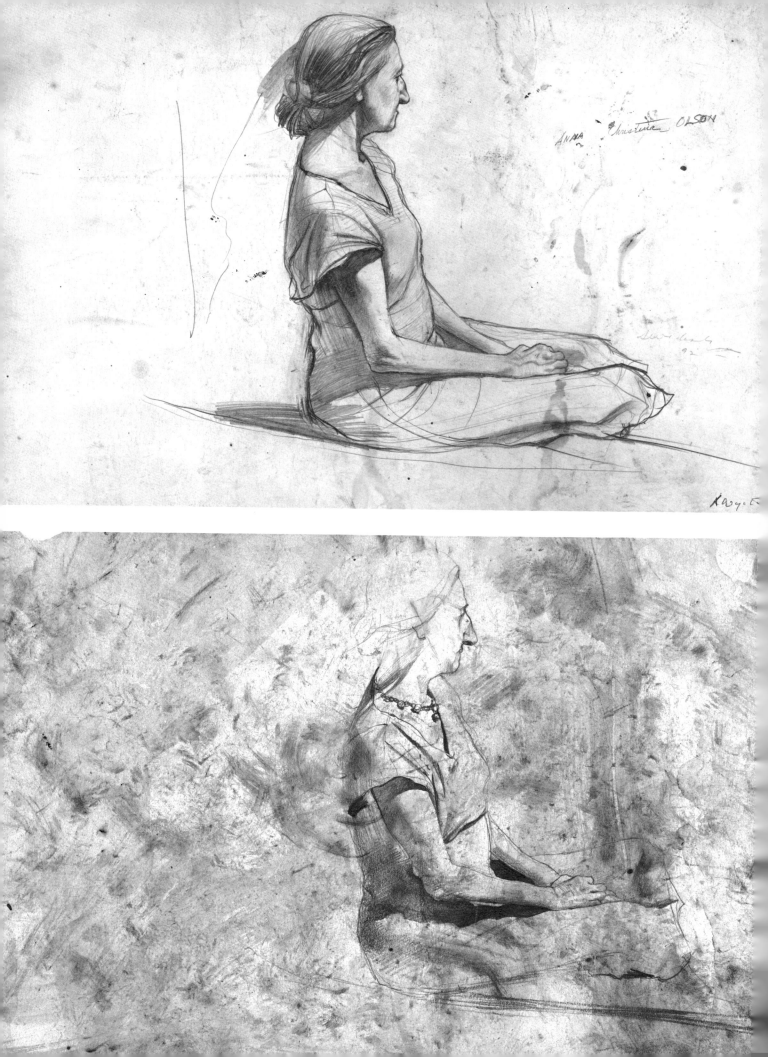

18

119

I often look back on a summer's work or winter's work and think of the different moods of my studio or of the location where I am working. The atmosphere of that winter or that summer is always so different. You know you can't continue. You think you are doing it in the same place and it is going to be the same, but it isn't. Your attitude changes. You can't stand still. That's the thing that fascinates me so. But it is very sad in some ways too. I would like to retain something, but the only way you can do that is in what you're trying to paint.

"In the various portraits of Christina there were remarkable changes. In some cases you might never know it was the same person. But behind everything, there was always that strange relationship we had, one of perfect naturalness, excellent communication without too many words. Every once in a while we would talk about her life, the two weeks she spent in Boston years before to be checked on by doctors, which was the only time she'd been to Boston in her life. She remembered every day and hour of the trip and visit. She told me right on down to details of how she took the train, who was on the train, to whom she talked, absolute descriptions so indelibly carved in her memory. She would tell of a few times when she went up to launchings of large schooners in Thomaston, which was once a great shipbuilding town, and she would get in the sloop that her father owned, sail up the Georges River, beach her, and then watch the launchings. They were festive occasions with banners flying. She would tell precisely what they had for lunch those years and years ago, the sandwiches, coffee, and cakes.

"She was a very intelligent person. Whenever I had an exhibition at the Farnsworth, which is the local museum in Rockland, I would take her up to see it, and I showed her what I had there – the watercolors, the temperas – and asked her what she liked the best: tempera always, and I asked her which tempera she liked the best, and, of course, *Christina's World* was her favorite. Of the portraits of her, there are *Christina Olson* [113, 117], *Christina's World* [106, 114, 122], *Miss Olson* [115, 129], *and Anna Christina* [116, 134].

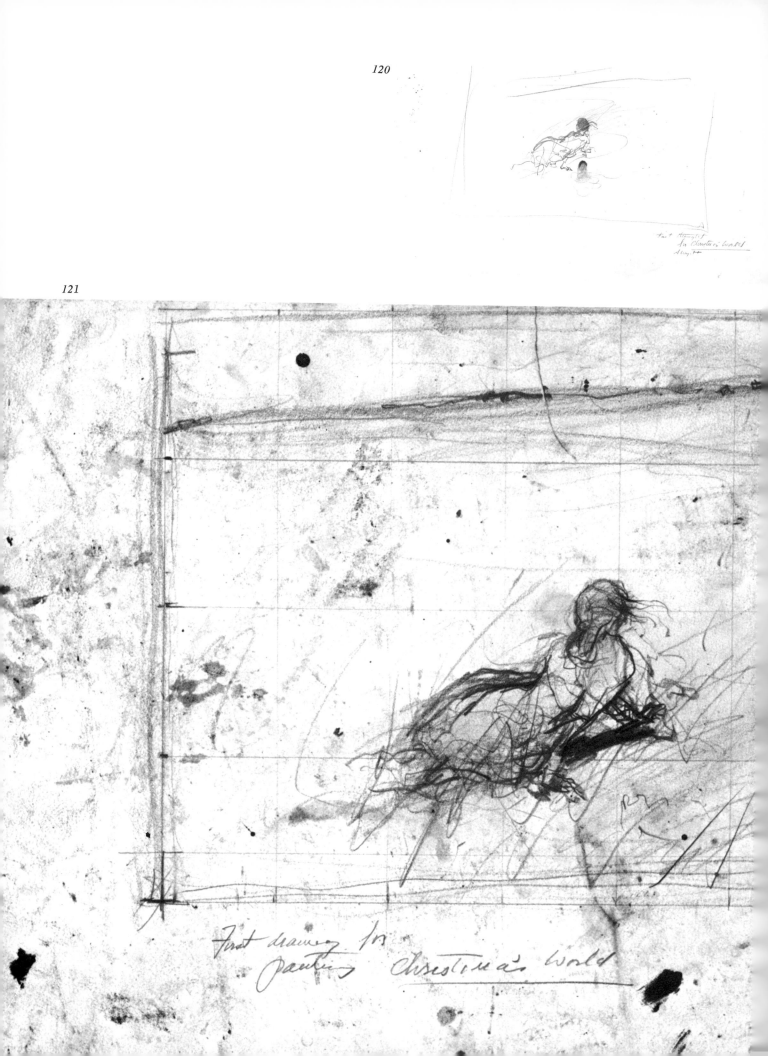

First thought
for Christina's World
Study

121

First drawing for
painting Christina's World

"Christina's World is more than just her portrait. It really was her whole life and that is what she liked in it. She loved the feeling of being out in the field, where she couldn't go finally at the end of her life. I saw her in the field, not exactly in that location, but a lot of it came out of what she told me. She was out getting some vegetables and she was pulling herself slowly back toward the house. It was late afternoon, and I happened to look out of the third-floor window, where I was finishing the picture called *Seed Corn* [164], and there she was. I just got to thinking about it that day while I took my dory back to my farm. We had a gathering in the afternoon at Betsy's house. We had a few drinks and then I left the party, went out into the barn, picked up a piece of paper, and made that first notation in pencil [120]. The next day I did the second drawing which is squared off for transfer to a panel [121]. Then I drew it a little in my mind and imagination. I got a panel 48 x 32, squared it off, because I like the position I had gotten in that first drawing. I squared it off and lined it up. There it was before me and I knew it was right. The next day I put the panel in the back of the Jeep, drove it to Olsons, took it upstairs onto the easel, sat there, and looked at it. It wasn't until the following week that I could really begin anything. I wanted to think about it, and at the same time I needed to get something tangible down, so I'd know that was what I wanted. You have to get something down, so you can relax a little and think. But you simply have got to get something tangible. You know, it isn't tiring to actually work on a painting, but it is terribly tiring when you have nothing on the panel but just one stroke and you are filling in between the lines of what's not there. Those are the times that are the most exhausting to me. That's when I lose weight like mad, because I am seeing something that doesn't yet exist. Once I get going and get rolling, I can work for long hours with no fatigue.

"I worked on that picture from eight o'clock until
five-thirty every day for weeks. I had that room upstairs,
and I'd move the tempera panel around to different
rooms to look at it while I was working. I was worried
that she knew what I was doing. I know I was getting
pretty close to putting Christina in the position I wanted,
the arms and everything, you know, where it showed the
tragedy as well as the joyfulness of her life. There were
two sides to her. But then one day, suddenly, I noticed
that my chair had been moved and I could see by the
dust on the floor that something had dragged itself along
across the steps. The floor was polished slightly. She
knew what I was doing, all right, and never said
anything."

122

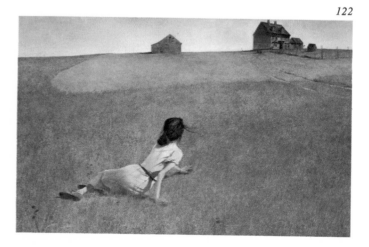

22. Christina's World, 1948. Tempera, 32¼ x 47¾ in. The Museum of Modern Art, New York, Purchase, 1949
23-126. Studies for Christina's World

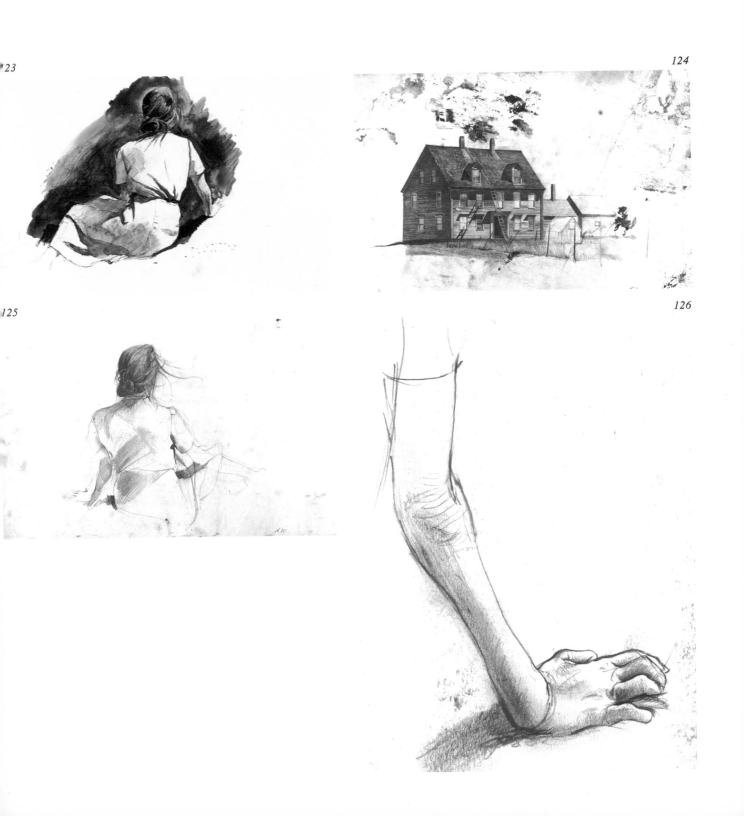

23

124

125

126

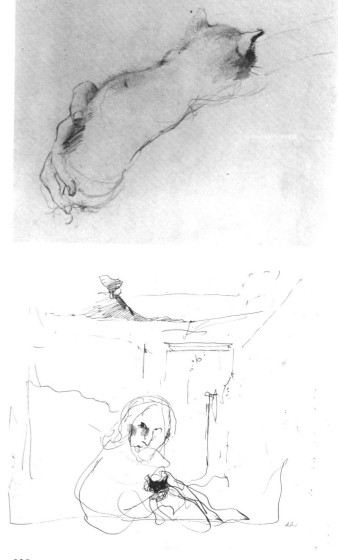

128

"In the portrait of her that I call *Miss Olson* [129], I used to see her with that kitten and I decided to do her with it. I decided in this painting to try to get right into her. I am a very strange portrait painter. Most portrait painters stay three or four feet away from the model. I don't, I may be six inches and sometimes even closer than that to the model. I like the communication. You can see the pores and the act of breathing and you can almost feel the moist hot breath. I decided to use the kitten because a very fortunate thing happened, at least for me. The kitten had been ill for about three or four days because it had eaten too many mice that its mother had brought it. And Christina held it and I was able to paint that. The hair on that little kitten was sort of matted. It was a strange, scrawny kitten.

"In my portraits of Christina, I go from *Christina Olson,* which is a formal one, a classic pose in the doorway, all the way through *Christina's World,* which is a magical environment, that is, it's a portrait but with a much broader symbolism, to the complete closeness of focusing in *Miss Olson. Miss Olson* was a shock to some people who had the illusion that the person in *Christina's World* was a young, beautiful girl. And that is one reason why I did it, in order to break the image. But I didn't want to ruin the illusion really, because it's not a question of that. One has to have both sides: one, the highly poetic; the other, the close scrutiny.

"It's very interesting that *Christina's World* has such a wide appeal. People seem to put themselves into it. I get literally hundreds of letters a year from people saying that it's a portrait of themselves. And then they describe their own life. And they rarely mention the crippled quality. They don't see that. It doesn't seem to enter into it. In a very real way, Christina was not crippled at all. I remember once I ran into a very prominent lawyer in Rockland and he said that he had seen Christina that day and he said, 'What a monument of a tragic figure she is!' That evening I went down and saw Christina and she said, 'Andy, I saw a friend of yours who comes from here but has to spend his time in New York City. What a tragic man he is.' Who's in the cage?"

29

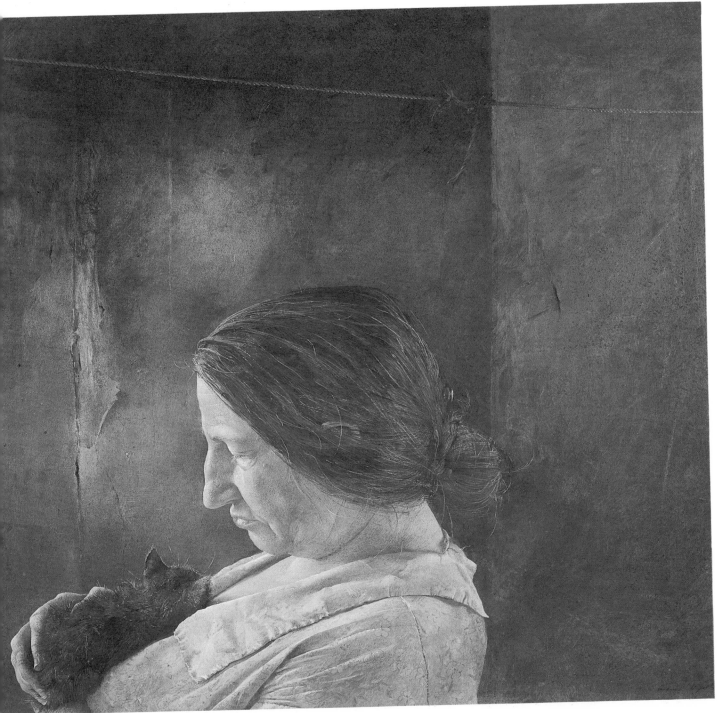

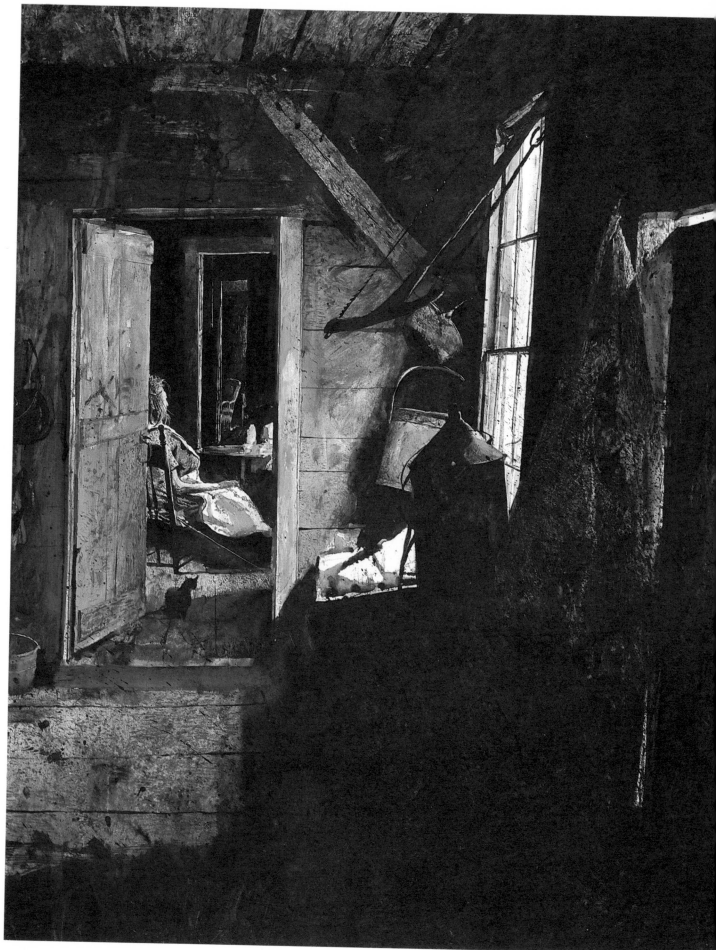

130. Room after Room, 1967. Watercolor, 28⅞ x 22⅞ in.
Patricia Anne Leonard
131-132. Studies for Room after Room (see No. 130)

"Let's discuss some of the portraits of Christina. What about the drybrush and watercolor called *The Apron,* and *Anna Christina?* How does *Room after Room* fit in here?"

"*Room after Room* [130] predates *Anna Christina* [134], but it was done the same summer. I first got the idea of her in the kitchen looking through the full length of the house. If you'll notice in *Room after Room* it's the succession of rooms that makes the impact. You are looking way down the hall, but past her, through the door, into the living room. The light pull and the whole thing is there. I was sitting in the woodshed, and looked up and here she was sitting there. I wanted to get the whole depth of the house, the length of it, the different compartments of it. And so I did this watercolor, *Room after Room,* which is rather freely painted. There are also a couple of black and white drawings for it."

131 132

133. *The Apron. Drybrush, pencil, and watercolor study for Anna Christina (see No. 134)*
134. *Anna Christina, 1967. Tempera, 21½ x 23½ in. Amanda K. Berls and Museum of Fine Arts, Boston*

133

"I thought at the time that I might do a tempera of *Room after Room*. That's why I did this close study called *The Apron* [133]. I started to work on that and I was quite excited about it. Then I realized, I sensed, I don't know, I had a premonition that things were coming to an end, and I thought, God, I'd better zoom right in on her and do just her remarkable head. And so I started this tempera of her sitting there. It's called *Anna Christina* [134]. I started it at a time when we had dense fog for about a month and a half in July to August. I painted her in the kitchen but with the door open so that her head was really against the white fog. In the painting you will notice that the fog creeps into all the tonalities of her skin. That was fascinating to me, because it brought out the intensity of her eyes, the slight pinks around the eyelids, her mouth. The whole thing is really a portrait of the weather at that time. I could hear the Whitehead foghorn off in the distance, moaning, and I could sense the stillness of the day. She would pose only in the afternoon. I would get there in the morning, and I worked on the background alone for practically two or three weeks. If you'll look at the picture closely, you will notice that it is built up very carefully. There's a slight transition of tones, it's white but it's got a subdued, warm cast by which I wanted to make you feel the fog. This was done before I painted her head in. So I would work there all morning, for three to four hours, and then about twelve-thirty, one o'clock, I would be out in the shed and I'd hear a voice, 'I'm all ready,' and I would come in, move my easel in there, and I'd work on the head. So fog is really the whole reason for this picture. Other pictures of her are in very definite lights. I mean *Christina Olson* [117], in the doorway, is definitely afternoon light."

"Yes, that's light and shade and very dramatic."

"Right, but in this painting, *Anna Christina,* you notice there's no definite light or atmospheric emphasis at all. There's a transparency about her skin that is the real reason for this picture. And I was intrigued as far as color is concerned with the flour and the green sour apples that she made her pies out of. That's an interesting green in contrast with the tone of her skin. There's a tonality

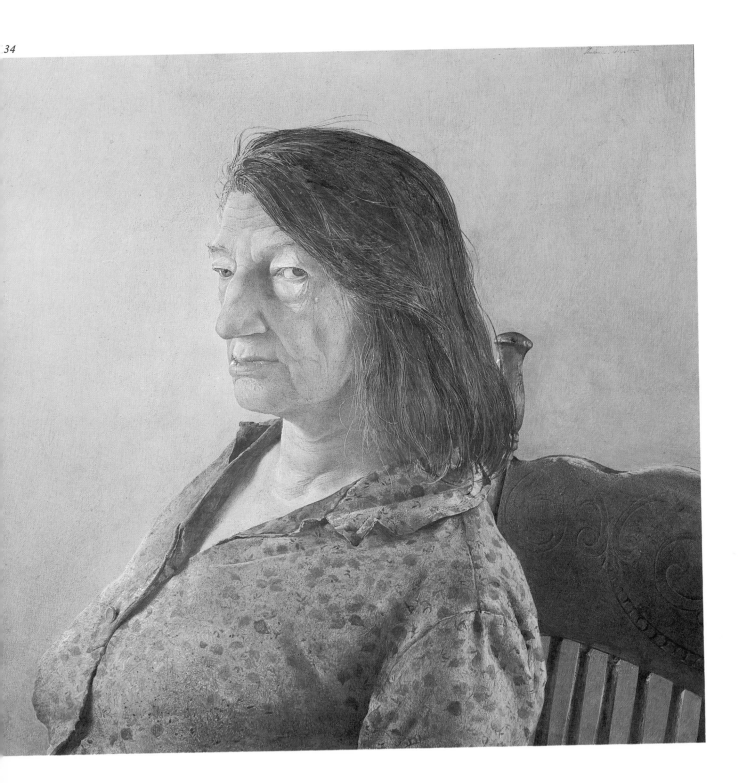

135

137

136

in this that brings out the quality of her eyeball and the way she would look around at me. She had the quality of a Medici head, you know. There was a terrific power in her strong neck, interesting thing."

"In some of the drawings for *Christina Olson* and definitely in *The Apron* and *Anna Christina,* you have that head turned slightly, so the eye has to wander up the side of its socket."

"It fascinated me. Every now and then she would look up at the clock which was up above and she had the strangest expression. Amazing, just amazing."

"In some of the drawings that precede *Anna Christina,* she's always looking slightly aside so then you go to almost a total profile, then you get rid of all of the architectural elements. Because you're going toward this wonderful fog. In one of the studies you have the window or the door in the background, and the chair is really an important part of the composition."

"There's another drawing that shows a string on the chair; I never realized why she put it there. I guess it was to hold the chair together, because it would spring out without the string. It was a tough chair, but used. This is the chair she pushed along with her hips and consequently wore out the legs."

"Then out comes the intriguing string."

"Well, I guess I didn't think it was necessary to the final picture. Christina's was a powerful face with a great deal of fortitude. It's not a glowering or dour face. There she was, without any affectation. I didn't need to put anything into it. I mean the face is good in itself. I've often wondered whether I even needed the chair, but there's something about these spindles in it that did do something. As you know, the head is life size and I wanted that mass, that bulk of the neck."

"Did she die after this?"

"She died that winter."

138

15

"In a sense, *Wood Stove* [143] is a portrait but obviously not a direct portrait because her face isn't shown."

"I wanted to make a record of the kitchen and of the two sides of the house. This is facing the sea and here she is facing the land. I wanted a record of the wood stove and all the things that I knew so well, her geraniums and so on. It was a document of the interior of the house. I was interested in the plate metal of the stove that gives off a hollow sound and feeling. This again goes back to my interest in metals and sounds, and the luster of metals, how they shine and don't shine. It's like all sorts of armor. In addition, it was at that time that the house was deteriorating very quickly. Windowpanes were dropping out and there were terrific drafts in it.

"I went up there the day of her funeral. It was snowing. I happened to look into this kitchen. It had snowed hard during the night, and the snow had sifted in the cracks and chinks of the door so that there was a thin line of snow right across the floor right up over her chair and down. It was icy white, almost like a finger pointing. Damnedest thing. God, the way the snow had sifted, very much how grain will sift through the finest sliver or opening. It was like lightning coming across the chair. I was wandering around and I looked into this dark room from the window and at the same time I could hear them using a jackhammer to dig the grave down there because the ground was so frozen, and I was shocked by that line of snow."

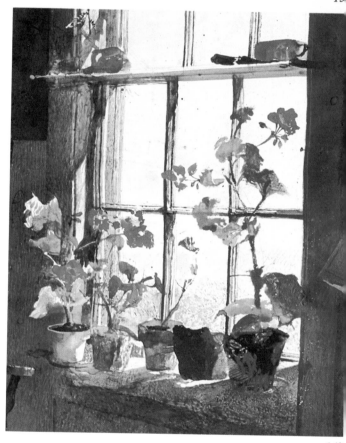

142

142

140

141

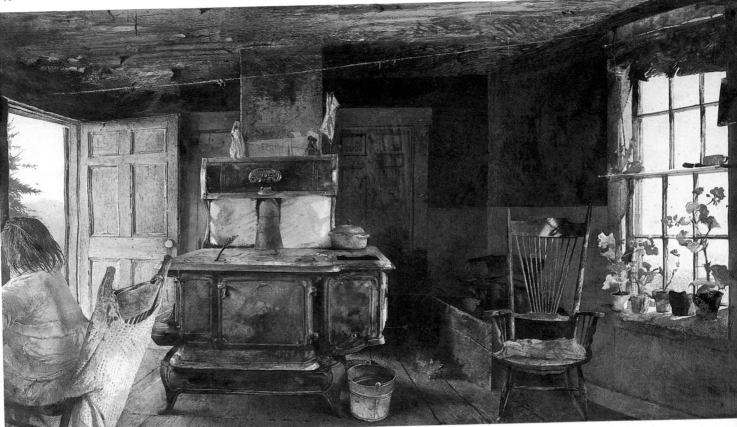

143

144. *Wind from the Sea, 1947. Tempera, 19 x 28 in. Private
Collection*
145-147. *Studies for Wind from the Sea (see No. 144)*

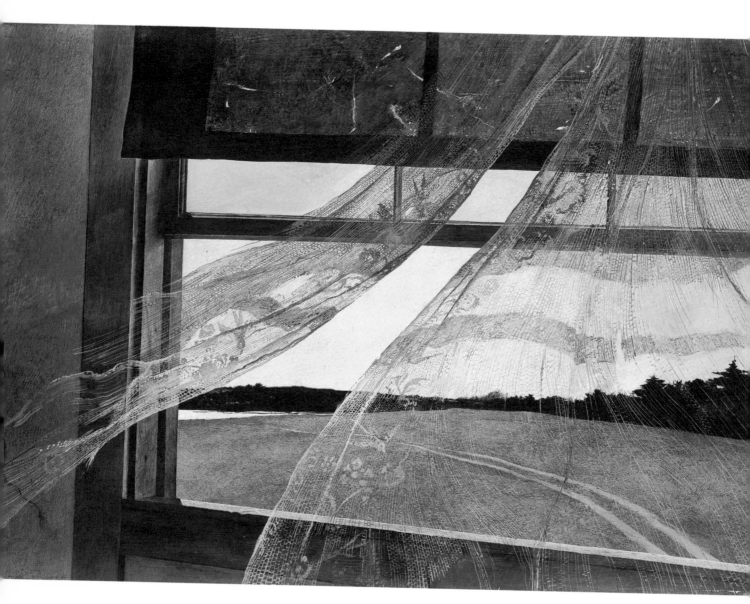

"One of the most poetic images of Olsons to me is your tempera called *Wind from the Sea* [144]."

"Of all my work at Olsons this seems to me to be the one that expresses a great deal without too much in it. I walked up into the dry, attic room one day. It was a hot summer day in August, so hot that I went over to that window, pushed it up about six inches and as I stood there, looking out, all of a sudden this curtain that had been lying there stale for years, God knows how long, began slowly to rise, and the birds crocheted on it began to move. My hair about stood on end. So I drew it very quickly and incisively and I didn't get a west wind for a month and a half after that either. I did many drawings for it because I was so moved by that sudden thing."

148-149. Studies for The Revenant (see No. 150)
150. The Revenant, 1949. Tempera, 30 x 20 in. The New Britain
Museum of American Art, Harriet Russell Stanley Fund

''You never, or almost never, put yourself physically into any of the Kuerners or Olsons experiences do you? The shadow in *Brown Swiss,* which is of you sitting on the hillside, can't be called a proper portrait. But in one instance at Olsons, in a picture called *The Revenant* [150] you are there in a self-portrait. How did that come about?''

"I'd been out sailing all day and went into the cove late in the afternoon, anchored below, and walked up to the house. I walked in, went upstairs, and suddenly I was startled. There was another figure standing there. It was me in a dusty mirror. It was one of those days that you call a smoky sou'wester, the sun was hidden but the sun was burning through the haze. I was in a faded blue jacket and pants. I walked in and suddenly this illusion was there. It's a very odd picture. It's more impression-istic than most of my other work because I was after

that strange, close color value, in which the color quality has gone out of the pale blue of the jacket. My face is rather dark because I was sunburned. I didn't do it as a real self-portrait. The reason I did it was that I wanted a portrait of the dryness of the place, that special sort of dryness of dead flies that are left in a room that's been closed for years. That's really what got me, and the quality of the tattered curtain. It has the dryness of an Egyptian mummy, you know? That's what I wanted to epitomize in the picture.

"The whole Olson house has that feeling; it's like a tinderbox, that crackling-dry, ancient, bones type of thing. My friend Ralph Cline (I painted him in *The Patriot*) has a sawmill and I asked him to take down cordwood to the Olson house toward the end of their lives, to supply them with wood and to bill me for it. I remember in the spring I went over to see him and thank him for doing it. They really burned wood in that place during the winter. He had to take down six or seven cords of wood during the winter. 'Well,' he said, 'It's like heating a lobster trap.'

"But the Olsons and Christina really were, to me, symbols of New England and Maine and ancient Maine, witchcraft, all sorts of things like that. That's what really got me into the Olsons environment. I just couldn't stay away from there. I did other pictures while I knew them, but I'd always seem to have to gravitate back to the house. Very strange. And when I'd be offshore, I'd think of that house even though I couldn't see it. I'd think of that house sitting there and Christina down in that kitchen, hearing in my mind the sound of the lids of the stove rattling. I'd hear the scraping of her chair being pushed along. She'd rock it in such a way as to wear the legs right down. She had a terrific muscular development through her arms and shoulders. Her hips were very powerful. It was *Maine*."

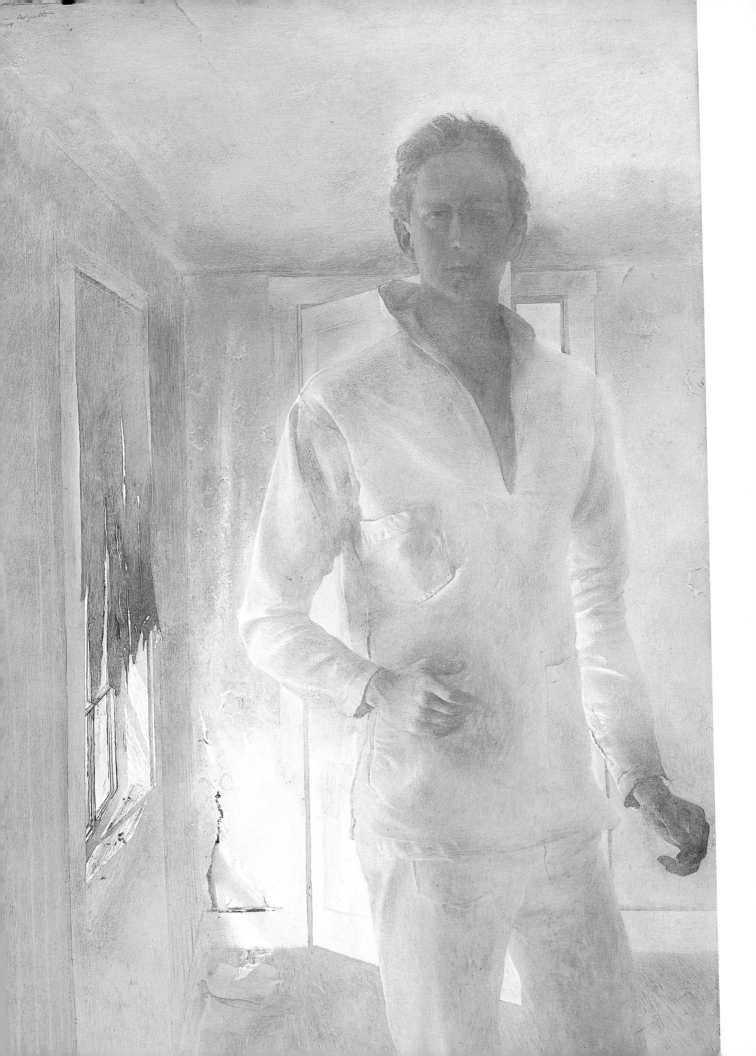

"Another general portrait of the Olsons' whole environment is entitled *Alvaro and Christina* [153]. That was done the summer after their death. I went in there and suddenly that door seemed to me to express those two people, the basket and the beautiful blue door with the strange scratches on it that the dog had made – all gone."

15.

152

151-152. Pencil studies for Alvaro and Christina (see No. 153)
153. Alvaro and Christina, 1968. Watercolor, 22 x 28 in. The
William A. Farnsworth Library and Art Museum, Rockland, Maine

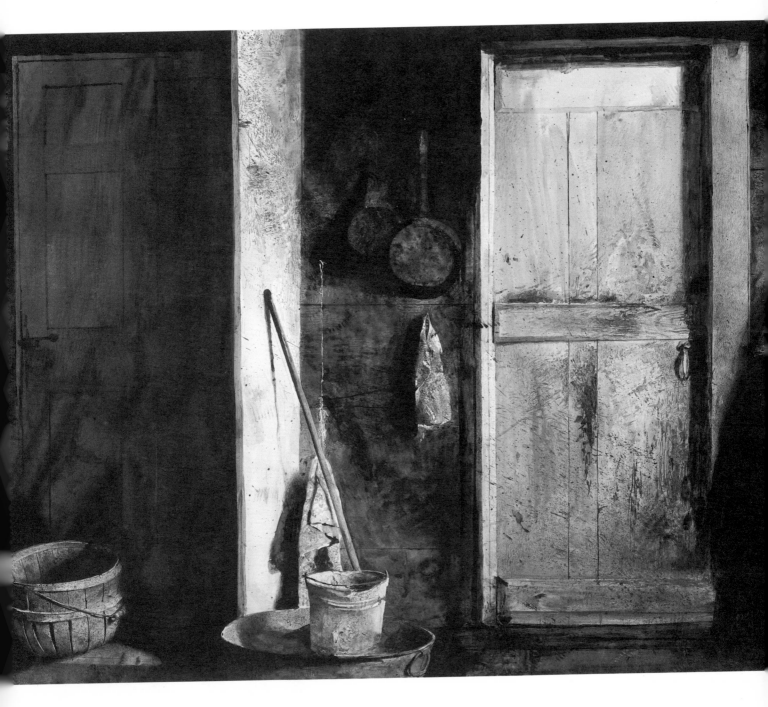

154. Pencil study for Weather Side (see No. 156)
155. Breakfast at Olsons, 1967. Watercolor, 23⅝ x 16 in.
Private Collection
156. Weather Side, 1965. Tempera, 48 x 27¾ in. Mr. and
Mrs. Joseph E. Levine

"At Olsons, as at Kuerners, you focus in on the house itself as a grand portrait of everything, the people, the land, the spirit, and, of course, the house itself. But in the two major portraits of the Olson house, other than *Christina's World,* there is an utterly different feeling than anything done at Kuerners in *Brown Swiss* and *Evening at Kuerners* and *Wolf Moon,* where you took considerable liberties with the house itself, removing windows, changing the architecture a bit. In the two portraits of Olson I'm speaking of, *Weather Side* [156], done in 1965, and *End of Olsons* [165], done in 1969, there are a remarkable number of very precise studies. They are almost construction drawings."

"You're right. There are more studies for the portraits of the house than practically for anything else. I was intrigued with the structure of that building. That building was a monumental thing to me. But I had a feeling that the house was made of thin boards, not real timbers, I felt it was something like jackstraws, the game 'pick-up sticks.' I had a feeling that someday the house will look like that game. In my drawings, I literally put the building together as if I were the builder. For *Weather Side,* I actually counted and studied each of those clapboards. Up on the right-hand side of the painting, near the top windows, near where the cloth is stuffed into the window, there's a couple of white pieces of wood. Those are out of my own house. Alvaro wanted me to repair it and I did. I wanted *Weather Side* to be a true portrait of the house – not a picturesque portrait, but a portrait that I would be satisfied to carry around in my wallet to look at, because I knew the house couldn't last. I did it purely for myself. I had this very deep feeling that it would not be long before this fragile, crackling-dry, bony house disappeared. I'm very conscious of the ephemeral nature of the world. There are cycles. Things pass. They just do not hold still. I think probably my father's death did that to me.

"In *End of Olsons* [165], I started off in studies by looking through the window at the end of the house, over the kitchen roof. Then the window disappears and I came right in on the chimney. The chimney to me was the ear of the house. *End of Olsons* was done after Christina and Alvaro were dead. That was the last picture I did of the place. That's why I called it the *End of*

154

156

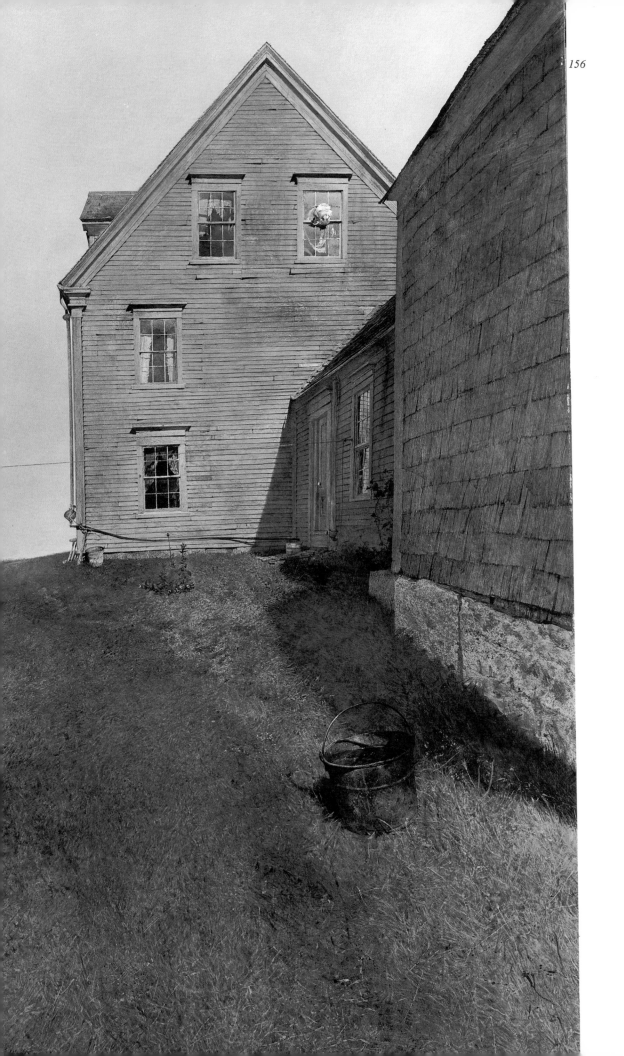

157

159

Olsons, because it has a double meaning. When they were alive, and I was up there working on other pictures like Seed Corn [164], with the window open, I could hear their voices carrying right up that chimney and I could listen to their conversations. And the way the chimney bulged on the top due to the masonry giving way seemed to me to be like an ear listening. Of course, it wasn't listening to me, I was listening to it, but just the same, it had that feeling for me. That's the real meaning of the picture. To me, a picture will really contain those remembrances, those voices, those faces, those conversations. And in the two portraits of the Olson house, I never left a window out as I would subconsciously at Kuerners. And, as you observe, the drawings of the Olsons' house are much more precise than the Kuerners' farm, right down to the individual pieces of its manufacture, its nails, and pieces of wood."

"I am fascinated by the profusion of studies of the various windows, which seem to loom very large in importance for you."

"In the portraits of that house, the windows are eyes or pieces of the soul almost. To me, each window is a different part of Christina's life. You will notice in Weather Side that there's an upstairs window that has a pink feeling. That's her bedroom. I wanted each one of these windows to tell part of the whole story – they were not just stuck in there by chance. Each has its specific role in helping to explain the overall personality of the portrait of the house and its occupants. There's even a hanging lamp in one of the windows. Why the hanging lamp? That's her mind and eye, in a way. You will notice that there is a piece of glass that's dropped out of one of the windows, and I was fascinated by the clothes Alvaro stuffed in a broken pane so the cold wind wouldn't blow through, and I made many studies of it [157]. I even used binoculars to study the windows from afar, because I wanted to be truly intimate with them. I wanted to be in the whole thing, because I knew Christina was there in it. Christina and Alvaro were not physically there, but they must be there in the picture. That's why these are more than just windows for me.
"I wanted this intimate focus on windows, with the

darks and lights of the glass, and the light through the windows, and the door with no glass. They're extremely important elements in the Olsons experience. At Olsons, I'm very much captivated and carried away by my experience. At Kuerners, I'm carried away, but in a different way. I don't think if you're truly emotional, you can concoct, truthfully anyway, the same set of values for one place as you can for another. A lot of people seem to be able to carry the same thing into something else. But I think that shows an unemotional quality and lack of true involvement. I think an artist should be a sounding board for all these nervous vibrations and should not just carry a set of rules and tricks around with him, and use them on different objects.

"Weather Side is a major work to me in the Olsons experience. It is somewhat similar to Snow Flurries because I felt that the house was a universal thing. So I started looking at it deeply and penetratingly, doing pieces of it, the bucket on the lawn, the drainpipe, and the shapes of the windows. The thing that I realized after painting the house in a rather haphazard way for many years and after having done portraits of Christina, which sharpened my vision, was that the pitch of that roof took me years to get right. That's an odd thing for me to say. But the pitch of the roof, which to me has a Gothic quality, is very steep compared to most houses in Maine. You know there's a picture hanging over in my house in Maine of a house with a hound on a chain and people will see that and say, 'Well, that's Olsons, isn't it?' But the pitch of that roof is not nearly as steep as Olsons. See the pitch of that thing? It's hard to believe. Whoever built that – and it doesn't matter, of course, who did it – did it differently than most houses. I think that is what gives the Olson house its strange quality. If you'll notice some of the earlier drawings and paintings of that house, you can see that I'm wrong in that pitch. I had gotten it too flat. But as I began to see clearer through the multiple drawings, and began to understand Anna Christina and Alvaro, I really began to study that pitch of that roof as I would have studied the curve of Christina's nose. We study a face or an ear as the absolute truth. We are apt to look at a hill or a building and not do it with the truth that is there. We think we can get away with it."

"Well, maybe you don't recognize the truth – "

"No, we just don't see it."

"Don't you think that a building has its personality, which is just as strong as the person who built it and as strong as those who live in it for years?"

"Absolutely, it's like every ear. Every person's ear is different. Ears to me are important in portraits. But a lot of people make them all look alike. They're not. It's a matter of being sensitive."

"Some of your more meticulous written notes to yourself appear in the studies for *Weather Side,* and I suppose that this means that you were troubled with the progress of the drawings somehow and forced yourself to be very precise."

"That's right. Absolutely."

"What strikes me is that they really aren't architects' drawings; they are builders' drawings in a sense. There's a great difference, because this house did not have an architect."

"No, it didn't. You're right."

"It had a builder, and because of that somehow it has a much more organic quality than what an architect perhaps would have achieved."

"You're right about a builder. That's absolutely it."

"There's a marvelous waving quality of the sides of that house and the clapboards. I mean it's really like the soft swell of the sea in a curious sense."

"Yes, it is."

160

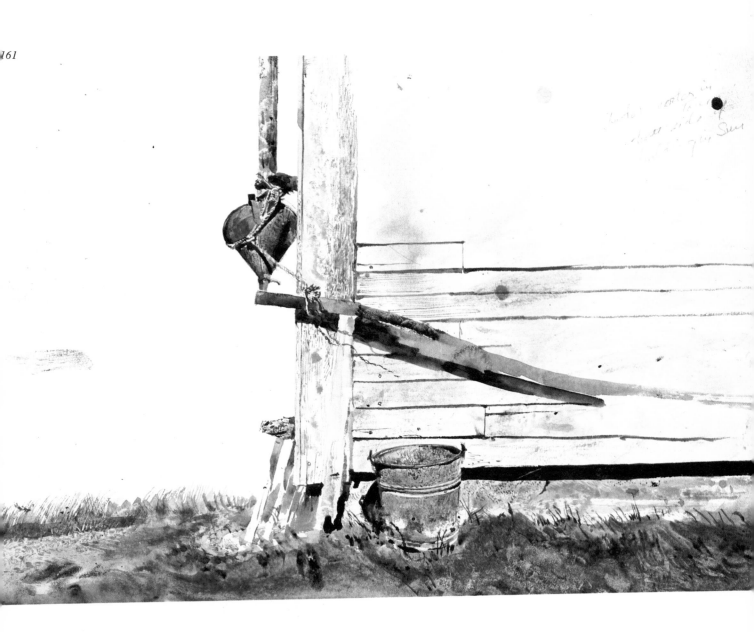

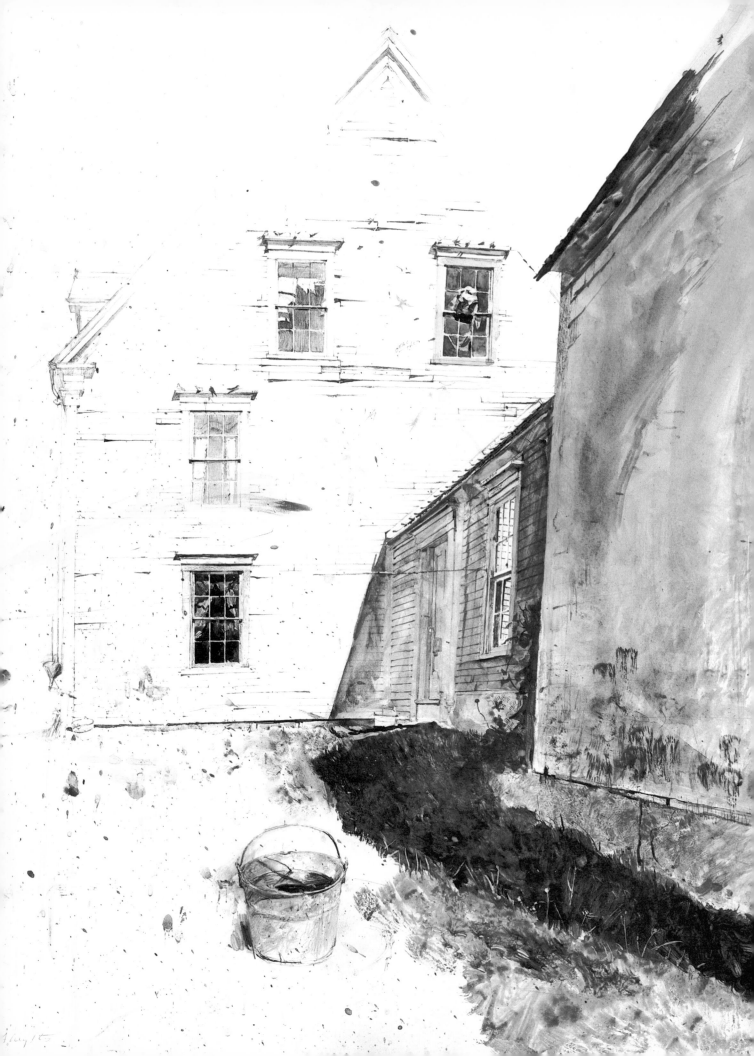

62. Barn Swallows. Pencil and watercolor study for Weather Side
(see No. 156)
63. Pencil study for Weather Side (see No. 156)

62

'The study with the bucket is very precise [158] and then in the water in the bucket you pick up a whole series of reflections. In addition, the very minute and specific written notes next to the bucket and the very precise handling of the shingles all seem to be extremely important.

"After a long look what I appreciate more about *Weather Side* are the varied textures, the dried-out grass, the bucket, the reflection in the bucket, the stone, the varied shingles, the clapboard with the boards beginning to split, and then that piece of fabric stuffed into that window. Your eye kind of climbs up and then goes right toward that window with the sharp accent of blue in the cloth stuffed in the window and then on up to the remarkable line of the roof. It is really an anagogical picture in the sense that it leads from where humanity is, on the soil, up and up and up."

"But you notice the gray. Although there's a lot of shifting colors in that gray it still stays gray, even in the shadows. It's like a person with a pale face. It's consistently pale, it's consistently gray. I didn't want to bring any feeling of impressionism into this painting, because I wanted that house to be able to stand out to a fisherman who might be miles away at sea. That gray house is *gray.* You know? In any light it's still gray. It's a symbol of gray to me. That's why I call it *Weather Side.*"

"The watercolor study of the drainpipe [161], the old funnel and the cord tying it up in a casual way that works, is very fine. You were obviously very much taken by it because it has all of the qualities of the finished painting."

"Yes, indeed, Alvaro contrived that thing with the funnel and everything for the drainpipe. Amazing. Just around the corner of the house, you can see the ladder that is leaning against the house in *Christina's World,* casting a shadow. It is there, ready to be put up on the roof if there's a fire in the chimney. You will notice this in a lot of New England houses. Of course, being frame, they have to be careful."

"The studies of this section with the pail are excellent. They really have many elements that you appreciate deeply."

"You see, this whole thing was an abstract excitement to me."

"I particularly like this clothesline that just goes off to nowhere instead of hanging down."

"To me, that line really brings the whole picture together. That little taut line coming across is a very, very important formal consideration. All this power on the right side of the painting, where the house is, is held by that line. I think that it's just subtle enough. Suddenly, you see it, but at the same time it doesn't dominate anything. It kind of creeps out of the clapboard because it's on a different angle and then it goes its own way."

"I can't really recall a portrait of a building like this."

"Well, that's what I wanted to do. I thought that I had not done justice to that house. I hadn't done a portrait of the house, which was just as important as Christina and Alvaro to me. It was as if I were painting, say, the president of the United States. It was just as important."

"*Barn Swallows* [162] is a study for *Weather Side,* isn't it?"

"Oh, yes, that was a study for it."

"Why did all the swallows disappear in the finished tempera?"

"Because it was earlier in the year. They happen only in a certain period and then they go. And I finally didn't want them anyway. The birds made the picture too momentary to suit me. I felt I wanted the picture to be utter simplicity. For a while in the tempera I even had the strange moving shadow of the smoke that appeared in the morning when they started the fire, but I eliminated it. Those are too momentary effects to suit me. I wanted this to be a very simple, direct picture, really boiled down. It has all the details you want in it, if you want to look at it that way, but I think you can get close to it or far away from it and it still holds its own just as a piece of simple pattern. That's a thing that I'm interested in. I don't believe a picture should be liked because of its detail. I want it to live at both ends. I want both

detail and simplicity at a distance. I remember once my father, when he was in his impressionistic period, to which he was very strongly inclined, would get bothered by people who wanted to stand too close, and he'd say, 'Get back, you can't see it that way.' Well, I used to feel that there was nothing wrong looking at it close. It should hold up. What's wrong with using your eyes? But it ought to be something at the same time that carries."

"What was it that Alvaro said when he saw *Weather Side?*"

"He looked at it and said, 'Well, Andy,' he said, 'You finally got the pitch of that roof right, didn't ya?' He had known all along that it wasn't right. But he wasn't going to say anything. It was sort of what happened to me years ago when I anchored in a harbor near Eastport. I went to bed, suddenly woke up because I was hanging out of my berth, for the boat was on its side in a mudflat. No one told me I was anchoring in a mudflat. Jesus, mud all over the damn thing, over the whole side of the boat. Somebody could have told me, but didn't. That's Maine. They let you make your own mistake."

"There is a more formal and more deliberate structuring of things in the Olson experience than Kuerners, isn't there? This, indeed, may be necessary because the architecture of the forms are established that way."

"Well, perhaps it's a Gothic quality in Olsons that makes this true. Even Christina's character was like that. The difference between Anna Kuerner and Anna Christina Olson is quite great. Anna Christina is a direct Maine type of Yankee, New England, whereas the other is foreign and, yes, small and quiet but underneath, of course, tremendously pugnacious. Quite a difference there. Difference, of course, is something that interests me very much. There's such a difference in a structure made out of wood and another of stone. If you're going to put a building in a landscape, there's a difference abstractly between the house and the grass, dirt, hedge, the curve of the hill. It's like the difference between the quality of Anna's skin and the quality of the dryness of the wood of the door behind her in *Christina Olson* [117]. You can almost just do the cheek against dry wood or

the watery eye compared to the dryness of the skin, and you've got the whole thing. All these things, to me, go beyond light effect. And that's what I was trying to do in *Anna Christina* [134], not rely on light effects but try something that goes beyond time of day, something that exists at nighttime as well as in daytime. That form is – well – existing. It's not made of a black shadow that makes it jump out. The light effects in my pictures come only from looking. I think you don't really grasp the realness of objects if you rely on tricks."

"You are suspicious of the way the light comes into a painting, aren't you? But at the same time you love it!"

"Sure, I love it, but I think you have got to be careful that it does not take over the whole picture. Yes, it catches the eye, but after you've been struck by effectiveness, there's nothing much else to look at. I think that's what you like about the building in *Weather Side:* it's a real building there."

"What I like about that is that it is overall and in detail too, and the house has been observed in such a way that it's been taken down in your mind and rebuilt clapboard by clapboard."

"That's absolutely right. And you notice the light effect is really quite unimportant to it. The light's coming to the right-hand side but it's not over-effective."

"I'm extremely impressed with *Seed Corn* [164], which has some superficial analogies to some Kuerner things, but is totally different, when you get down to it. It has this extraordinary bone cracking feeling."

"Bone-dry quality. Absolutely. I was looking out on the same view as *End of Olsons,* actually. It was one of those gray days when those strange dried-out corncobs seemed to come to life hanging there. It's a tiny picture."

"Another poetic image, a rather haunting image of Olsons that I believe has been misinterpreted as simply a sweet Maine picture with a boat, is the tempera *Hay Ledge* [170], which shows the Olson barn and a beautiful, pure white dory stored away up in the hay. What's the story behind this one?"

64. Seed Corn, 1948. Tempera, 15⅜ x 22 in. Private Collection

164

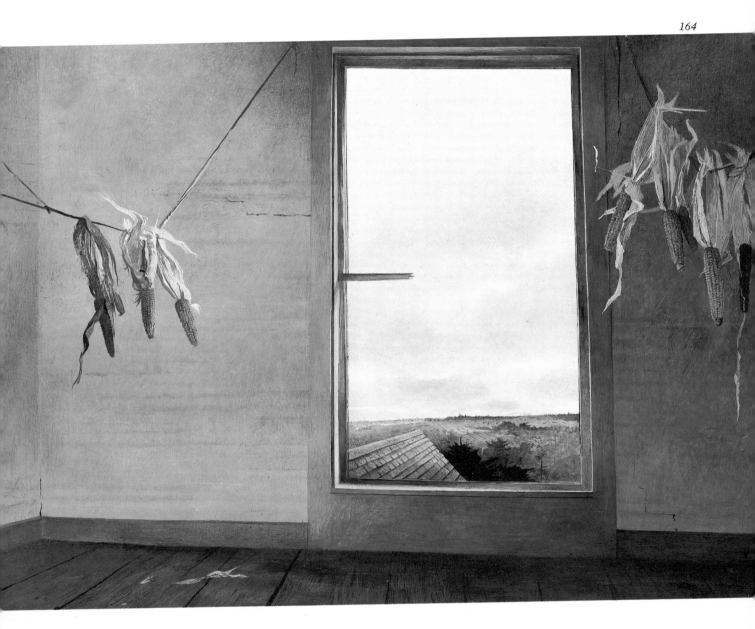

165. End of Olsons, 1969. Tempera, 18¼ x 19 in. Mr. and
Mrs. Joseph E. Levine
166-168. Pencil studies for End of Olsons (see No. 165)
169. Christina's Funeral, 1968. Pencil, 13½ x 16¾ in. Private
Collection

165

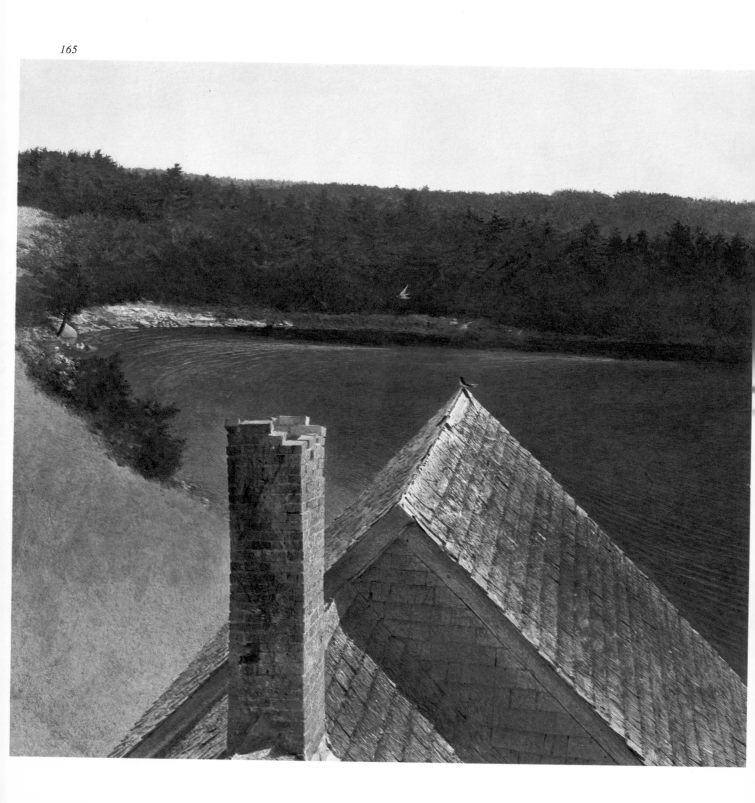

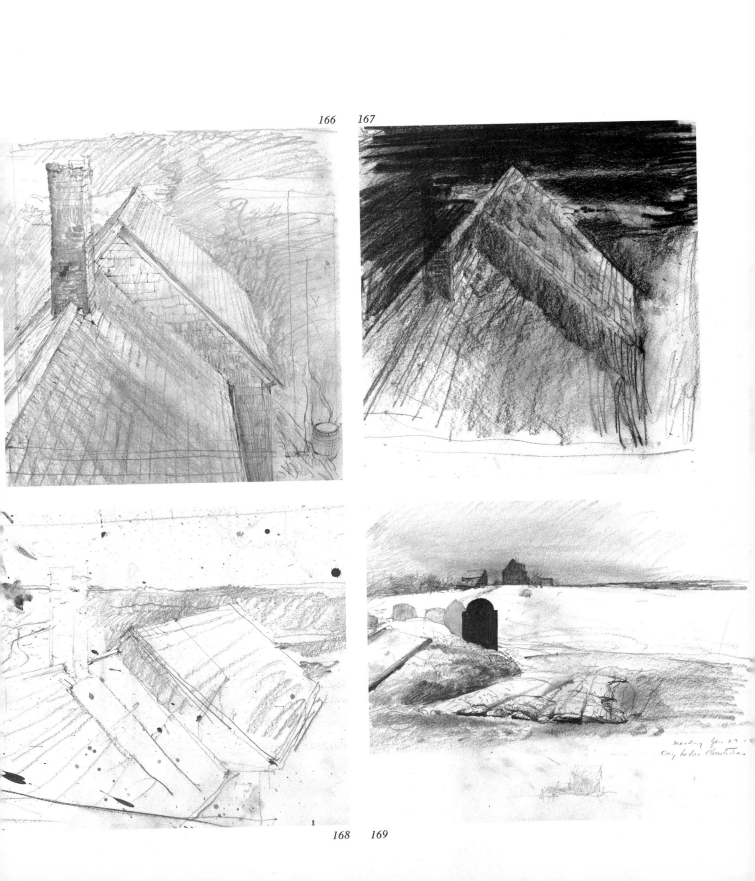

monday Jan 23
Day before Christmas

170. Hay Ledge, 1957. Tempera, 21 x 45 in. Mr. and Mrs. Joseph E. Levine

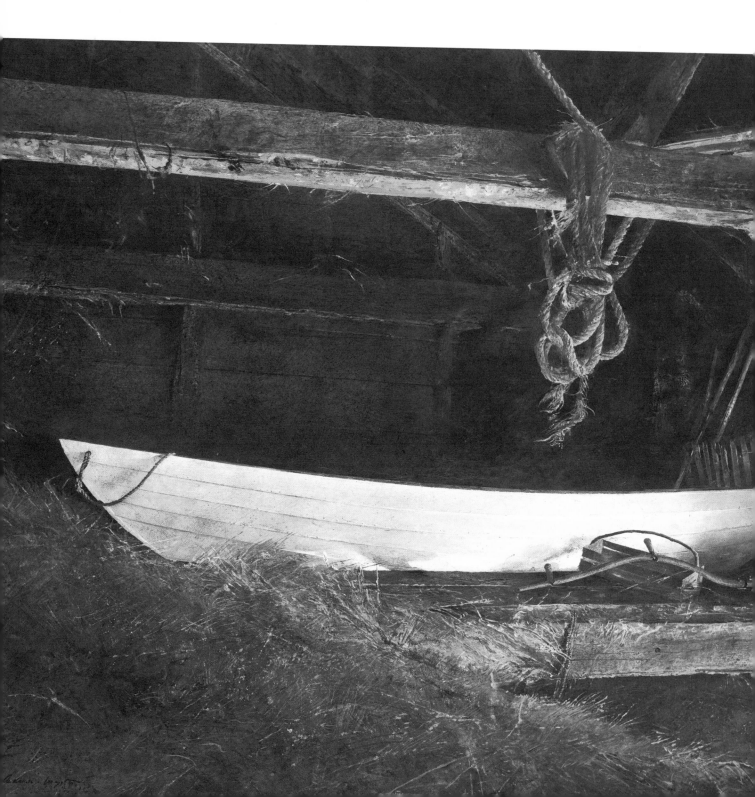

171

172

173

174

"What happened was this. Alvaro used to fish, and then
he realized that he would be off all day hauling his nets
with his sister there alone after the mother and father
died, and he would be the only one who could take care
of her. And so he stopped lobstering in his dory. He
stopped, just like that, one day. He put the dory up in
the loft and started to garden. That dory, that beautiful
white Penobscot dory, sat up in that loft, in the hay.
And I used to see it there, for years. Sometimes the sun
would come up and reflect up under it through the hay.
There were some boards with openings in them to hold
up the hay and the sun would come through and hit the
boat. It was almost like the phosphorescence that you
get in the sea water. That's what I was reminded of.
When I finished it, I called it *Hay Ledge* because there
is a ledge off the Georges River called Hay Ledge. But,
of course, that was a different type of hay ledge."

"Another painting that I find particularly effective is one
called *The Stanchions* [173]."

"That wasn't an easy picture to paint, owing to the
difficult tonalities. In it I wanted the whole feeling of the
worn stanchions where they kept their cow at one time.
The blueberry basket particularly fascinated me. It's
in the shed where I worked, looking out the small
window. The stillness of the place impressed me but it
was that blueberry basket that really got to me. I love
the way ash baskets are put together. It's more than
something made for farm usage. The object transcends
that. It's really a remarkable piece of construction. You
study a thing like that for a while and you'll see marvel-
ously subtle flat planes on the bulging side. It even
reminds me again of some sort of armor or a fine musical
instrument with infinitely differing surfaces."

175

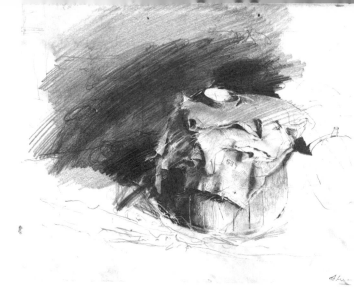

177

176. Grain Bag, 1961. Watercolor, 22½ x 15 in. Private Collection
177. Pencil study for Blue Measure
178. Blue Measure, 1959. Drybrush, 21⅜ x 14⅞ in. Private Collection
179 (overleaf). Blue Measure, 1959. Watercolor, 15¾ x 22⅝ in. Private Collection

176 177

"Studies of that basket appear in quite a few things you did at Olsons. Some have blueberries in them and some don't, but it appears again and again. It becomes a happy object, the way it comes in and out."

"It enabled me to obtain the reflections of the people who used it. In a sense, it's Alvaro. As I told you, he wouldn't pose for me, except in a very quick manner, other than for *Oil Lamp,* the early picture, so this basket became in a sense a portrait of him. Like *Egg Scale,* he's there because he's using it, he's near it, and it keeps coming in and out. Now in the painting of the side of the house, the watercolor done early in the morning with the smoke coming out of the chimney [155] you see him. He's gotten up early to get his breakfast, and he's started the fire. And I was out at about five-thirty one foggy wet morning and he came to the window and looked at me. You can see him in the watercolor, in silhouette, peering at me while I draw. That was another one of those momentary things and yet very expressive of him."

"The watercolors *Grain Bag* [176] and *Blue Measure* [179] I find very satisfactory."

"These are, in a sense, portraits of Alvaro, too. He was a strangely delicate man, a sensitive man. He looked like Emerson at times, even like Henry David Thoreau. Very New England. And it makes me sick to think that I never really painted him the way he was. Sometimes, he'd come in from the barn wearing this old hat with cowlicks shooting out of the hole in the top of it, making him look as if he were wearing a knight's helm with a feather coming out, and there he'd be covered with hay and straw and feed . . . interesting. Just part of the barn that he lived in. When the wind would blow, it would all blow off of him. It was just marvelous."

166

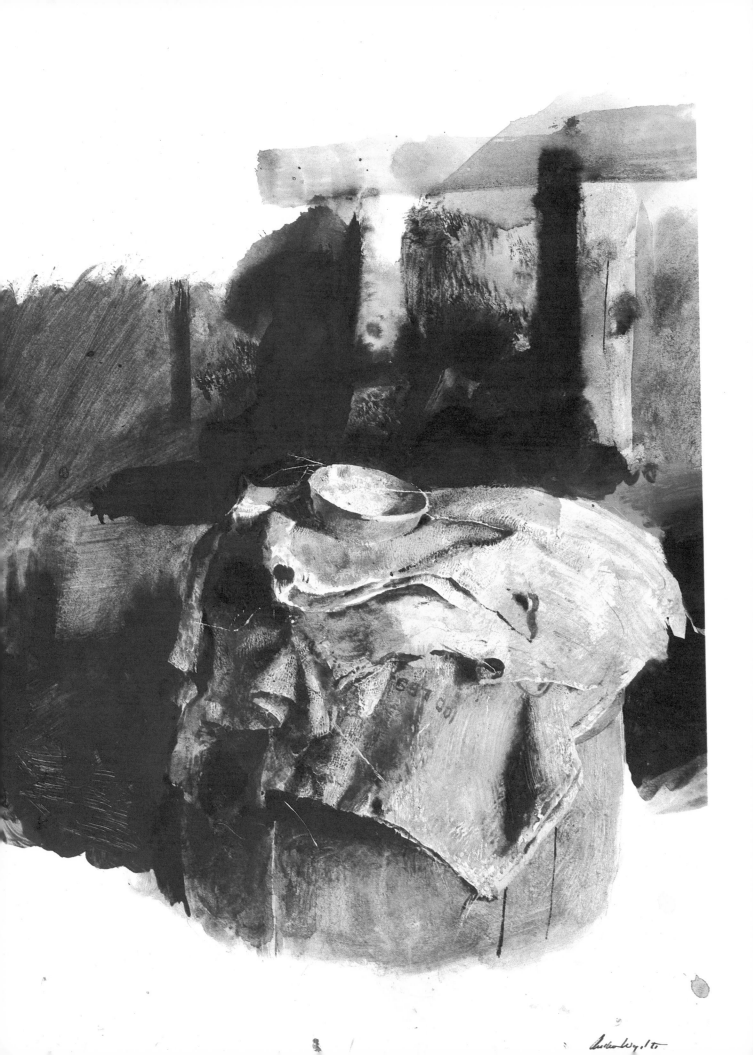

"Well, it's a shame that he had this somewhat forbidding attitude. Earlier, when we were discussing the aspects of the various media, you made the statement about how sometimes just a spontaneous flash of color when you absolutely don't expect it can illuminate something. Was this the genesis of *Geraniums* [180]?"

"That's right. I saw blue. I was after the subtlety of the blue distant sea on a smoky sou'wester that you can see looking down toward the mouth of the river, toward Teel's Island and Monhegan, with that spruce tree and those geraniums, which are just a pure red. In the picture, that's Christina near the kitchen with a totally different blue of her dress. There's also a white sheet over the table. You know, New England people put a sheet over the table where their sugar and butter and things are. And you can see a Mason jar there that fascinated me. I was also entranced by the solidity of the clapboards, too."

"I also like the way the black of the ceiling has been handled in the reflection in the window."

170

"I think painting reflections in a window is a terribly difficult thing to do because it can become terribly academic. It's got to be done with restraint."

"In reflections, and certainly in some studies of shadows, you do it with absolute precision. Then you seem to say, all right, that's done now, let's do something abstract, like the shadow in *Wolf Moon* on that tin roof. In the study for that, it's absolutely accurate at first, and suddenly you go wholly abstract."

"I do because I want the essence of the thing. In some studies for windows, particularly in the Olson series, I observe shadows with absolute intensity, then when I come to finish the picture, I make what to me will be a pleasing abstract, which also picks up the reality of the image. I'm trying to tell the story or mood in the simplest terms. I have looked at a lot of early Flemish painting of the period of Bruegel and Hieronymus Bosch. If you're not a real student of it you can look at a lot of them and say, well, they're all great. But the difference between the real master and the others in the handling of shadows is such a great difference!"

"How right you are. We have a painting at The Cloisters by Robert Campin, called the Mérode altarpiece [181]. You've no doubt seen reproductions of it. There's the interior of a room and a view out into the street and there are two wings to the altarpiece, one depicting an exterior, the other an interior. When I was working at The Cloisters, I looked at it every single day and wondered what it was about the picture that seemed to make it throb. It never seemed to be at rest. It was not just there frozen, and I wondered why it was more satisfying than even some pictures by Van Eyck. I began to look at it even more carefully. Then, in a revelation, I observed that in the painting, an object didn't cast one shadow, it cast about eight, and that there are numerous complex shadow overlays, one shadow over another. Now this meant that the artist, practically for the first time in history, observed that light bounces in a highly complicated way and that there's not just one shadow line, there were many, many subtle angles of shadow. Light comes in, makes a major shadow, and then that light bounces off the walls, the ceiling, other objects, and creates faceted shadows from all different sides. And then I realized that this is what really made that particular picture. It was very seldom done again. As a matter of fact I don't even know if it was done again.

"When you talk broadly about the differentiations between the work at Olsons and at Kuerners, I find in the Olsons a far greater attention to formal qualities and characteristics. In Olsons there is a more conscious ordering of elements. You line things up more into relationships of squares, rectangles, and so on. There is in Olsons a feeling of being able to see the earth and then go way up in the sky. I don't know why that is, maybe it's the quality of the sky in summer. Maybe it's the light."

"Well, Maine to me is almost like going on the surface of the moon. I feel things are just hanging on the surface and that it's all going to blow away. In Maine, everything seems to be dwindling with terrific speed. In Pennsylvania, there's a substantial foundation underneath, of depths of dirt and earth. Up in Maine I feel it's all dry bones and dessicated sinews. That's actually the difference between the two places to me. One is moist, another's dry. If it is moist in Maine, it's a surface moistness. Look at the portrait of *Anna Christina* [134] and compare it to the portrait of *Karl* [78]. I think that clarifies what I'm trying to say."

"You don't work at Olsons anymore, do you?"

"No, I don't. Without Alvaro and Christina, it's just an object, nothing more – interesting perhaps, but not emotionally interesting. But in a strange sense there is a continuation of Olsons and Christina in some of my recent work. This appears in the paintings I have done of the young girl Siri, when she was fourteen, fifteen, and sixteen."

"Who is Siri? Where did the idea spring from?"

"I had completed *Anna Christina,* which, as I said, was the last portrait I ever did of Christina Olson. And that fall, when I completed it, just before I left for Pennsylvania, I stopped in at a certain farm, owned by George Erickson, with Betsy one day because she wanted to have a look at a strange-looking building that sat way back from the road. Now George is a Finnish man whom I'd seen over the years with a little blonde-haired

182. *The Finn, 1969. Drybrush, 28¾ x 21 in. Mr. and Mrs. Joseph E. Levine*
183. *Detail of The Virgin (see No. 184)*

18.

daughter whom he'd had late in life. At that time he was about seventy and she was thirteen. As we went by the house, he came out and we stopped and Betsy talked to him. As this was going on, I saw behind him a lovely tow-headed little girl. And as Betsy and George Erickson walked into the back of the lot to look at the house, I stayed and talked to this little girl who said her name was Siri. I had seen her several times before, walking down the road. I asked her if I could come back the next day after school because I wanted to make a drawing of her. She said, 'Sure,' in a shy way. So I came back, and I made a little drawing of her standing in the doorway with a black cat, a very brief sketch. I left the drawing in my book and didn't do any more about it.

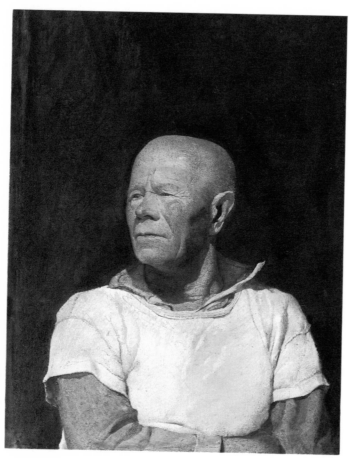

182

"I left for Pennsylvania about a week later. During the early winter I kept thinking about this little girl. Then I got word that Christina had died. I went up to the funeral. It was very snowy. I remember going by the girl's house as I followed the hearse to the funeral. And as we passed, I remember looking at her house surrounded by some enormous pines and thinking, gosh, that little girl's in there. I was really hanging onto the thought because I could realize that that moment was the end of Olsons. And all the rest of the day I kept thinking that the young girl was there. It did fascinate me. It was almost as if it symbolized a rebirth of something fresh out of death. That sounds a little dramatic, but actually it is true.

"Next spring I went to the Erickson farm and talked to George Erickson and Mrs. Erickson and told them I would love to do a portrait of their daughter. I later painted George; I call the painting *The Finn* [182]. I said I'd like to paint her picture someplace on the farm, perhaps in the barn. I went back the next day. Erickson told me that he thought it would be best to do it in the sauna, since it wasn't used. It was an excellent spot since it was right in front of the house near a clump of beautiful pine trees. I told him that was fine, wonderful. Siri was there looking lovely with her high-colored skin and very long hair. I told her we would go out to the sauna and she cleaned and swept it up the next day.

"I made a drawing of her by the window sitting there with a towel around her. At first I made two drawings of her head, very quickly, and I was thinking about it and the next day I went back, and suddenly I had this brainstorm – well, I thought, here we were in this sauna. I thought with her damp hair, we just might act if this were a real sauna – a working sauna – with heat. And she told me that she often sat in there anyway and she came out with a towel wrapped around her over her breasts with her shoulders bare. I started a full drawing. I took it home and I was very excited about it. I've never told this story before. I showed Betsy the drawing. She thought it was remarkable, terrific; she said, 'You really caught the girl, looking directly at you, no off-looking or looking away.' Here was a young, fourteen-year-old girl, looking you clear in the eye, with blue

eyes and damp hair, hands clenched, wonderful strong shoulders, solid knees, and with her feet placed firmly side by side. Betsy said, 'It's a shame you couldn't get her to take off that towel.' I said, 'George Erickson maybe will shoot me, you know she's fourteen years old.'

"But Betsy put the seed in my mind. That's all I needed. So I went back and I started to draw the thing on a panel. Then I asked her, 'Siri, would you pose without the towel around the upper part of your body?' 'Sure,' she said, and she started to take it away and I said, 'Wait a minute, you go and ask your parents, because this can be a rather tricky thing.' She said, 'It's strange you said that, because Daddy said last night, if he's going to do you in a sauna bath, why do you have a towel around you?' Well, that was very encouraging. She came back, she said, 'Fine,' but her father wasn't there at the time and she asked her mother. I thought her father, too, had cleared it. Anyway, I sat there, and she said, 'Close your eyes.' I shut my eyes, and she said, 'Now you can look' and there she was. She was flustered for a few minutes and finally it meant nothing. And I started right in on the painting. At first, I had objects around, such things as birch branches used in saunas to switch yourself. Anyway, I had that in her hand. I soon eliminated these props because with them the painting lost its impact. I thought, 'Well, if I'm going to do it, I might as well really do it.' I brought the nearly completed painting down to my studio to show it to Betsy. She came into the studio and sat right down. It was the only time she's ever looked at one of my works and just sat down in astonishment. She said, 'You're going to have trouble with this picture.'

"I was already thinking of another painting which I had already entitled *The Virgin* [184]. Later, it turned out to be a shocking picture to people. I think it's because they had built up an image of me at odds with *The Virgin*. That picture shocked the hell out of people."

"Andy, tell me about *The Virgin*, which was painted a year after *The Sauna*, is that right?"

"Yes. She was fifteen. That was a remarkable experience because by that time she'd really become a young woman. I did the painting in the Erickson barn and started it on a foggy day. I said to her, 'Come on, Siri, we're going to do this.' She said, 'Well, you stay downstairs.' And she went upstairs in the barn and then came down those steps – a remarkable girl. It was an amazing experience with the quality and the smells of the barn, and this healthy Finnish girl, no affectation, no lipstick, never had had any dates, absolute virgin. It was remarkable, like finding a young doe in the woods. I consider that picture a very precious picture to me because I knew I was looking at something that was untouched, unaffected. Here's a girl who only had outside privies, who had slept all her life in a room on a mattress where the snow could drift in across it. She was healthy, vital, and an intelligent girl, too.

"I worked for about four weeks just on the proportions of her standing figure. You will notice there's no real location again. You're looking down at the feet and up to the head at the same time. You couldn't get that angle with a photograph. She moved in different positions to get the right pose. I wasn't particularly located in any spot. There is a floor there in the painting, but it isn't there, in a sense. I started working on the body and began to paint it in. The sun came out one day, in the morning, and she stepped back, you notice the windows across a barn door. The sun came through them, and her head just hit the sun, which fell against her face and upper body for a short time. I painted like mad. She stepped up the steps a little just to catch that, and it made the picture. It has a marvelous bit of gold with the rest of the room in the shadow. That's what happened, simple as that.

"I really like the painting because it has a kind of mythical quality. Do you know *Pohjola's Daughter* by Sibelius, which is to me an amazing composition? It all goes with that. She once told me she liked to ride bareback in the summer at nighttime completely nude with her blond hair streaming behind her. It's wild country back there. I used to think about that story and about that amazing figure. This healthy, young Finnish girl on the horse. I even thought of her connection with moose, in terms of the early Finnish legend about an elk and a beautiful girl and the combination of the two. You see all of this came into it. It's a world all of its own. I never

consider it a nude painting. I consider it more than that. But *The Virgin* was good, because that is absolutely what it was, it was a virginal idea for me, fresh, untouched, with this golden glow about it.

"One thing happened during it that came as a great shock to me. I was painting one day and suddenly I could see her staring intently out of the crack of this door. All of a sudden, she rushed out, grabbed a club, and killed a groundhog that had gotten into her father's garden and was eating the vegetables. She just clubbed it to death. Terrific. Blood spattered a little on her legs. Now this is really true, it is her background. She's an earthy girl, God. She was powerful. I was in the right spot. It was a bit of luck. I've often thought I've built my career on happening to find things that are suddenly unusual. Of course, it's what you seek and what you grasp as an opportunity and follow up on again and again that really does it.

"*The Virgin* started off as a much bigger panel. For a while there were baskets of corn hanging above which you use for seed corn in the spring and some stalls with hay. All that was in it for a time, but in the end I cut the panel way down to make it a much better composition. I realized that the emphasis was just right at that cut-down size. I had to go through the other things that were familiar to me before finally I had the guts to put down something fresh. I was relying on the strict disciplinarian side of my nature and then I broke out of that into the freer side by focusing in. Artistically, I went from complexity to simplicity. Within myself I went from the disciplinarian side to the free side.

"Somehow I can't imagine that picture being dated. Maybe the slight mark of the bikini might, but I doubt it, it's so subtle. You wouldn't notice it unless you looked close. And I love that strange line around her that outlines the body. I think it's some of the purest tempera painting I ever did in that torso, because it almost becomes an abstraction of the truth. There are parts of the picture that are almost watercolor. But I thought this is the flash in the picture. This is the sparkle. I think you run from that waxen quality of the lower part of the figure going up all of a sudden to the sunlight on the upper body. I had to paint like mad to get it. But, fortunately, I had the whole figure painted in and could work quite directly on the head and hair. I refined it, of course, later on, but to get it there had to be some pretty excited strokes when that sun came out. The line, for instance, coming down across her chest out over the breast, was a very definite shadow under the corded part of her neck and up to her ear. It was very definite and contrasted with the luminosity of the part where the curls break slightly.

"To me, these pictures of the young Siri are continuations of Olsons, and at the same time they are sharp counteractions to the portraits of Christina, which symbolize the deterioration and the dwindling of something. Then you get suddenly this change of such an invigorating, zestful, powerful phenomenon. Here was something bursting forth, like spring coming through the ground. In a way this was not a figure, but more a burst of life. I don't think it lives just because it's a nude girl. That wasn't the reason at all for painting it. There are a lot of farms more effective than the Kuerners' but that isn't the point at all. Here, as always, I try to go beyond the subject. That's the summation of my art. Emotion is my bulwark. I think that's the only thing that endures, finally. If you are emotionally involved, you're not going to be easily changed. But if it's purely a technical experience that's going to be very short-lived. Both technical and emotional have got to be on even terms to be good.

"Brahms' music affects me a little. I used to love it. But it's soft now, when I listen to it. I really don't care for it. It hasn't got the edge of Beethoven or Bach. It's round-shouldered. There's too much mumbling to suit me. And this is the way I feel about painting. People often have said to me, 'What's made you keep on against the tide? Supposedly, you're so way behind that you're ahead!' Not really. The answer is pure emotion. I was interested in Christina, I was interested in that house. I was fascinated by the Kuerners and the farm. I wasn't at either place to paint a nice group of pictures or bucolic memories or Maine images. I was emotionally involved in the thing and I just had to get it out of my system. That's all.

"Art, to me, is seeing. I think you have got to use your eyes as well as your emotion, and one without the other just doesn't work. That's my art."

TWO WORLDS OF ANDREW WYETH: KUERNERS AND OLSONS

Pictures illustrated in the earlier section are not shown here, and this list does not include some of the studies that are exhibited with the finished paintings.

Kuerners

1. *Soaring, 1950. Tempera, 48 x 87 in. Shelburne Museum, Inc., Shelburne, Vermont*
2. *Tree in Winter, 1946. First study for "Winter 1946." Watercolor, 20¾ x 28¾ in. Dickinson College, Carlisle, Pennsylvania, Fine Arts Collection*
3. *Kuerners Hill, 1946. Pencil study for "Winter 1946," 11 x 20 in. Robert H. Kubie*
4. *Kuerners Hill, 1946. Drybrush study for "Winter 1946," 21¾ x 44¼ in. R. L. B. Tobin*
5. *"Winter 1946," 1946. Tempera, 31⅜ x 48 in. North Carolina Museum of Art, Raleigh, Museum Purchase Fund*
6. *Snow Flurries, 1953. Tempera. Private Collection. See No. 89*
7. *Archie's Corner, 1953. Pencil study for Snow Flurries, 13¼ x 18¼ in. Private Collection*
8. *The Woodshed, 1944. Tempera, 31½ x 56¾ in. Private Collection*

9. *Crows, 1944. Brush, gouache, and ink, 33 x 47 in. The Lyman Allyn Museum, New London, Connecticut*
10. *Winter Morning, 1946. Drybrush, 25½ x 38⅜ in. Private Collection*
11. *Karl, 1948. Tempera. Mr. and Mrs. John D. Rockefeller III. See No. 78*
12. *Karl, 1971. Pencil study for The Kuerners, 12¾ x 13¼ in. Mr. and Mrs. Frank E. Fowler*
13. *Out of Season, 1953. Drybrush, 13¼ x 20½ in. Mr. and Mrs. John Warner*
14. *Study for Brown Swiss, 1957. Pencil and watercolor. Private Collection. See No. 37*

15. *Hill Pasture, 1957. Watercolor. Mr. and Mrs. Paul Bidwell. See No. 50*
16. *Chimney Smoke, 1957. Watercolor. Mrs. Oscar B. Huffman. See No. 46*
17. *Brown Swiss, 1957. Tempera. Mr. and Mrs. Alexander M. Laughlin. See No. 35*
18. *Trodden Weed, 1951. Tempera. Private Collection. See No. 105*
19. *Karl's Room, 1954. Watercolor, 21½ x 29¾ in. The Museum of Fine Arts, Houston, Gift of Mrs. W. S. Farish*
20. *Oil Drum, 1957. Watercolor, 13¾ x 21¾ in. Private Collection*
21. *Cider and Pork, 1956. Watercolor, 21¾ x 29 in. Amanda K. Berls*

9

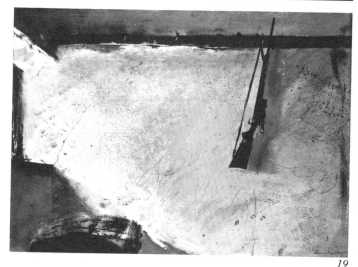

19

10

20

12

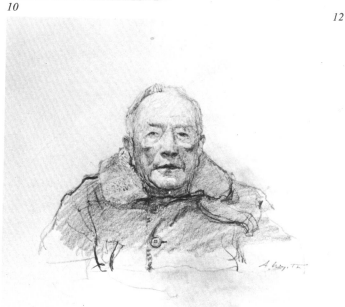

21

22. *Hickory Smoked, 1960. Watercolor, 29 x 37 in. Honorable and Mrs. William W. Scranton*
23. *Below the Kitchen, 1960. Drybrush, 22¼ x 17½ in. Private Collection*
24. *Gum Tree, 1958. Watercolor, 21½ x 29⅝ in. Mrs. William H. Kearns*
25. *First Snow, 1959. Drybrush study for Groundhog Day, 13⅜ x 21¼ in. Delaware Art Museum, Wilmington, William and Mary Phelps Collection*

26. *Wild Dog, 1959. Watercolor. Mr. and Mrs. James Wyeth. See No. 73*
27. *Groundhog Day, 1959. Tempera. Philadelphia Museum of Art, Given by Henry F. duPont and Mrs. John Wintersteen, 59.102.1. See No. 74*
28. *Young Bull, 1960. Drybrush. Private Collection. See No. 26*
29. *The Trophy, 1963. Drybrush, 22⅜ x 30½ in. Mr. and Mrs. Tate Brown*
30. *Moose Horns, 1963. Drybrush, 16 x 23⅜ in. Mr. and Mrs. William B. Klee*

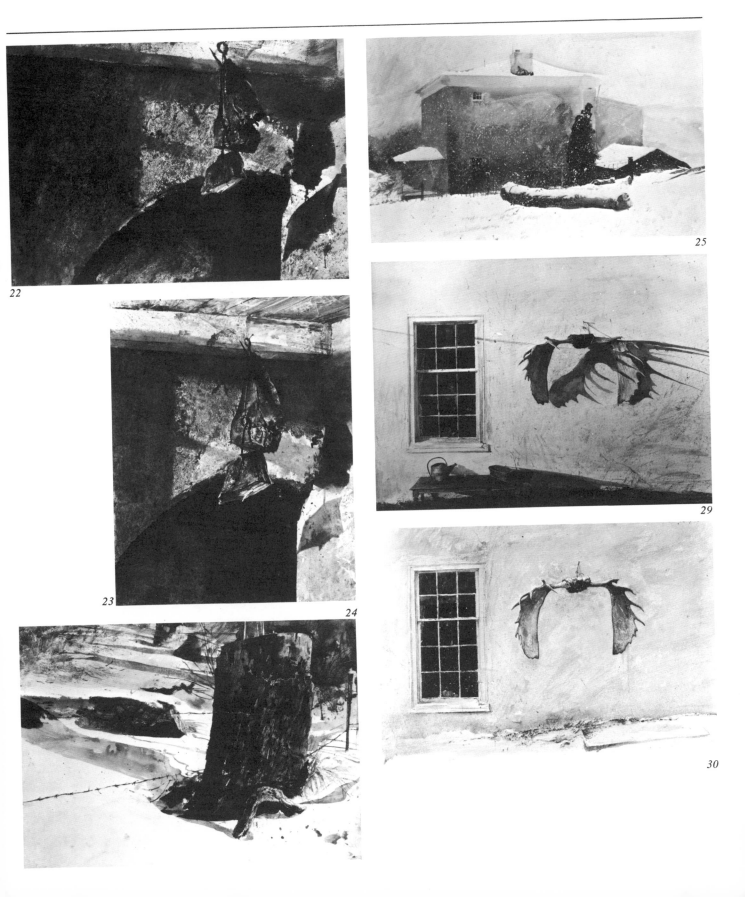

22

23

24

25

29

30

31. *Frozen Pond, 1968. Watercolor. Private Collection. See No. 27*
32. *Easter Sunday, 1975. Watercolor. Private Collection. See No. 104*
33. *Heavy Snow, 1967. Drybrush, 20 x 40 in. Zula McMillan*
34. *Gate Chain, 1967. Watercolor, 21½ x 13½ in. Private Collection*

35. *Milk Room, 1964. Watercolor, 28⅞ x 23 in. Thomas M. Evans*
36. *Spring Fed, 1967. Tempera. W. E. Weiss, Jr. See No. 61*
37. *Cordwood, 1968. Watercolor, 25 x 30 in. Private Collection*
38. *Toward Atwaters, 1968. Watercolor, 11¼ x 21½ in. Mr. and Mrs. Nicholas Wyeth*

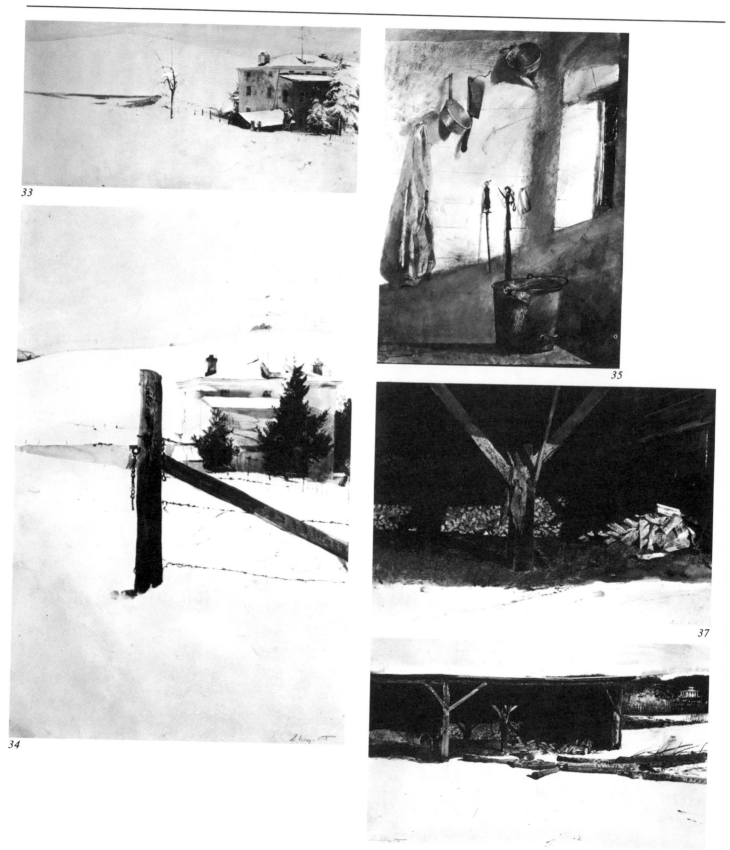

33

34

35

37

38

39. *Downgrade, 1968. Watercolor, 21¾ x 29¾ in. Private Collection*
40. *Springhouse Door, 1971. Watercolor, 21 x 29 3/16 in. Private Collection*
41. *After Christmas, 1971. Watercolor, 21½ x 40 in. Private Collection*

42. *Where the German Lives, 1973. Watercolor, 21½ x 29½ in. Phil Walden*
43. *Kuerners Farm, 1972. Pencil, 18 x 24 in. Roul Tunley*
44. *Lamplight, 1975. Watercolor. Anton A. Vreede. See No. 32*
45. *Pine Baron, 1976. Tempera. Private Collection. See No. 102*
46. *Anna Kuerner, 1971. Tempera. W. S. Farish III. See No. 83*
47. *Anna Kuerner, 1971. Pencil study for Anna Kuerner, 10 x 13 in. Private Collection*

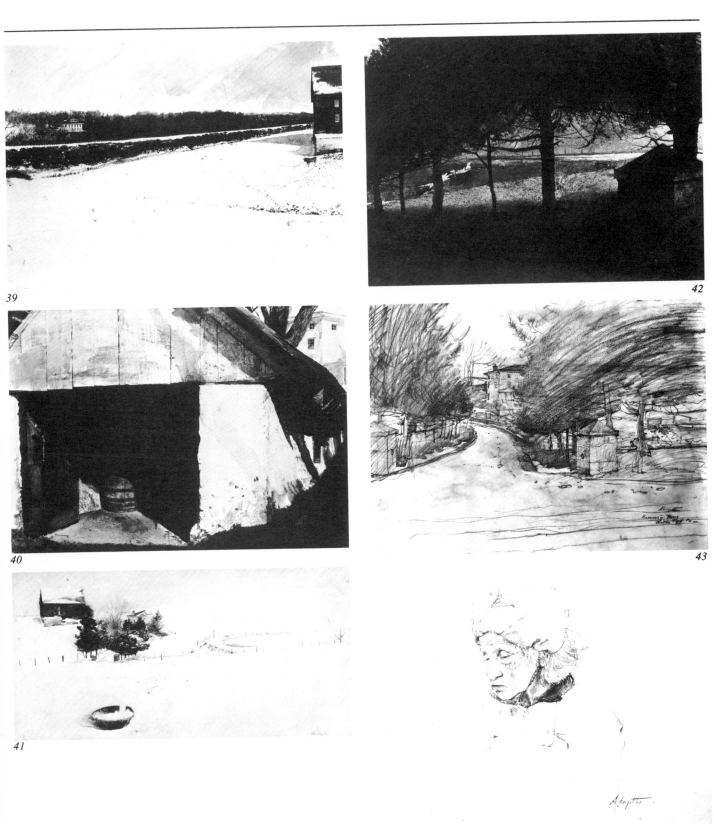

39

42

40

43

41

47

48. *The Kuerners, 1971. Drybrush. Private Collection. See No. 88*
49. *The German, 1975. Watercolor. Private Collection. See No. 99*
50. *Bull Run, 1976. Watercolor, 30 x 52 in. Harry A. Levin*
51. *Wolf Moon, 1975. Watercolor. Private Collection. See No. 64*
52. *The Prowler, 1975. Watercolor, 21 x 39 in. F. Szabo*
53. *Patrolling, 1975. Watercolor, 20¼ x 29 in. Private Collection*

54. *Evening at Kuerners, 1970. Drybrush watercolor. Private Collection. See No. 55*
55. *Spring Cleaning, 1964. Watercolor, 20½ x 29½ in. Private Collection*
56. *Spare Room, 1973. Watercolor, 19 x 30 in. John L. Lavrich*

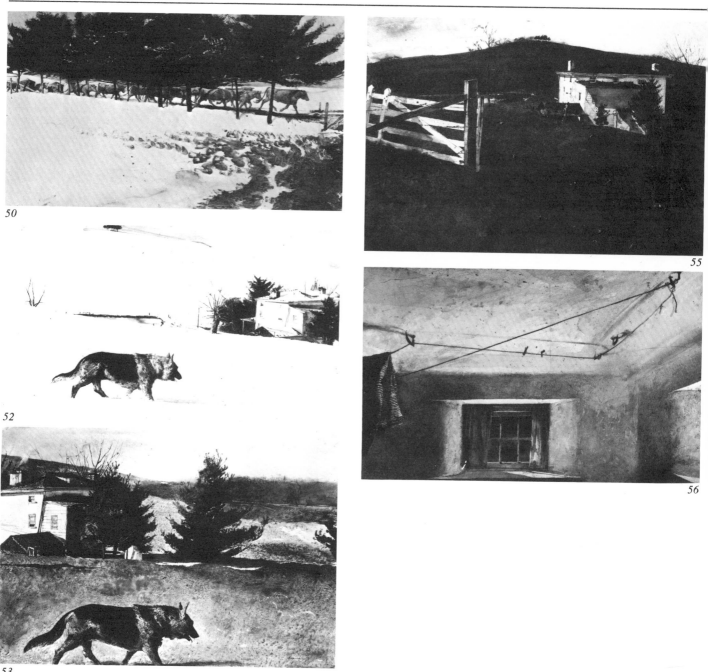

50

52

53

55

56

Olsons

57. *Off at Sea, 1972. Tempera, 33¾ x 33½ in. Private Collection*
58. *John Olson's Funeral, 1945. Watercolor, 21½ x 29½ in. The New Britain Museum of American Art, Charles F. Smith Fund*
59. *Oil Lamp, 1945. Tempera. The Museum of Fine Arts, Houston, Gift of Mrs. W. S. Farish. See No. 110*
60. *Christina with Beads, 1947. Pencil study for Christina Olson, 17 x 22¾ in. Private Collection*

61. *Doorway, 1947. Pencil study for Christina Olson, 23¼ x 17¼ in. Private Collection*
62. *Christina's Head, 1947. Pencil study for Christina Olson, 17 x 22¾ in. Private Collection*
63. *Christina's Head, 1947. Watercolor study for Christina Olson, 12 x 9½ in. Private Collection*

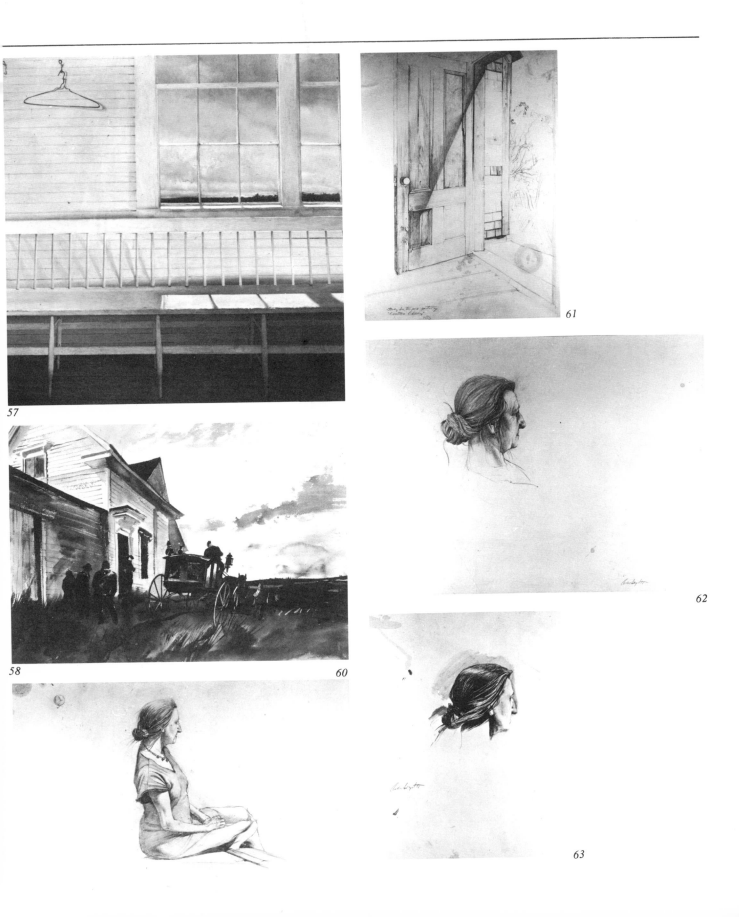

57

61

58

60

62

63

64. *Christina Olson, 1947. Tempera. Private Collection. See No.*
117
65. *Open Window with Artist's Notes, 1947. Watercolor study for*
Wind from the Sea, 11¾ x 15⅝ in. Private Collection
66. *View out an Open Window, 1947. Pencil study for Wind from*
the Sea, 14½ x 21⅜ in. Private Collection
67. *Window with Blowing Curtain, 1947. Pencil study for Wind*
from the Sea, 17 x 14 in. Private Collection
68. *Wind from the Sea, 1947. Tempera. Private Collection. See No.*
144

69. *Christina's World, 1948. Tempera. The Museum of Modern Art,*
New York, Purchase, 1949. Lent for New York City only. See
No. 106
70. *Seed Corn, 1948. Tempera. Private Collection. See No. 164*
71. *Christina's Bedroom, 1947. Watercolor, 22 x 30 in. Private*
Collection
72. *Miss Olson, 1952. Tempera. Mr. and Mrs. John D. Rockefeller*
III. See No. 129
73. *Miss Olson and a Kitten, 1952. Pencil. Mr. and Mrs. John D.*
Rockefeller III. See No. 127
74. *The Witch Door, 1948. Watercolor, 29 x 22 3/16 in.*
Christina Malkemus

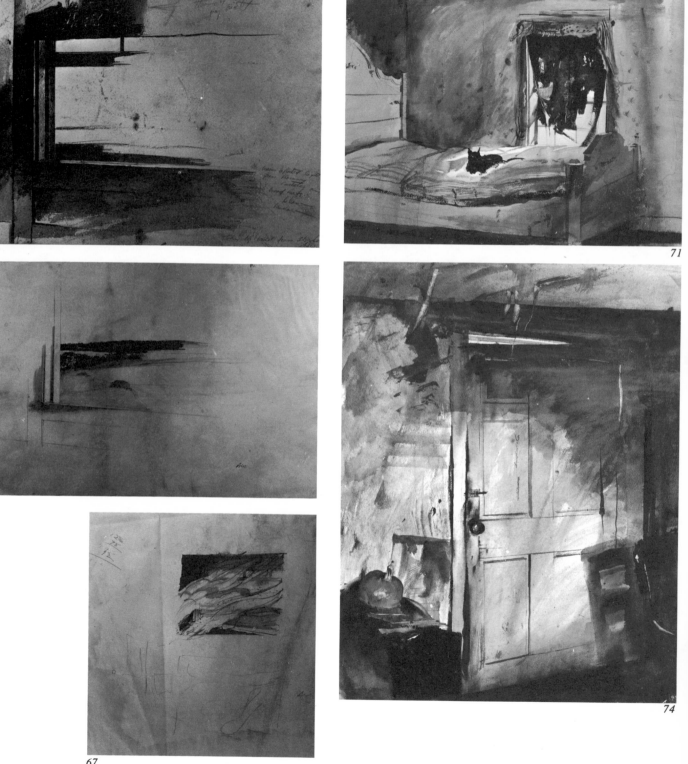

65

71

66

67

74

75. *The Blue Door, 1952. Watercolor, 29¼ x 21 in. Delaware Art Museum, Wilmington, Delaware*
76. *Alvaro and Christina, 1968. Watercolor. The William A. Farnsworth Library and Art Museum, Rockland, Maine. See No. 153*
77. *The Revenant, 1949. Tempera. The New Britain Museum of American Art, Harriet Russell Stanley Fund. See No. 150*
78. *Sea Fog, 1954. Watercolor, 29⅞ x 20 in. Mrs. Henry J. Heinz II*

79. *Incoming Fog, 1952. Watercolor, 29 x 21 in. Mrs. Louis G. Bissell*
80. *Hogshead, 1955. Watercolor, 19½ x 27½ in. Estate of Dr. Catherine L. Bacon, through Messrs. Frank and Charles Bacon*

75

78

79

80

81. *Egg Scale, 1959. Drybrush. Private Collection. See No. 111*
82. *Blue Box, 1956. Watercolor, 20 x 28 in. Mr. and Mrs. R. F. Mayer*
83. *Barn and Dory, 1957. Watercolor study for Hay Ledge, 21½ x 28 in. Coe Kerr Gallery Inc.*

84. *Barn Loft, 1956. Watercolor, 36 x 27 in. Dr. and Mrs. Robert K. Ferguson*
85. *Alvaro's Hayrack, 1958. Watercolor, 9 x 23 in. The William A. Farnsworth Library and Art Museum, Rockland, Maine*
86. *Blue Measure, 1959. Drybrush. Private Collection. See No. 178*
87. *New England, 1960. Drybrush, 18 x 23 in. Private Collection*

82

83

84

85

87

92

96

93

97

**Works by Andrew Wyeth in the collection
of Mr. and Mrs. Joseph E. Levine**

99. *Rum Runner, 1944-1974. Tempera, 28 x 48 in.*
100. *Rum Runner, 1974. Watercolor study for the tempera Rum Runner, 14½ x 7¾ in.*

101. *Sea Snails, 1953. Watercolor, 20 x 28 in.*
102. *Swimming Gull, 1954. Watercolor, 13½ x 19½ in. Richard P. Levine*
103. *Teel's Island, 1954. Drybrush, 9½ x 22 in.*

99

100

101

102

103

104. *Hay Ledge, 1957. Tempera. See No. 170*
105. *Tom's Shed, 1960. Watercolor, 13⅜ x 19¼ in.*
106. *Peter Hurd, Jr., 1961. Drybrush, 17½ x 21½ in.*
107. *Kitchen Garden, 1962. Drybrush and watercolor, 22½ x 1¼ in.*

108. *Weather Side, 1965. Tempera. See No. 156*
109. *Fence Line, 1967. Watercolor. See No. 18*
110. *Buzzard's Glory, 1968. Tempera, 18½ x 23½ in.*
111. *Christina's Teapot, 1968. Watercolor, 22¾ x 28¾ in.*
112. *Cider Barrel, 1968. Drybrush, 22 x 29 in.*

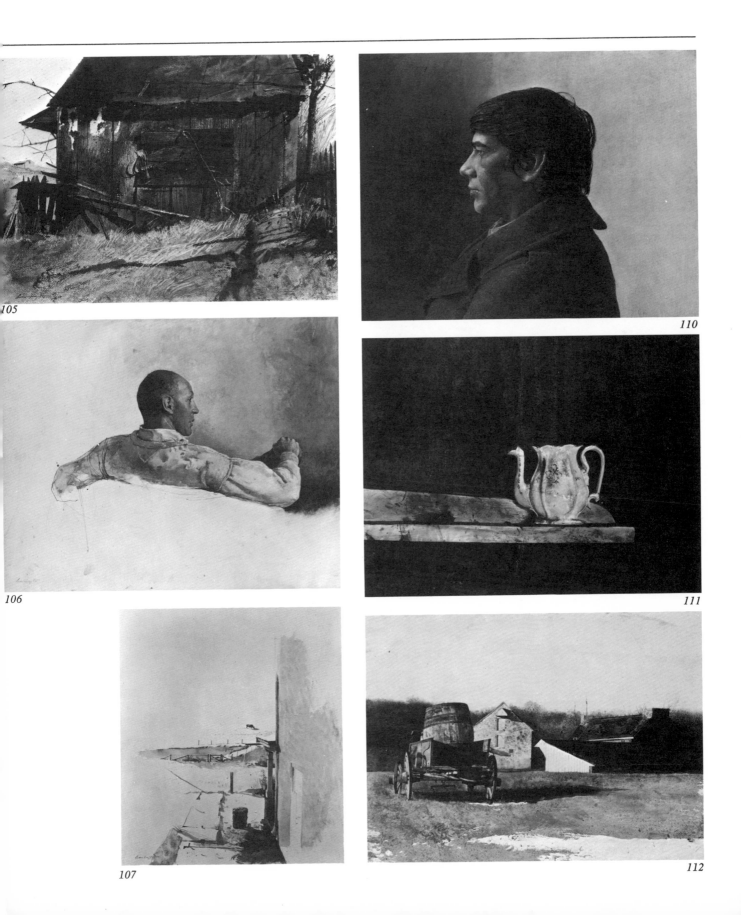

105

106

107

110

111

112

113. Elwell's Sawmill, 1968. Watercolor, 22 x 30½ in.
114. Logging Scoot, 1968. Watercolor, 22 x 30½ in.
115. Airing Out, 1969. Watercolor, 30½ x 22 in.

116. End of Olsons, 1969. Tempera. See No. 165
117. The Finn, 1969. Drybrush. See No. 182
118. Spruce Bough, 1969. Watercolor, 21¾ x 30 in.
119. The General's Chair. 1969. Watercolor, 29 x 20⅞ in.

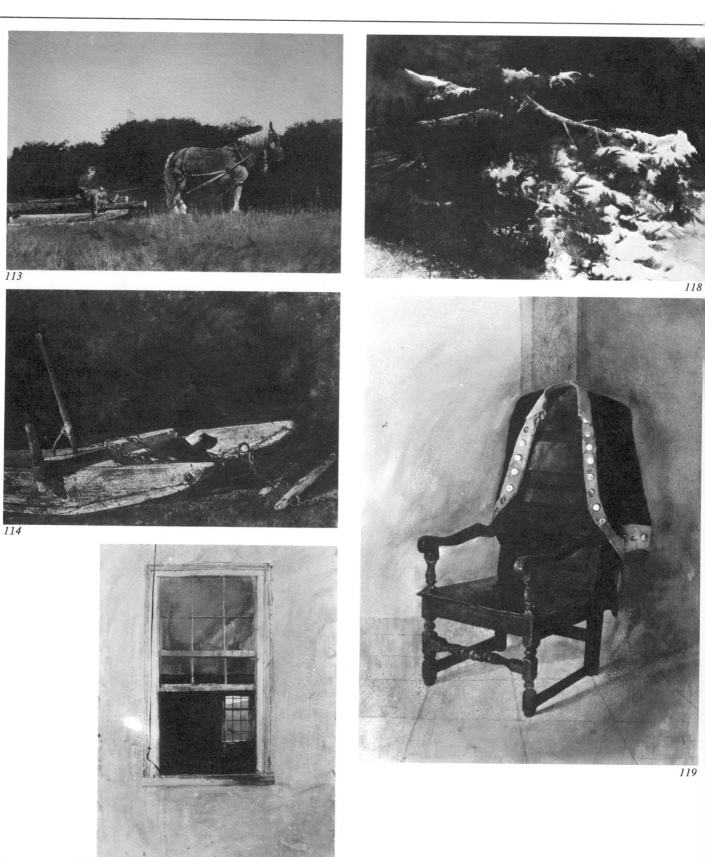

113

118

114

115

119

120. *Rain Clouds, 1969. Watercolor, 30⅜ x 22 in.*
121. *The Swinger, 1969. Drybrush, 14¾ x 24¾ in.*

122. *Afternoon Flight, 1970. Watercolor, 23 x 29¼ in.*
123. *My Young Friend, 1970. Tempera, 32 x 25 in.*

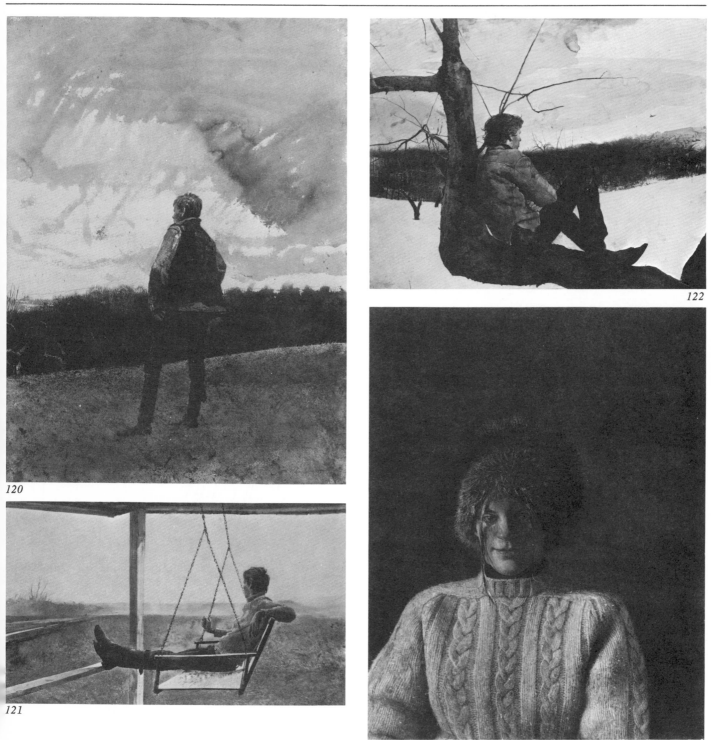

120

121

122

123

124. *Richard P. Levine, 1970. Pencil, 13¾ x 16¾ in.*
125. *Nogeeshik, 1972. Tempera. See No. 31*
126. *From the Capes, 1974. Tempera, 24½ x 18½ in.*

127. *Canada, 1974. Watercolor, 17¼ x 28 in.*
128. *The Quaker, 1975. Tempera, 36½ x 40 in.*
129. *Olsons in the Snow, 1975. Watercolor, 16½ x 20 in.*

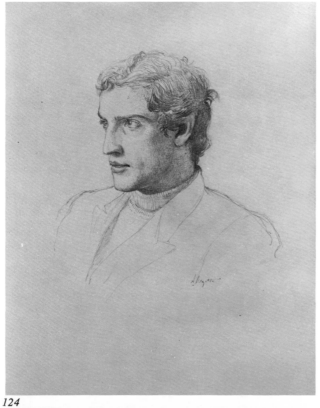

124

126

127

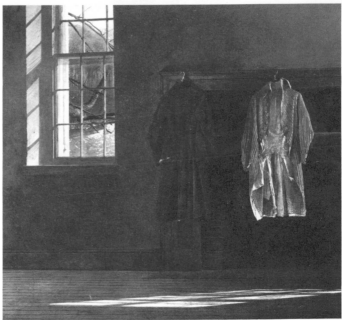

128

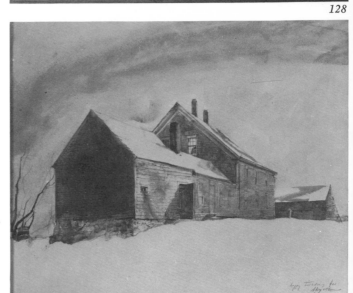

129